THE ART OF
SOMETHING
is KILLING the
CHILDREN ™

Published by

THE ART OF *SOMETHING IS KILLING THE CHILDREN*

BOOK DESIGN COURTNEY MENARD
PRODUCTION DESIGN DEANA AVILA
EDITOR ERIC HARBURN
PACKAGING TINY ONION, INC.

SPECIAL THANKS MAYA BOLLINGER & RAMIRO PORTNOY

SOMETHING IS KILLING THE CHILDREN
CREATED BY JAMES TYNION IV & WERTHER DELL'EDERA

ALL INTERIOR PAGE ARTWORK ILLUSTRATED BY WERTHER DELL'EDERA
WITH COLORS BY MIQUEL MUERTO

Ross Richie Chairman & Founder · **Jen Harned** CFO · **Matt Gagnon** Editor-in-Chief · **Filip Sablik** President, Publishing & Marketing · **Stephen Christy** President, Development
Adam Yoelin Senior Vice President, Film · **Bryce Carlson** Vice President, Editorial & Creative Strategy · **Josh Hayes** Vice President, Sales · **Mette Norkjaer** Vice President, Development
Ryan Matsunaga Director, Marketing · **Stephanie Lazarski** Director, Operations · **Elyse Raimo** Manager, Finance · **Michelle Ankley** Manager, Production Design
Cheryl Parker Manager, Human Resources · **Rosalind Morehead** Manager, Retail Sales · **Jason Lee** Manager, Accounting

THE ART OF SOMETHING IS KILLING THE CHILDREN, December 2024. Published by BOOM! Studios, a division of Boom Entertainment, Inc. Something is Killing the Children is ™ & © 2024 James Tynion IV & Werther Dell'Edera. All rights reserved. BOOM! Studios™ and the BOOM! Studios logo are trademarks of Boom Entertainment, Inc., registered in various countries and categories. All characters, events, and institutions depicted herein are fictional. Any similarity between any of the names, characters, persons, events, and/or institutions in this publication to actual names, characters, and persons, whether living or dead, events, and/or institutions is unintended and purely coincidental. No part of this publication may be used, reproduced, or transmitted in any manner whatsoever without prior written permission, except in the case of brief quotations for journalistic or review purposes. For information, email contact@boom-studios.com. BOOM! Studios does not read or accept unsolicited submissions of ideas, stories, or artwork.

BOOM! Studios, 6920 Melrose Avenue, Los Angeles, CA 90038-3306. Printed in China. First Printing.

Standard Edition ISBN: 978-1-60886-596-3, eISBN: 978-1-60886-598-7
Slipcase Edition ISBN: 979-8-89215-448-2
Kickstarter Exclusive Edition ISBN: 979-8-89215-252-5, eISBN: 979-8-89215-259-4
Kickstarter Exclusive Slipcase Edition ISBN: 979-8-89215-253-2

Kickstarter Exclusive Silver Slipcase Edition ISBN: 979-8-89215-254-9
Kickstarter Exclusive Gold Slipcase Edition ISBN: 979-8-89215-255-6
Kickstarter Exclusive Elite Slipcase Edition ISBN: 979-8-89215-256-3

CONTENTS

INTRODUCTION

It all started with that title.

Before Erica, before the House of Slaughter, before the series took the comic-book world by storm, there was *Something is Killing the Children*—a title James had kept in his back pocket for years, in search of the right story.

I remember first hearing the title at an Emerald City Comic Con years ago, as we were promoting James's first two-fisted foray into the original comics space: *The Woods* with Michael Dialynas and *Memetic* with Eryk Donovan. (Two incredibly formative works that, if you're holding this book and haven't read them yet, would absolutely be up your alley.)

As tends to happen at comic conventions, we were up far too late in a sparsely attended hotel ballroom, the lights blaring as the poor staff desperately hinted at us to get the hell out and go to bed. Oblivious to their cues, we continued to hatch new schemes for world domination—and with his trademark devious grin, James uttered that iconic phrase, long before "sentence titles" were the trend. There were no story details—no lead character, no plot. Nothing! But that didn't stop the title from worming its way deep into my brain, causing me to poke and prod James about the project every year or so until it finally came back around in 2018. And this time, it had Erica Slaughter in tow.

It all started with that title... but James will be the first to tell you, a title is just a title. *Something is Killing the Children* didn't become the juggernaut it is today until Werther came aboard and brought life to the haunting, beautifully realized world of the Order of St. George.

Funny enough, I also remember the first time I came across Werther's work—and it predates my entire decade-plus of knowing James. Way back in late 2010, when I was first brought on as an assistant editor at BOOM! Studios, I was tasked with trawling the internet in search of new artists. DeviantART, Tumblr, Twitter, and a handful of other platforms that no longer exist were the usual bread-and-butter... but it was on an unassumingly bare-bones Blogspot page that Werther's undeniable art first grabbed hold of me.

From the unparalleled character work to the pure confidence of his line, I was hooked from day one—and as anyone who was at BOOM! back in the old days will attest, I wouldn't shut up about it. Alas, it would take until early 2019 for Werther and I to first "meet" (not for lack of trying—many an email found their way into the digital graveyard of his dead address). But the instant I found the right connection and pitched him on this new book by James Tynion IV, it was Werther who was hooked. The rest, as they say, is history.

And I tell these stories here because, to us, *Something is Killing the Children* is more than just a title, and *The Art of Something is Killing the Children* is more than just the lines and colors on a page (stunning as they are!). It's the minutiae, the artistic decision-making both known and subliminal, the winding path of creation—and the wealth of amazing contributions from the best artists in this and any other industry. All of which you'll find here, lovingly curated by James and Werther themselves.

So, on behalf of the entire *SIKTC* team: thank you for joining us on this deep dive behind the scenes of the first five years of *Something is Killing the Children*—and here's to seeing you again in another five.

(It *is* a pretty damn good title, though, right?)

-ERIC HARBURN
EDITOR, *SOMETHING IS KILLING THE CHILDREN*
DETROIT, MI, 2024

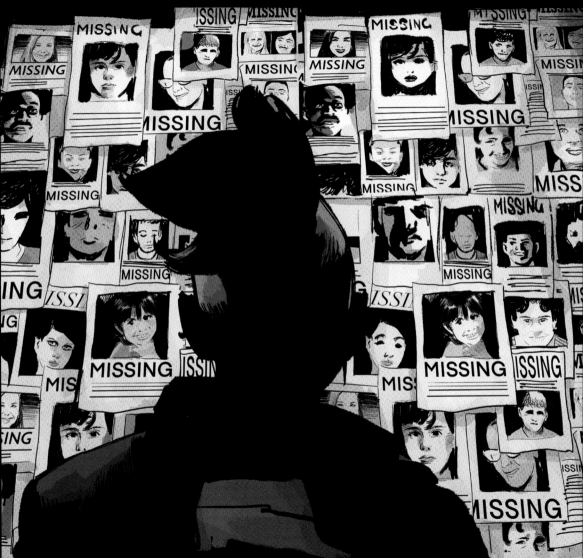

THE
ANGEL OF
ARCHER'S
PEAK

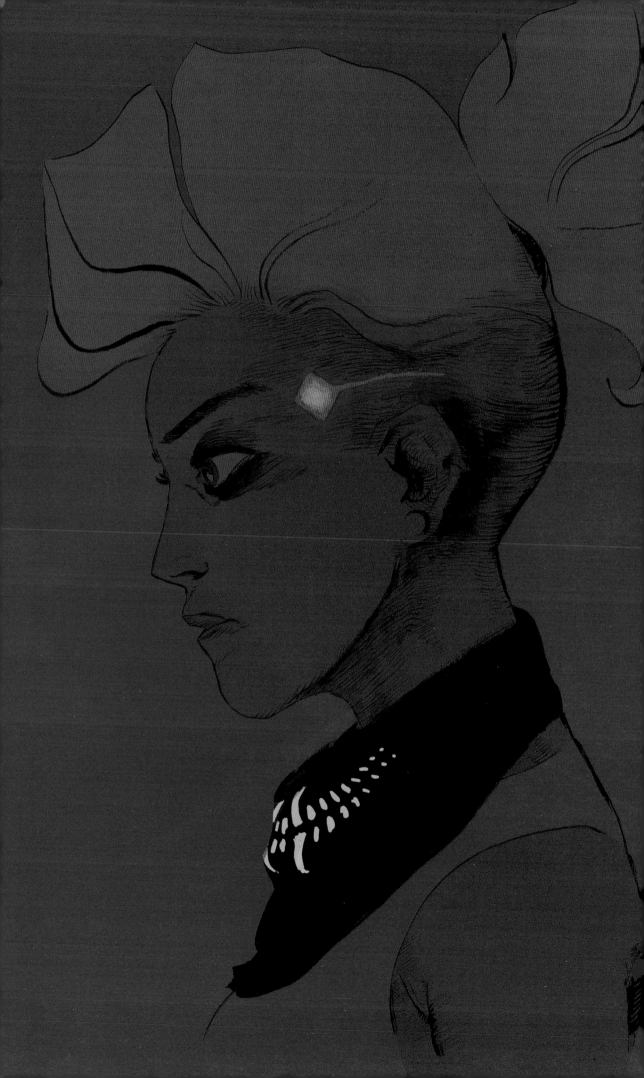

ON CREATING ERICA SLAUGHTER

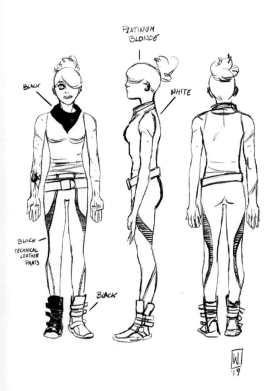

PLATINUM BLONDE

BLACK

WHITE

BLACK TECHNICAL LEATHER PANTS

BLACK

" So, the original image that was in my head when I started coming up with the idea for *Something is Killing the Children* was the idea of this woman in her late twenties, sitting in the back of a bus, traveling all over America. And she would be slight with deep shadows under her eyes and long blonde hair parted over one side of her face, hiding a scar on her temple.

I had the idea that she had a tattoo of St. George killing the dragon on her arm, which would be the symbol of the Order of St. George. Beyond that, I also had the idea that she would be carrying around what looked very clearly like a kid's backpack. Something that was a little more brightly colored and out of place for an adult woman to be carrying on this bus. But it was the tired eyes, the long blonde hair, the tattoo, and the scar on the side of her head—those were the central images that I initially brought to the table.

It wasn't until I sent all of that over to Werther to start cooking up the character designs that we got back one of the first images, which had Erica wearing this bandana over her mouth, with these monstrous teeth on it.

And there was a note from Werther with it: what if, to fight the monsters, Erica becomes the monster? And that was such a good and clear idea. It just immediately became central to the entire thesis of the book. And beyond that, it was just immediate. Once we saw that image, it was just like—*that is the key image of this entire series*. Erica in that mask is what makes her an iconic character, and Werther gets all the credit for that. "

—JAMES

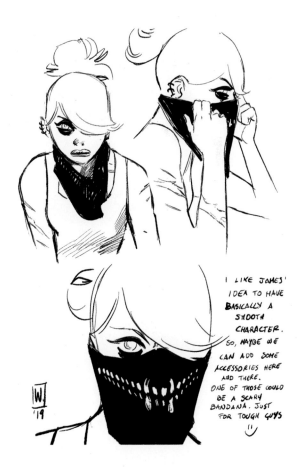

I LIKE JAMES' IDEA TO HAVE BASICALLY A SMOOTH CHARACTER. SO, MAYBE WE CAN ADD SOME ACCESSORIES HERE AND THERE. ONE OF THOSE COULD BE A SCARY BANDANA. JUST FOR TOUGH GUYS

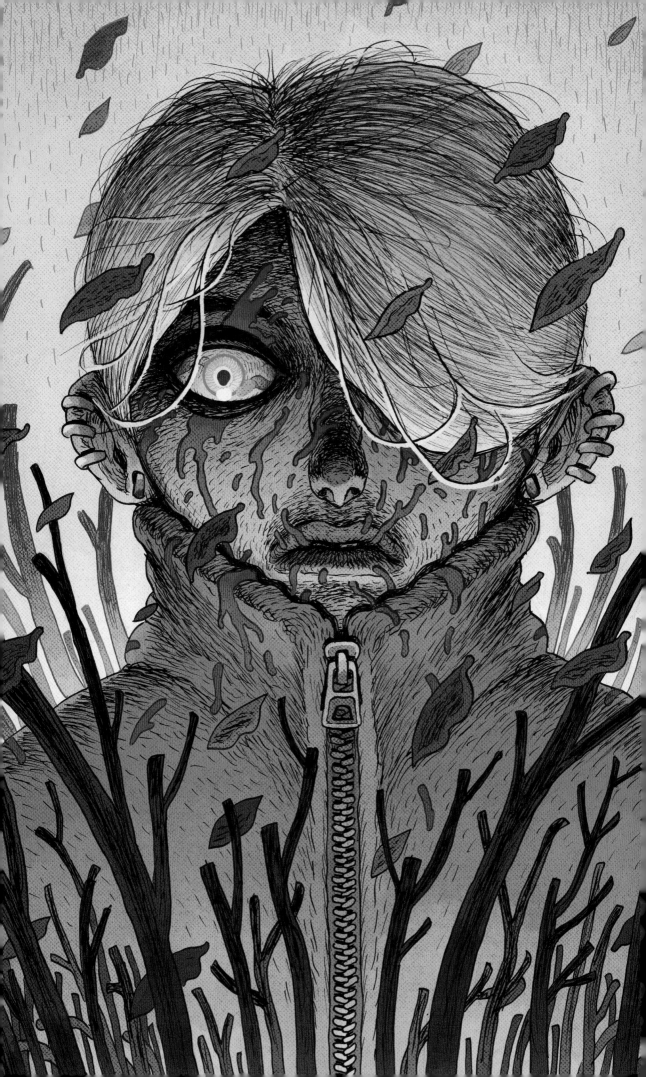

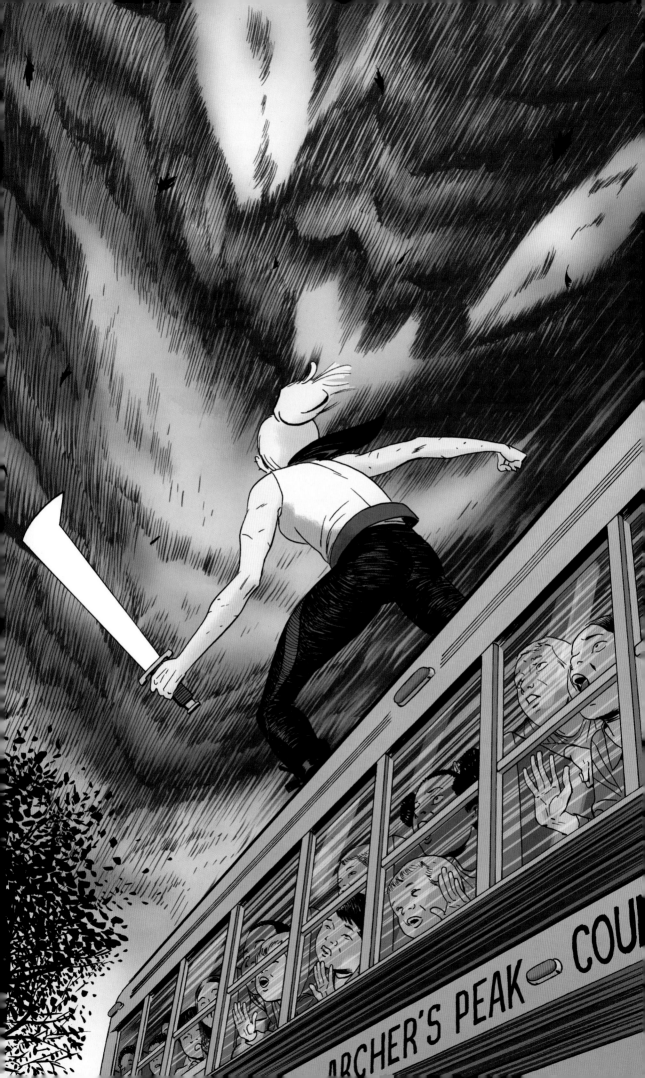

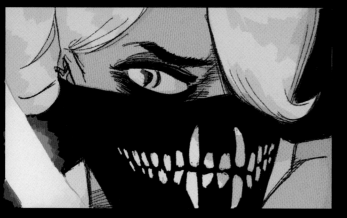

ABOVE
ISSUE #4 PAGES 20-21 PANELS 4-5

❝ Erica is the perfect creature. How we came to her creation is hard to explain. Some may call it alchemy, some may call it luck or chance. I don't believe in either, but I do believe in chemistry. But even that is using a term with well-defined rules to express something much more open-ended. No mathematical formula, no combination of real elements—just ideas and suggestions. Of course, even in the human brain, chemical processes take place! Maybe in James's and mine, these chemical processes did in fact give birth to the perfect creature.

Am I exaggerating? Maybe a little bit, but Erica is so adorable! Besides, how would you define something that comes out with maximum output and minimum effort? I call it the fifth essence of perfection (ha!) Okay, I'll stop kidding, but it's true—Erica came out in the easiest way possible.

I started from James's description, of course: a girl, about 29 years old, blonde hair, eyes marked with fatigue or black eyeliner, simply dressed, ready and comfortable to travel. Having all the freedom in the world beyond that, I decided to put into this character a few things I like.

First of all, the hair. I really wanted to pay homage to a cartoon character from when I was a kid, Sasuke. The adventures of a little ninja originally told in master Sanpei Shirato's manga. I love the personality of his characters—hence Erica's topknot and tail of hair.

BELOW
ERICA SLAUGHTER CHARACTER SKETCHES

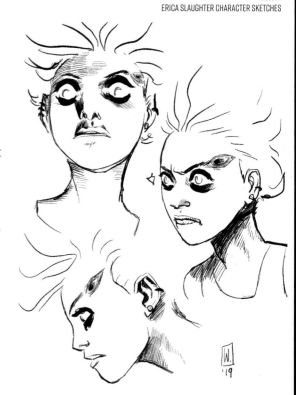

Moving to Erica's eyes—I had been struck by the description of tired, sunken eyes, so I thought of enlarging them to give her a weirder, kind of creepy expression. Also, you can usually only see one eye because the other one is covered—even spookier!

Then I moved on to the clothing. It had to be simple—a tank top, pants. I put her in tight-fitting biker pants, which are tough—those marks on the thighs and the shins are elastic openings for easy movement. Then a nice opaque parka to hide as much as possible.

The best detail came last. I thought, if she has to fight monsters, why not give her a mask? Something to hide her identity while she does what she has to do. Realistically speaking, the most comfortable and transportable thing for a person who only goes around with a backpack is a bandana—a nice black bandana. As I was drawing her fighting a monster with this bandana, I got the idea of adding monstrous teeth. Become a monster to fight monsters. With these two elements, James then built an entire world! **❞**

-WERTHER

RIGHT
ISSUE #1 COVER BY WERTHER DELL'EDERA & GIOVANNA NIRO

FOLLOWING, LEFT
ISSUE #1 VARIANT COVER BY JAE LEE & JUNE CHUNG

FOLLOWING, RIGHT
ISSUE #4 COVER BY WERTHER DELL'EDERA & GIOVANNA NIRO

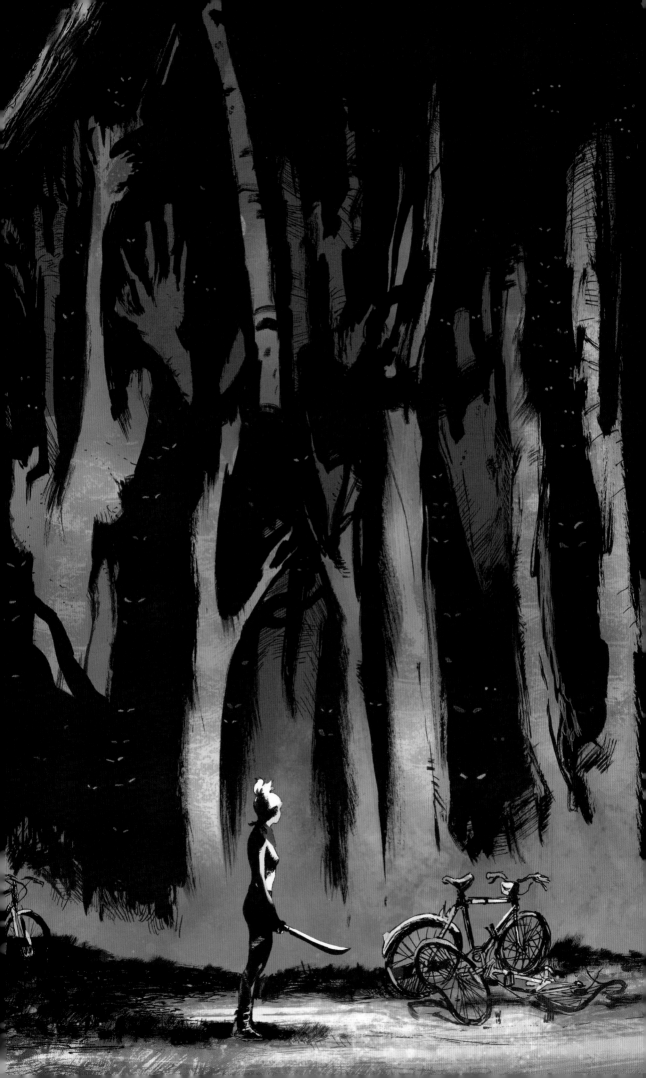

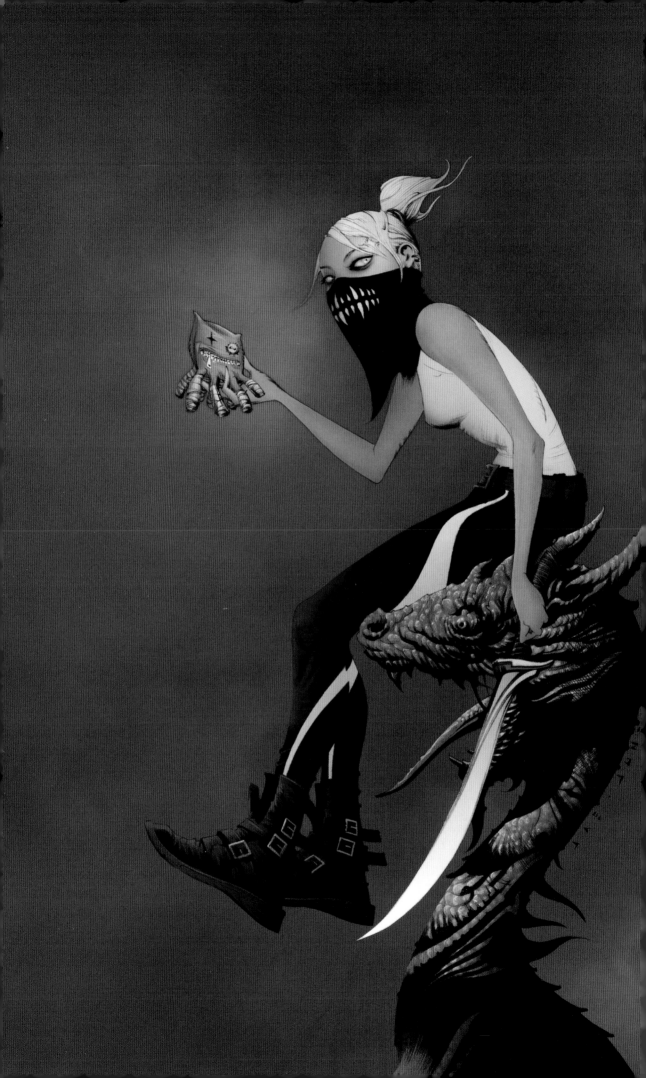

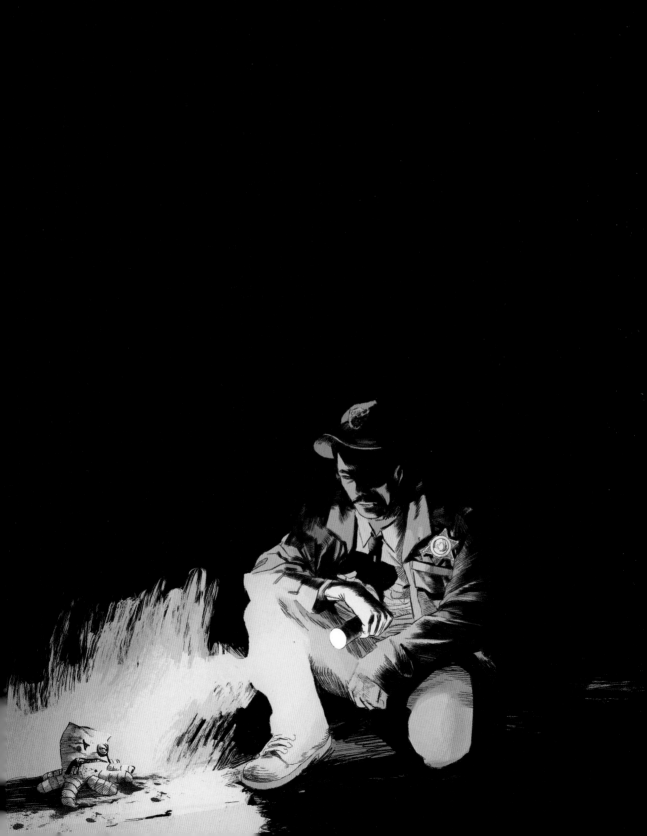

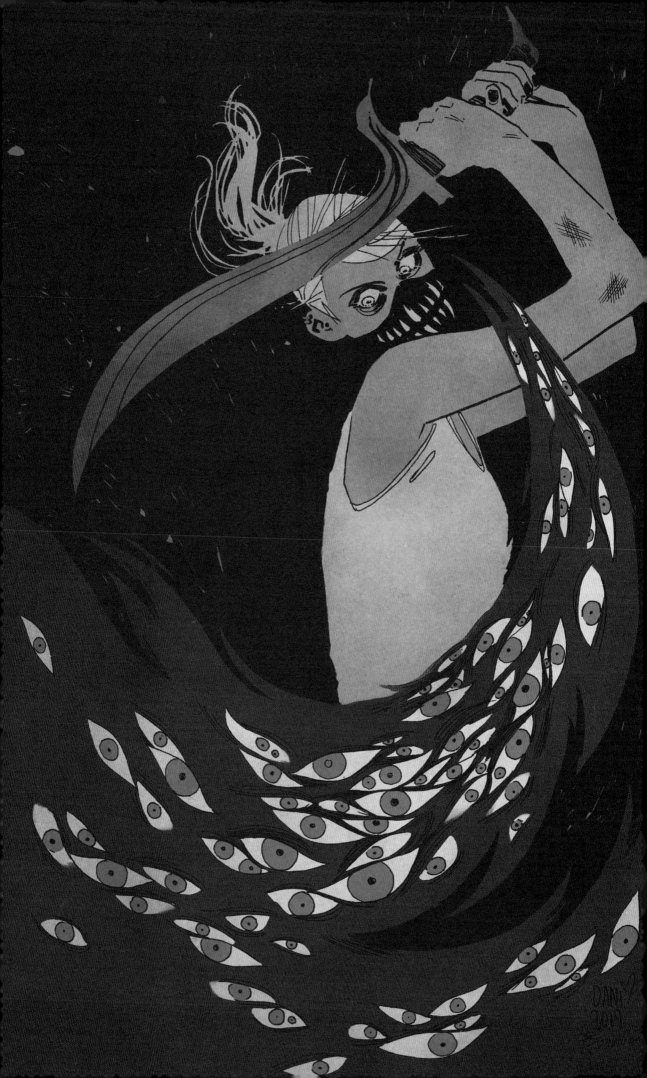

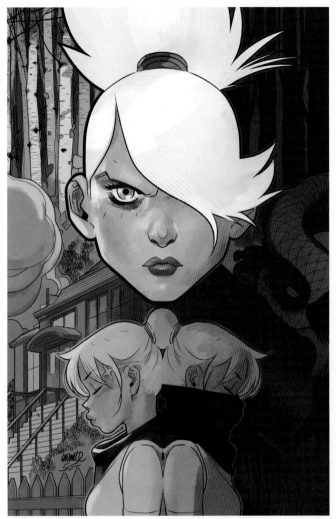

WERTHER:

So, what do you think about Erica? I mean, when you write her, are there parts of her character that you don't like, but you write anyway because they are unique to the character? In a broader sense, how much do you manage to abstract yourself from the characters you are writing?

JAMES:

See, that's a very interesting question because normally I don't abstract myself from the characters I'm writing. So many of the characters I write in my comics feel like a real extension of me and my personality. And there are obviously characters within the world of *Something is Killing the Children* who fall under those same rules. James in the first story cycle is the most obvious answer to that.

But there are a million little characters in the Slaughterverse who do feel like they reflect me—like Erica. But Erica doesn't reflect me. She is a fully separate character in my mind. She always comes very easily to me. I think that there are elements about Erica that I would find very frustrating if I met her in person. There is a kind of distance between her and the rest of the world despite her deep compassion, especially towards children. She's very, very driven. And she makes a lot of sense. So she's naturally a character that doesn't reflect who I am, but it does come from inside of me.

Something that I've always pointed to, or at least thought of when I've been writing the book, is how Erica represents the millennial generation, which I'm very much a part of. She went through an immensely traumatic moment in her young life and then had to live in the world built by that trauma. And this is something that I think my generation's had to face. You could line up the loss of Erica's parents chronologically to roughly around the time 9/11 happened, and it's not meant to be a direct reflection of that but it happens to compare. So there is a kind of core exhaustion to her, and then it's the fact that she's come of age in all of these broken systems. And in the face of these systems not working, she still has to try to live up to her morals and her standards, even though all of those systems are designed to stop her from doing that. And that's why she wants to work better than they do.

And I think that it's very relatable to people. Despite my feeling that Erica is extremely frustrating sometimes, and that she does stuff that I would never do, and that if a friend did what Erica has done, I would obviously be very upset—she comes from a traumatic background, and within that context, I understand why she does what she does.

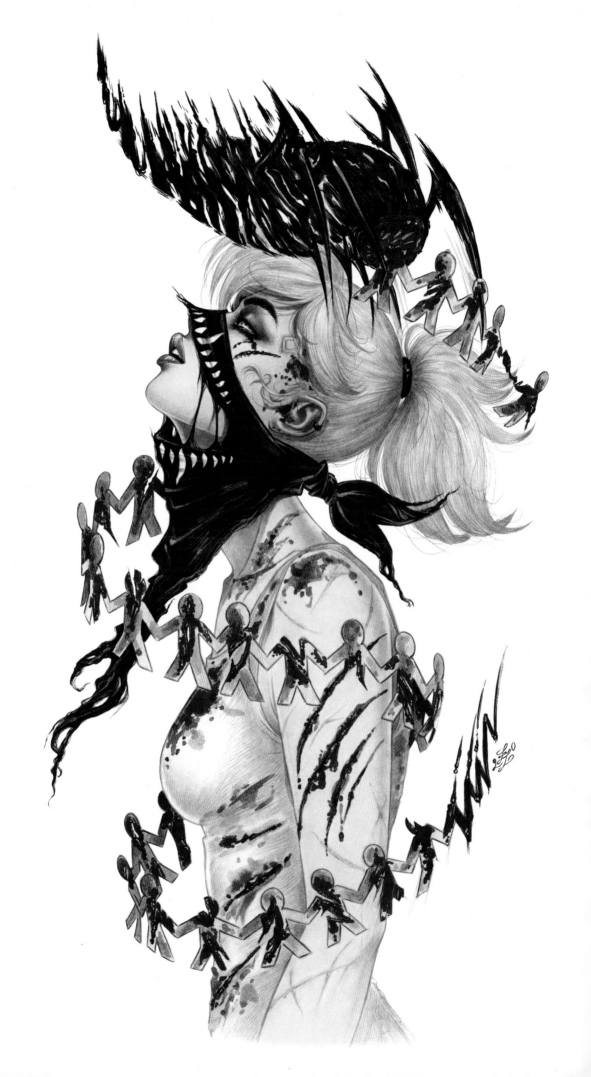

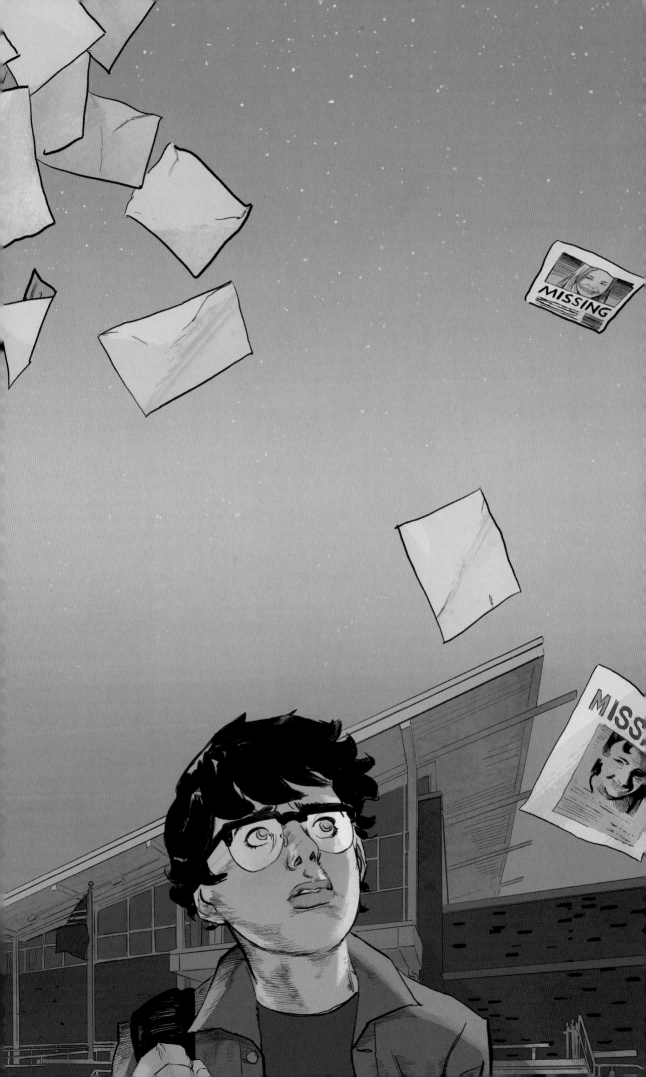

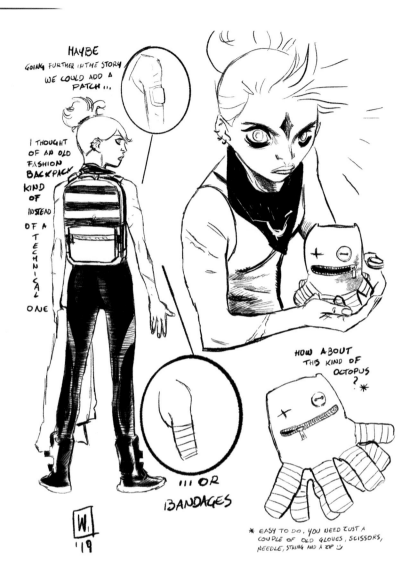

JAMES:

I know that for me, coming onto *Something Is Killing the Children* gave me the chance to throw off a lot of the constraints I felt had been holding me back writing superhero comics. Do you feel like *SIKTC* unlocked something new in your work? What were you able to do in it you had always wanted to do before?

WERTHER:

Oh yes, absolutely! I had been desperate to change something in my work for a while, and the fact that I could start a whole new adventure gave me a chance to wipe the slate clean and start from scratch. Of course, there was one problem with this plan: I was worried that it would not have made Eric Harburn [*SIKTC* editor] very happy, and probably you too, James. You had chosen me because of what my style had been up until that point, and I would have given you something else. I am known for making people happy, so I said to myself, *I will go all the way! I will disregard their expectations and make them happy!* I must say that, as good English speakers, you maintained a certain aplomb. You never pointed out that what I was doing was a little different from what I was doing before. You have been very patient; I hope I have repaid that patience!

RIGHT
ISSUE #2 THIRD PRINTING COVER BY WERTHER DELL'EDERA

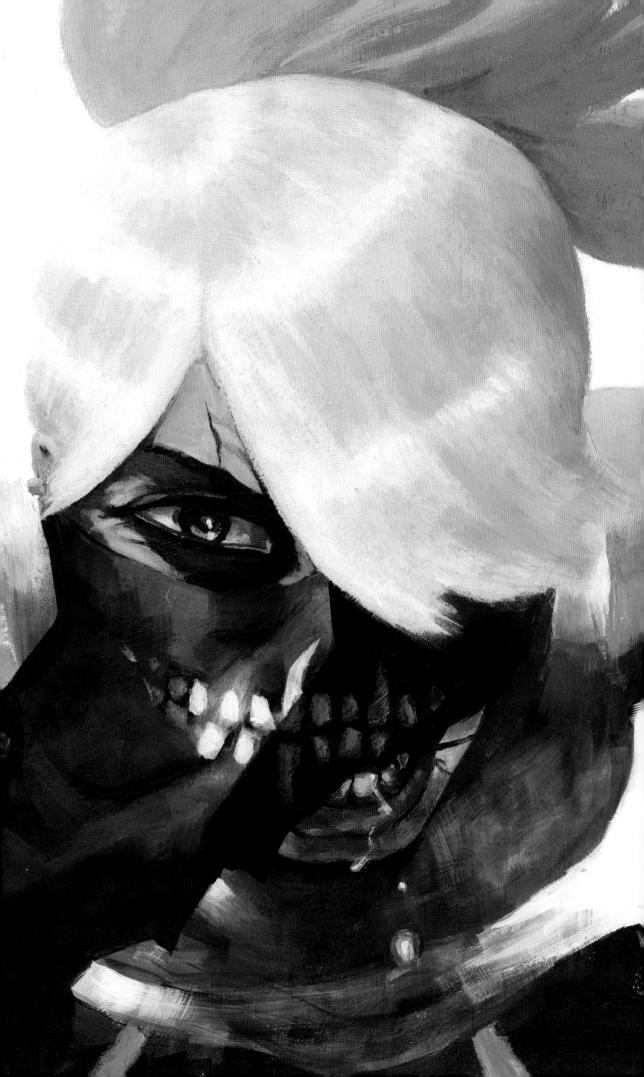

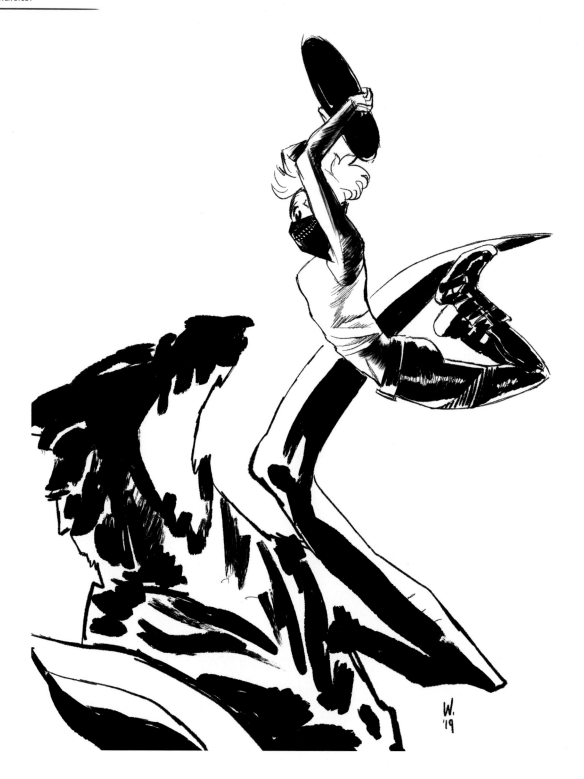

RIGHT
ISSUE #5 COVER BY WERTHER DELL'EDERA & GIOVANNA NIRO

FOLLOWING, LEFT
ISSUE #1 SIXTH PRINTING COVER BY ADAM GORHAM

FOLLOWING, RIGHT
ISSUE #1 THIRD PRINTING COVER BY NICK ROBLES

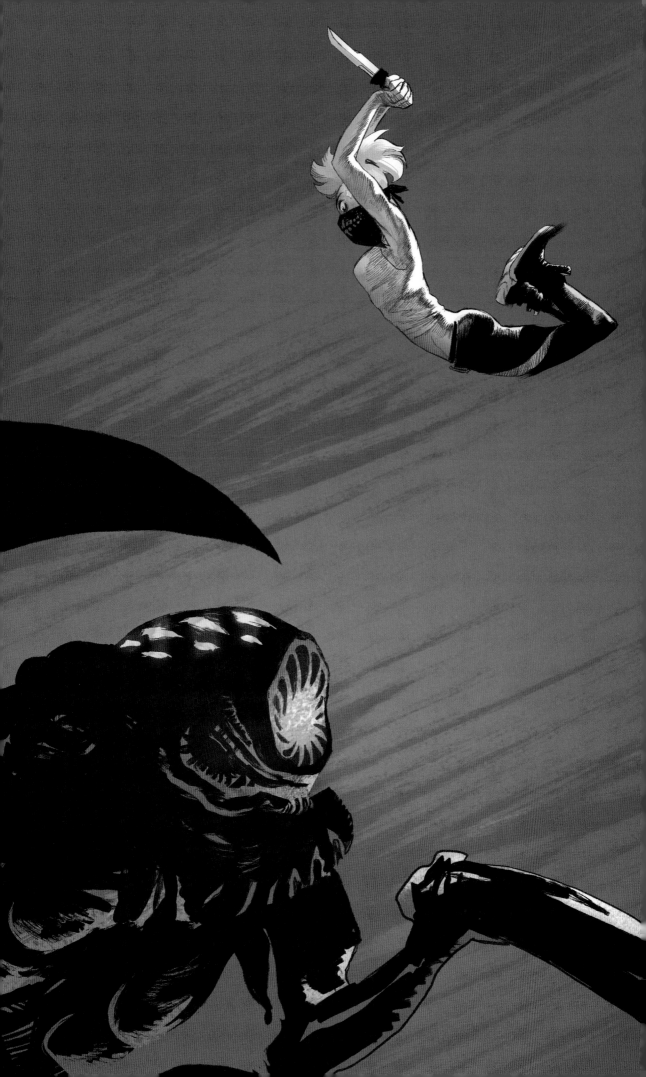

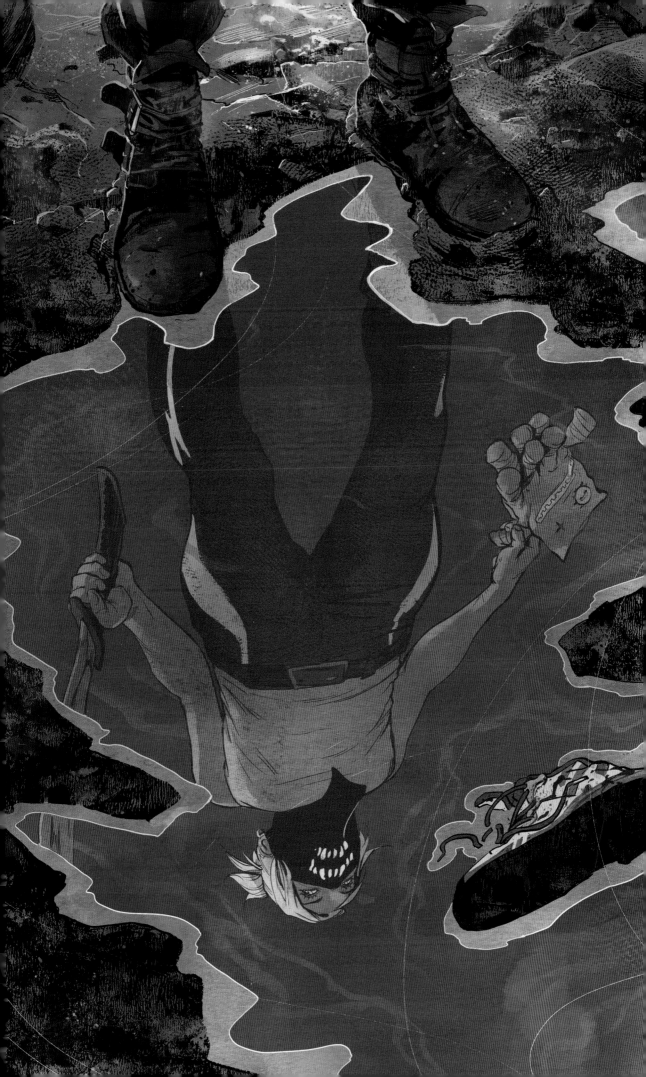

Pages 6-7

1.
We see a THICK LINE OF TREES. The edge of the forest at the edge of a country road.
It's daytime.

CAP: TWO WEEKS LATER.

2.
A YOUNG GIRL, maybe 10 years old, is sitting in a red Radio Flyer wagon on the side
of a country road. Isolated. She's in a pink winter jacket. One of her sleeves has
been knotted, showing that she is missing one of her arms. One of her eyes has a
gauze patch over it. None of these injuries are new, and they don't concern her much.
They are old news. What concerns her is what's happening in the forest. There is a
backpack sitting next to her in the wagon (this is Erica's backpack).

3.
We see her look up, alert. She sees something moving in the woods…

4.
A FIGURE starts to emerge from between the trees…

5.
WE SEE ERICA SLAUGHTER FOR THE FIRST TIME. She is holding two bloody machetes. Her
bandana is up. Blood is splattered all over her… Her whole body is steaming in the
winter air.

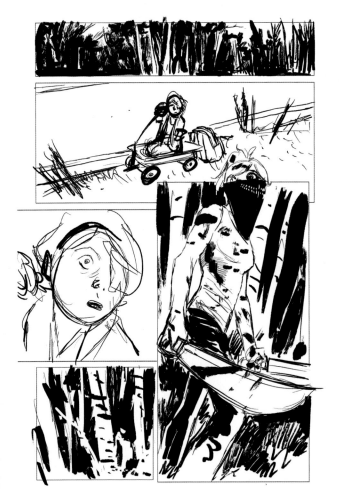

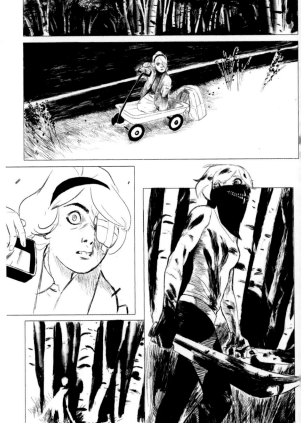

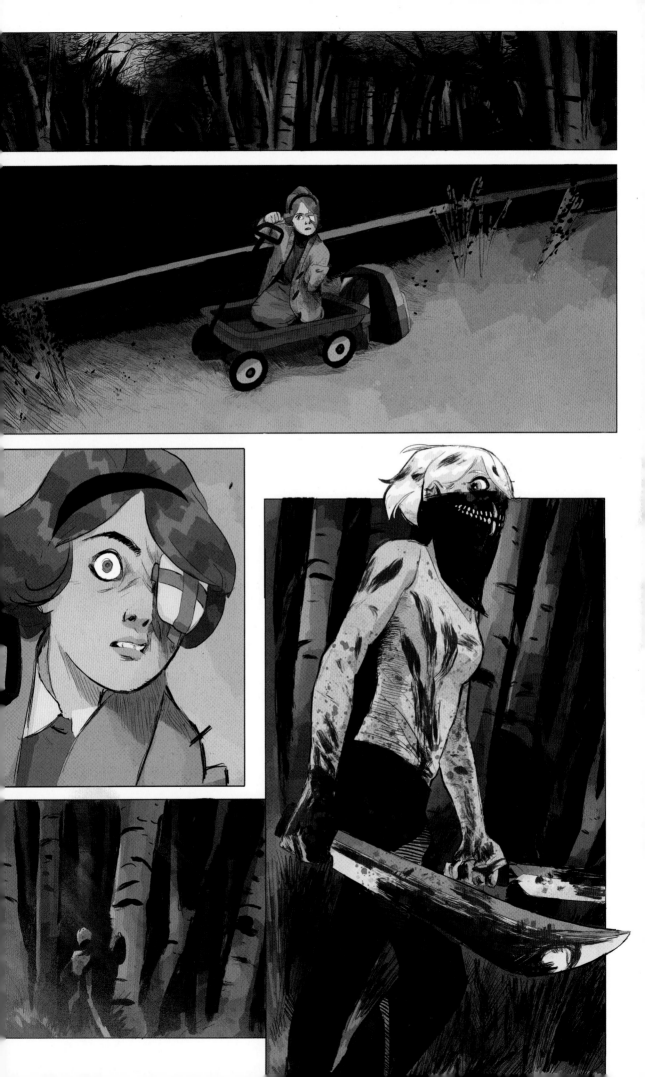

6.
ERICA drops the machetes at the edge of the road as she approaches the wagon, silently...

7.
She rummages through the backpack, ignoring the girl sitting next to it.

8.
She pulls out a large bottle of water from the bag, and sits next to the wagon.

9.
She drinks it, eagerly.

10.
THE GIRL watches her, waiting for her to talk.

11.
But ERICA doesn't. She drinks from the water again.

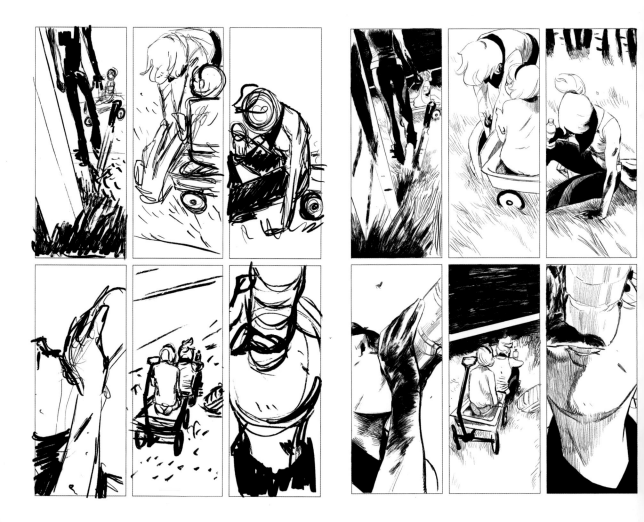

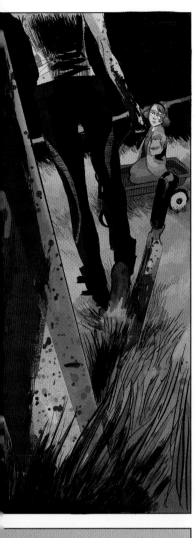
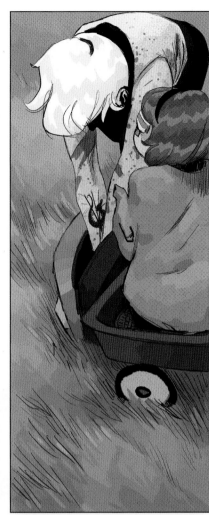
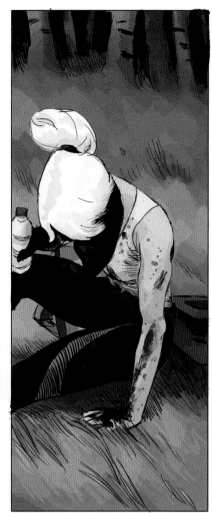
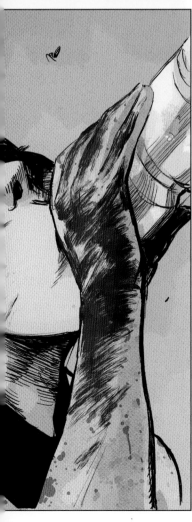
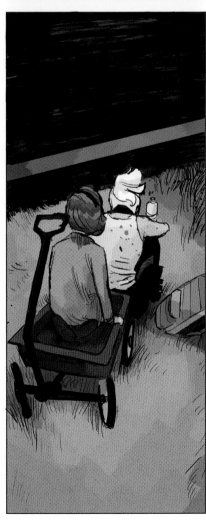

Pages 8-9

1.
THE GIRL finally gets up the
courage to ask what she wants to
ask.

GIRL: Is it over?

2.
ERICA.

ERICA: Yeah.

3.
THE GIRL responds.

GIRL: Good.

4.
And she responds again, to herself
this time. A small tear in her
visible eye.

GIRL (quieter, to herself): Good.

5.
ERICA, exasperated. This is the
last thing she wants right now,
after a successful hunt.

SFX: bzzz bzzz

ERICA: Shit.

6.
ERICA digs into the backpack again.

GIRL: That's a bad word.
ERICA: I know it's a fucking bad
word.

7.
We see the Caller I.D. on the small
flip phone she's pulled out of the
bag -- not at all high-tech. Not a
smart phone at all. The Caller I.D.
reads: ST. GEORGE

8.
She takes a deep breath, gathering
herself before the call.

9.
And answers it.

ERICA: Hi.

10.
We cut away to the bloody machetes
at the edge of the road.

ERICA: Yeah. Yeah, it's done.

11.
ERICA digs in the backpack again.

ERICA: Okay.

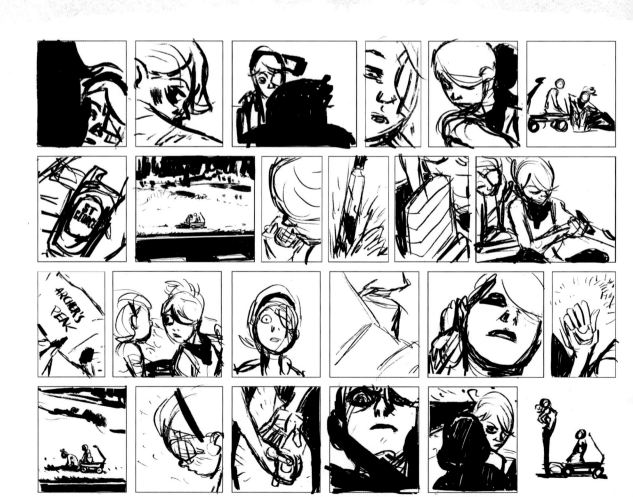

12.
We see her write something on her arm in Sharpie… THE GIRL is watching her, a little curious.

13.
We see the name written on her arm: ARCHER'S PEAK

ERICA: Sixteen hours, I think? Depending on bus schedules. And if I can get a shower.

14.
ERICA puts the phone down for a second, asking the girl:

ERICA: Can I use your shower?

15.
THE GIRL's face scrunches up, she doesn't know how to answer…

GIRL: My mom won't be home for another--

16.
ERICA continues on the phone.

ERICA: Yeah. Sixteen hours.

17.
ERICA. Done.

ERICA: Fine.

18.
She snaps the flip phone shut.

ERICA: Shit.

19.
A BEAT OF THE TWO OF THEM, ALONE…

20.
THE GIRL, smarter than she looks.

GIRL: There are more of them, aren't there?

21.
ERICA pauses a minute… Wanting to lie to her…

22.
BUT THEN SHE DECIDES NOT TO.

23.
ERICA, blunt.

ERICA: Yeah.

24.
ERICA gets to her feet.

ERICA: Let's get to that shower.

ERICA: I stink.

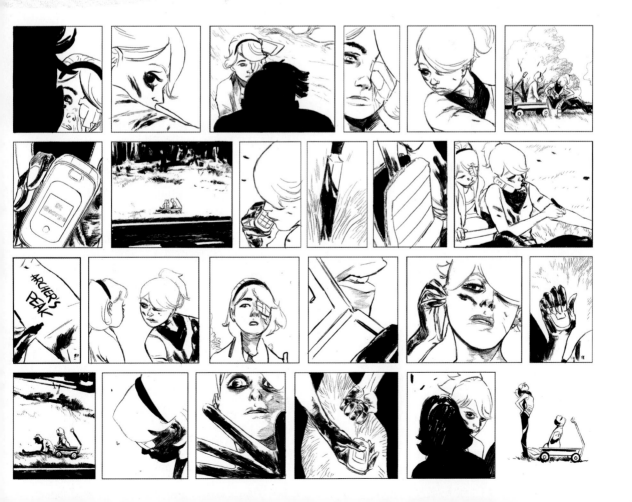

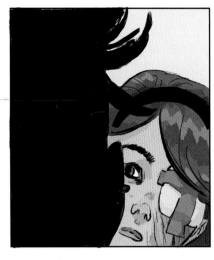
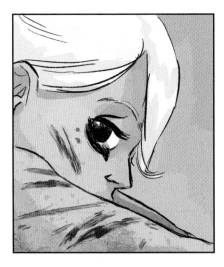
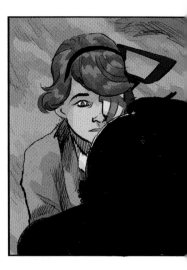

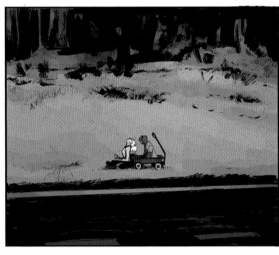

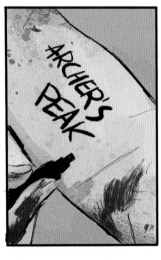
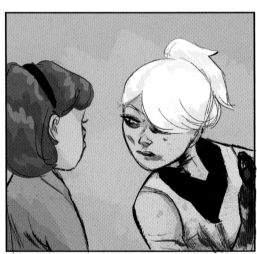
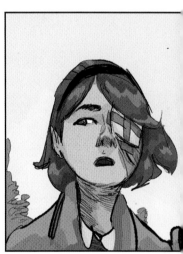
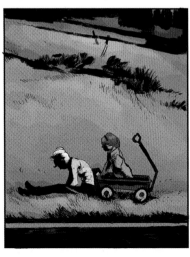

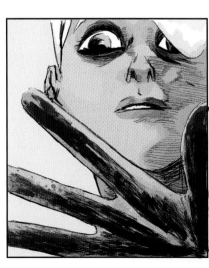

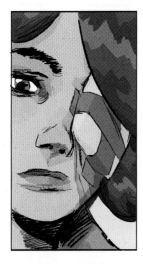
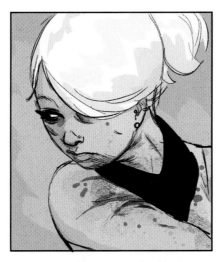
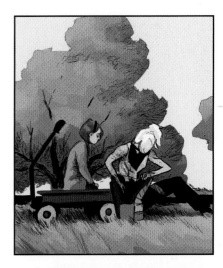

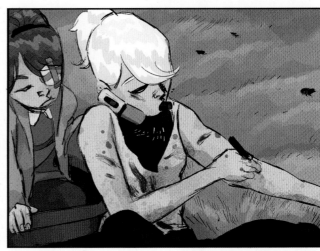

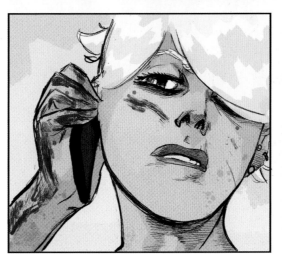
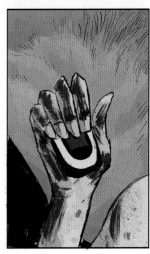
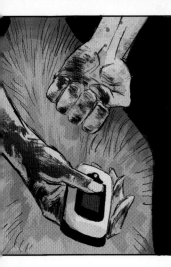

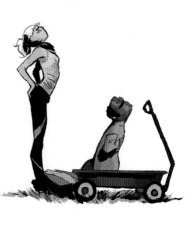

THE
HOUSE OF
SLAUGHTER

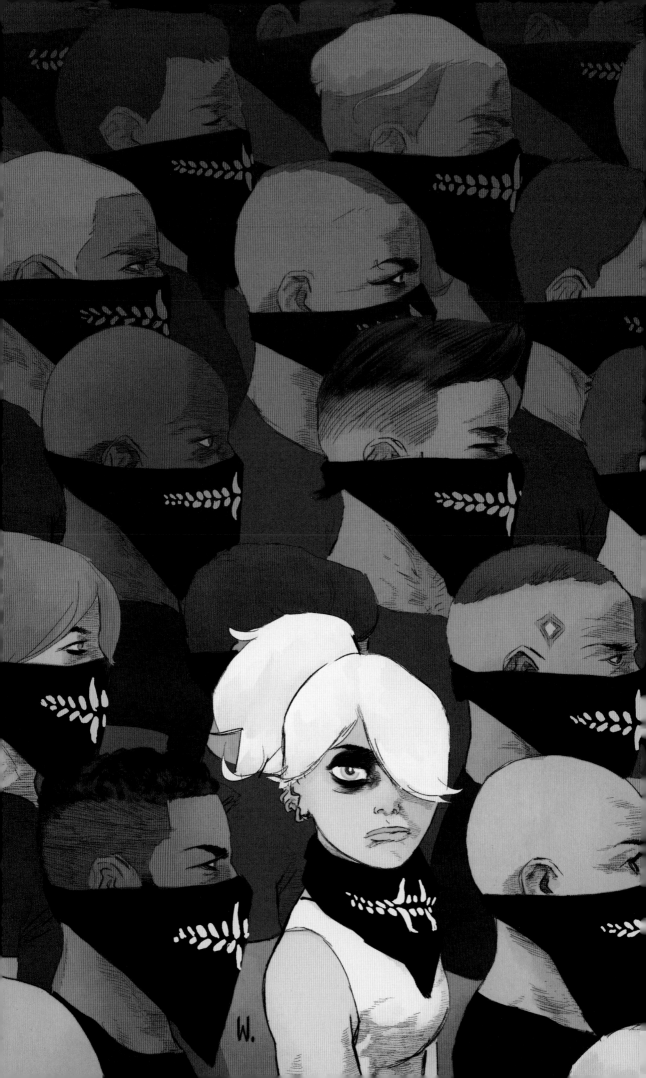

ON CREATING THE ORDER OF ST. GEORGE

" When we started *Something is Killing the Children*, it was only greenlit as a five-issue limited series. And my initial idea was that every single issue was going to be a one-shot; Erica would be this mysterious figure moving through middle America, and she was working for a mysterious monster-hunting organization, the Order of St. George. Beyond that, I didn't have a lot of details. The Order was always going to be a little distant. We would see Erica's handler on the other side of the phone, but we weren't going to dig into the rest of the Order.

I wanted to lean into the dichotomy. It was going to be clear that the Order of St. George represented some kind of obscene wealth and power. They would carry with them a sort of disdain for the ordinary people that Erica was trying to protect and save. And Erica, even though she's a part of this Order, wouldn't dress like she's one of them; she dresses like the ordinary people she's trying to protect, because she's much more of that world.

It wasn't until toward the end of the first arc that we knew we were going to be able to extend the story to at least 15 issues. At that point, I just started throwing some ideas down on the page. One of the first ideas was that I referred to Erica's specific house in the Order of St. George as the House of Slaughter. And that connected to the idea that Erica's last name "Slaughter" came from being a part of this house and this lineage. Also, "House of Slaughter" just sounded really, really cool—so I leaned into that.

The first time we cut away to the actual figures in the House of Slaughter, the direction that I had given Werther was: "We see these very elegant, very regal people, and they all have the bandanas up over their mouths—but the bandanas are all different colors, and each of them has a different stuffed animal sitting in front of them." And at that point we already knew that Octo, Erica's stuffed animal, actually had this dangerous monster inside of it. It's natural to extrapolate from there that they all have their own monsters, and that they all have their own masks. And then I also had the idea of the figure who ran the house, who would have this elaborate gold face mask, and that we would refer to that figure as the Dragon. So, from this initial description and Werther's illustrations sprang the whole larger mythology.

And then, I started talking to Werther and the editorial team about, like, what do the different masks mean? What does Erica's black mask mean versus one of these other characters' white mask, and all of that? I wanted to start playing with it. And then the roles of the other characters in the series kept growing bigger and bigger. It was a real natural evolution. **"**

-JAMES

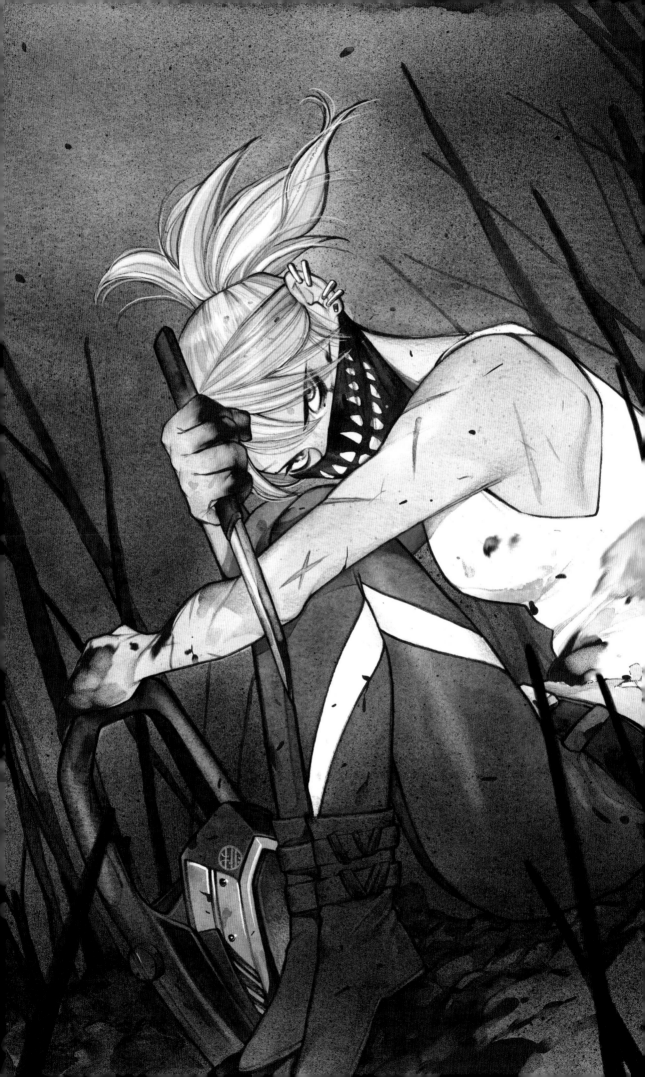

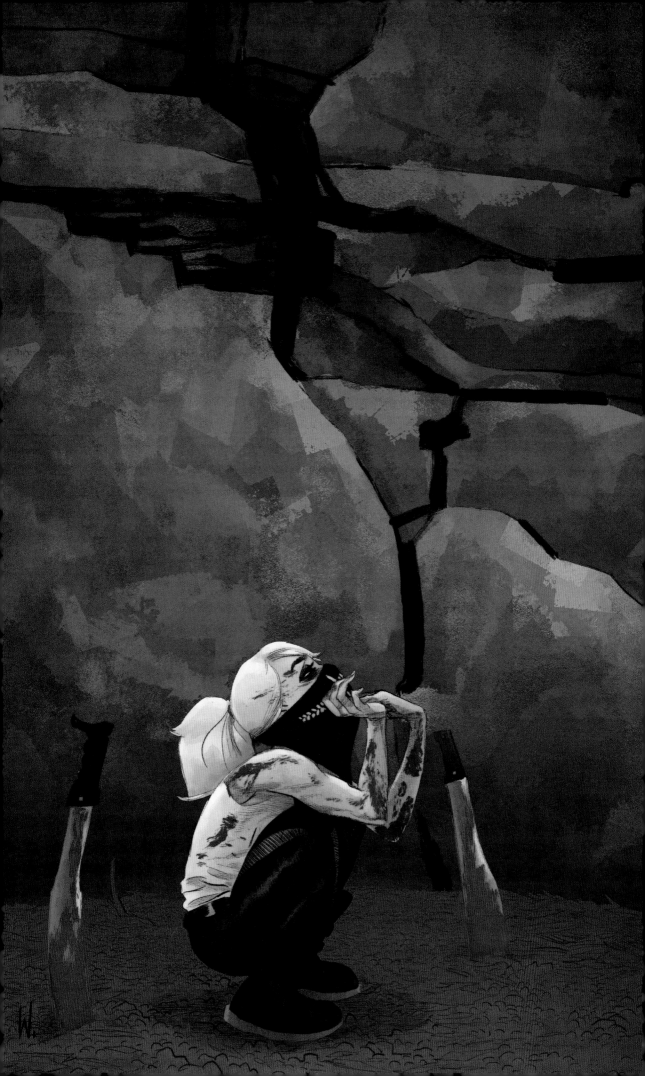

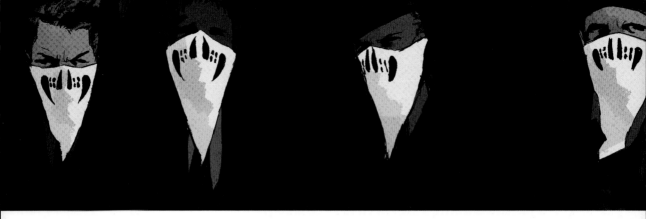

" The House of Slaughter was something unexpected, an idea that formed one piece at a time. James really likes to create new characters, and add new twists and connections each time. For me it is a great challenge, as well as a huge undertaking!

My mind is also very set on productivity, and anything that slows down the production process I find unnerving. It goes without saying that creating characters is nerve-wracking for me, because I want them to flow out of my hand without thinking—that's why I love Erica; she was already fully formed from the start. Of course, even if the creation process is painful, I've still been very happy with the results.

There are some characters that I really enjoy, like Tybalt and Paris. They are great to draw. Then there's Aaron! I wanted to give him a mysterious, undefined face that reminded me of one of those characters in *Corto Maltese*. James killed him right away, though—so now he only lives in memories… What a super dramatic moment Aaron's death was, though! Ah! (Do you want to know another character who came out as easily as Erica? Jessica!) **"**

-WERTHER

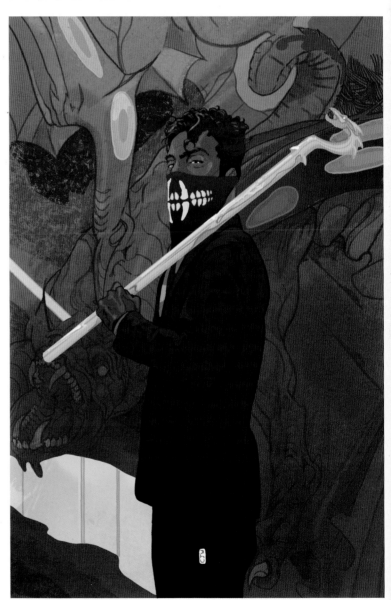

RIGHT
ISSUE #10 COVER BY WERTHER DELL'EDERA & MIQUEL MUERTO

FOLLOWING, LEFT
ISSUE #10 VARIANT COVER BY SIMONE DI MEO

FOLLOWING, RIGHT
ISSUE #6 VARIANT COVER BY JENNY FRISON

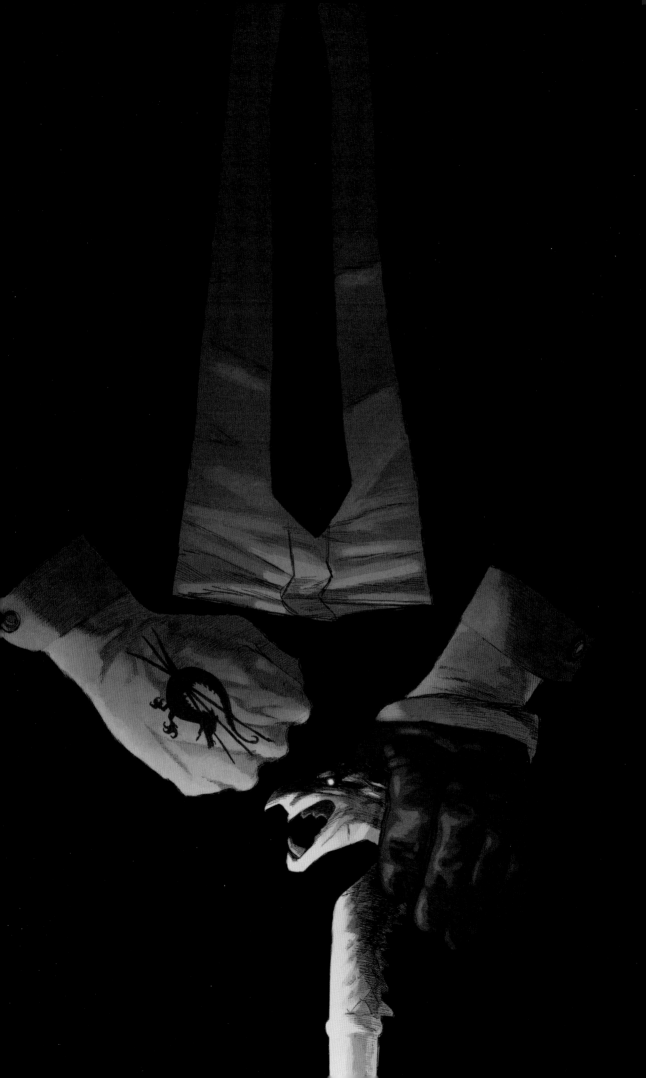

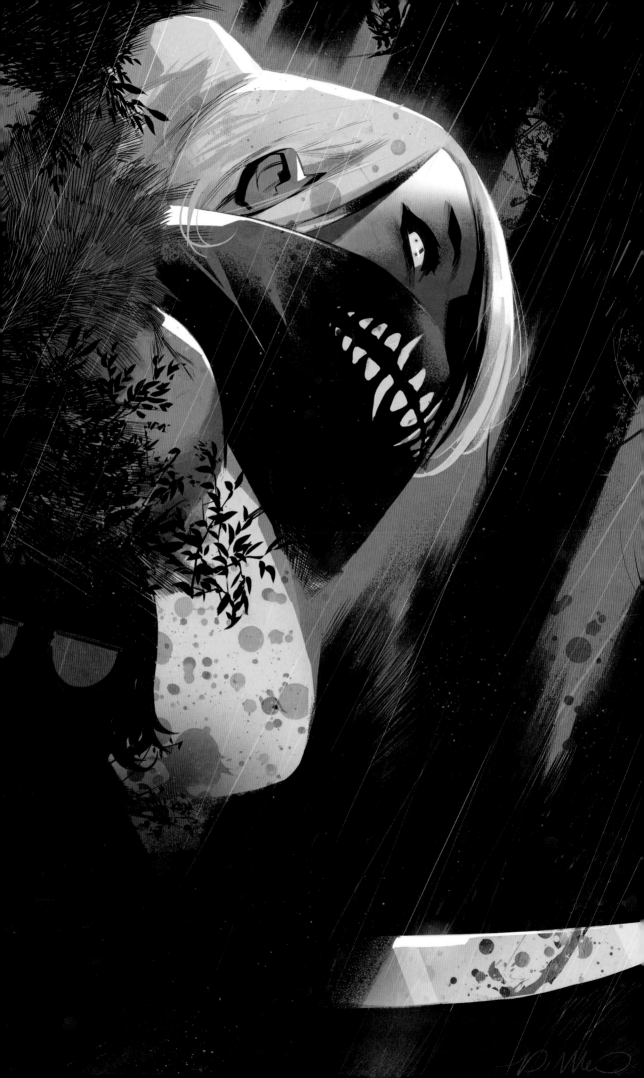

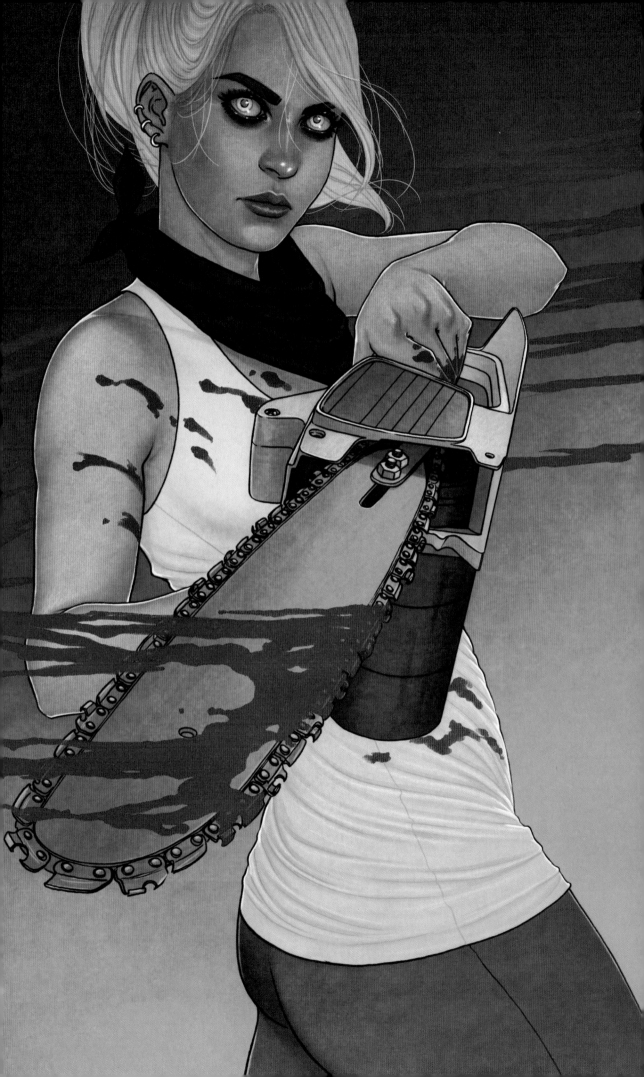

WERTHER:

One thing that really fascinates me is a writer's ability to control extended scenarios consistently. Do you have a method? Does everything fall into place like a checkerboard, creating patterns of story, or are they bricks that you put together piece by piece? And in that case, how do you give it coherence?

JAMES:

Honestly, I wish I had a very clear answer that I could boil down into a process that works for me every single time. But I learned very early on that the more I try to over-plan my stories, the less life there is in them. So, I try not to think too much about what happens. When I'm writing a single issue, one of a 15-issue story cycle, I'm not thinking so much about what's happening in, say, issue #13. I'll find that along the way. There are always a few road markers that I have to reference—generally, this is going to happen at the midpoint of the story, this is the status quo that we're going to end with, etc. I always know what direction I'm moving in, but I like to be able to veer off down a side road and lean into a character that I unexpectedly love writing a lot more than I thought I would.

A lot of times in *Something is Killing the Children*, the characters introduced are fairly minor but then become crucially important. For instance, the first appearance of Cecilia Slaughter was just meant to be a high-ranking official inside the House of Slaughter, obviously bossing around Erica a bit, but mostly meant to represent the cold face of

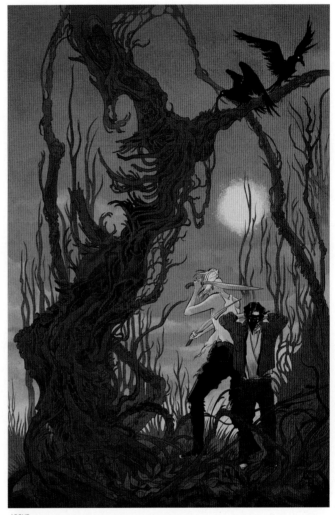

ABOVE
ISSUE #7 VARIANT COVER BY EMMA RÍOS & MIQUEL MUERTO

the system. I didn't know what her origin was or her connection to Jessica or her connection to Erica, really. But through writing her, I figured all of that out. So it's more like you start with the rough sketch of the story, and then you add details as you go. And as you do that, more details become more and more obvious, and then you're 40 issues in, and you realize that all these pieces connect in very intricate ways. And it's a feedback loop, where these details tend to drive you towards a more specific direction.

So, as we keep moving forward, I have a clearer and clearer idea of where the story is going to go in the future. The challenge then becomes how to find opportunities to take exits down the side roads and explore interesting and compelling detours. And that's happening in the story arc we're doing right now [issues #36-40]. It's all these little one-shot stories that take place before the Archer's Peak saga, and the wonderful thing about those is that I had the rough shape of each of these stories in my head beforehand, and another one you suggested. Yet, like most of them, I'm able to discover those on the page as I write. I know where Erica is in those stories emotionally, but I'm still able to discover more about each of the characters that we build around her issue by issue. And it's really fun.

LEFT
ISSUE #8 COVER BY WERTHER DELL'EDERA & MIQUEL MUERTO

FOLLOWING, LEFT
ISSUE #11 VARIANT COVER BY JENNY FRISON

FOLLOWING, RIGHT
ISSUE #6 VARIANT COVER BY DAVID MACK

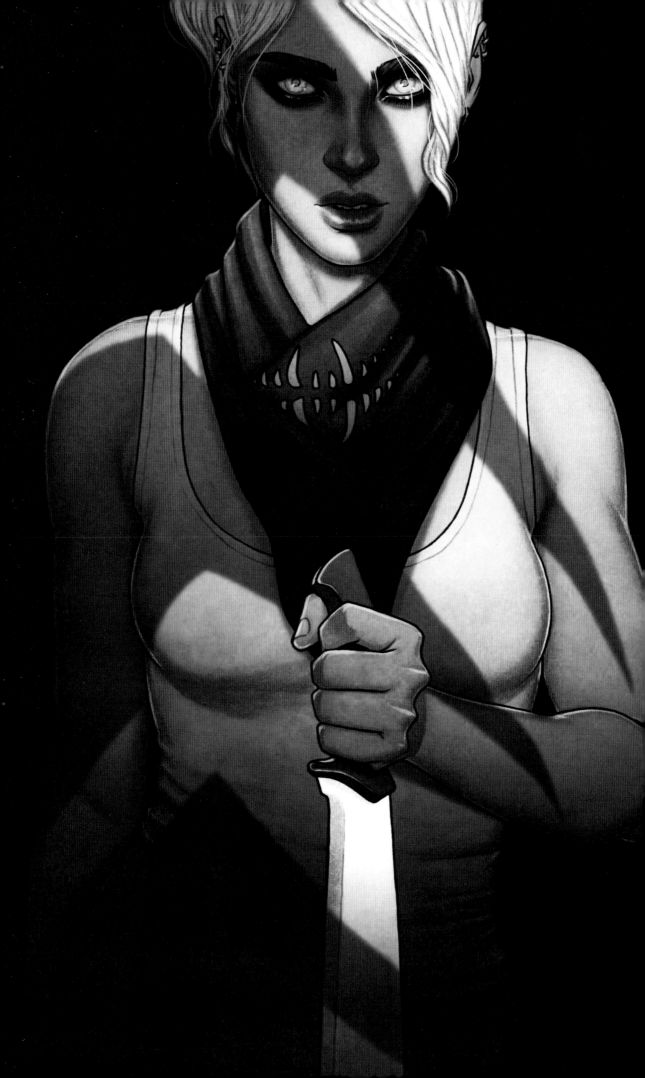

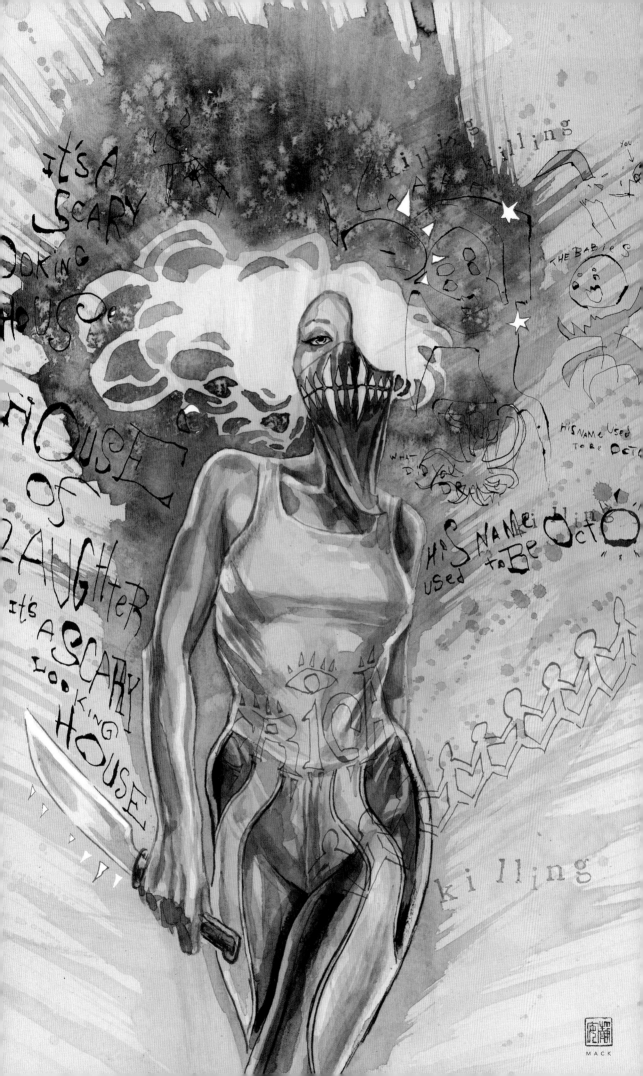

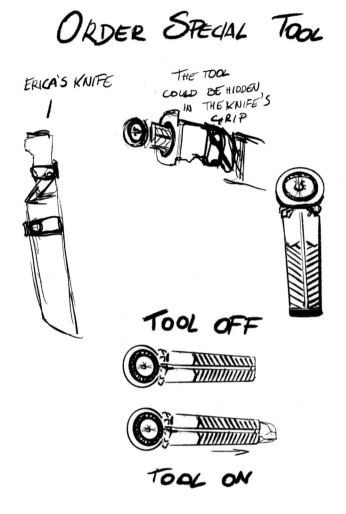

ORDER SPECIAL TOOL

ERICA'S KNIFE

THE TOOL COULD BE HIDDEN IN THE KNIFE'S GRIP

TOOL OFF

TOOL ON

JAMES:

Is there a sequence in the books—it could be a small moment that the rest of us might not notice—that has always been your secret favorite moment? Whether it's because of how you drew something, or because something in the script spoke to you?

WERTHER:

I must say that it is the script that inspires me. It is my reference point! Reading the dialogue, interpreting the situations according to the characters' personality, making them act by immersing them in the context. My favorite sequences are such because of the way they are written! That said, if you randomly fish out a scene from the story arc about Erica's past, that would probably be one of my favorite scenes. In just five issues there is an abundance of beautiful, emotional, intense scenes that I absolutely connect to. It's a roller coaster of emotions! I love that story arc!

However, if you really want to know a secret, my absolute favorite issue is #20, the last one about Erica's past, and my favorite page in the issue (and it's really hard because they are all emotional for me) is page 8. The one where Erica reappears in front of everyone on the porch of the Farm. It's all very charged. Emotionally, it is an explosion!

RIGHT
ISSUE #11 VARIANT COVER BY BENGAL

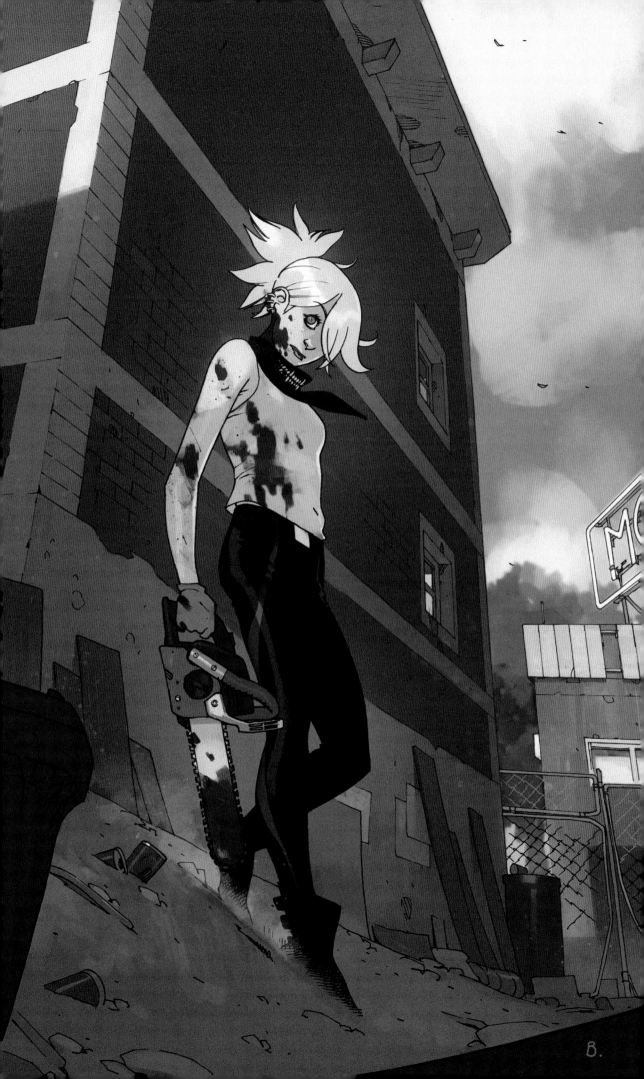

RIGHT
ISSUE #9 COVER BY WERTHER DELL'EDERA & MIQUEL MUERTO

FOLLOWING, LEFT
ISSUE #11 VARIANT COVER BY MARTIN SIMMONDS

FOLLOWING, RIGHT
ISSUE #11 VARIANT COVER BY KEN LASHLEY

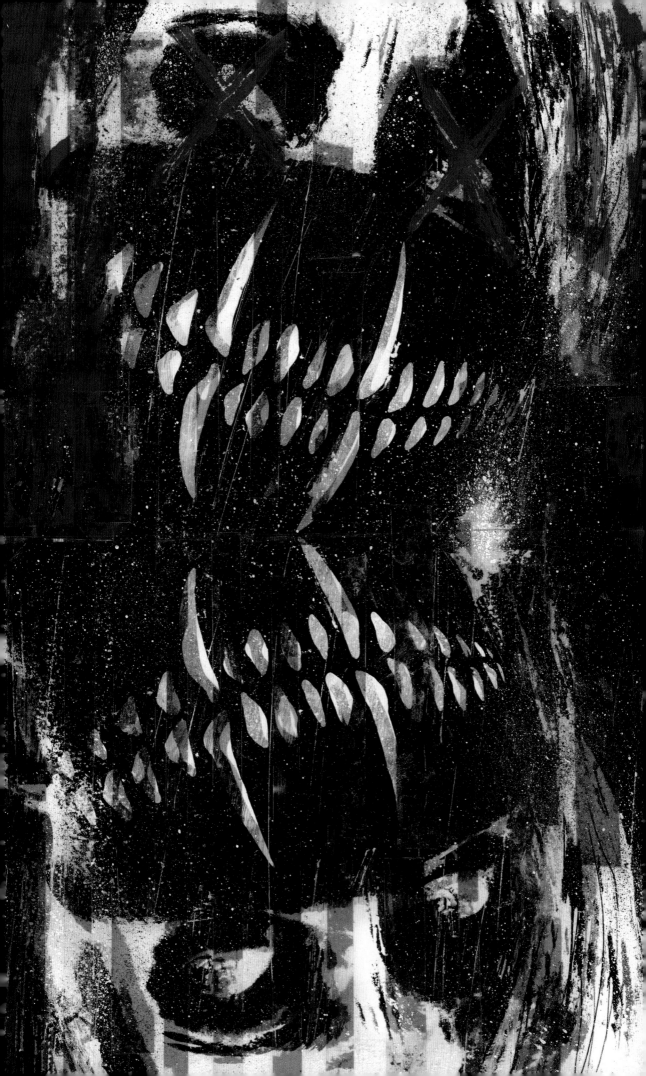

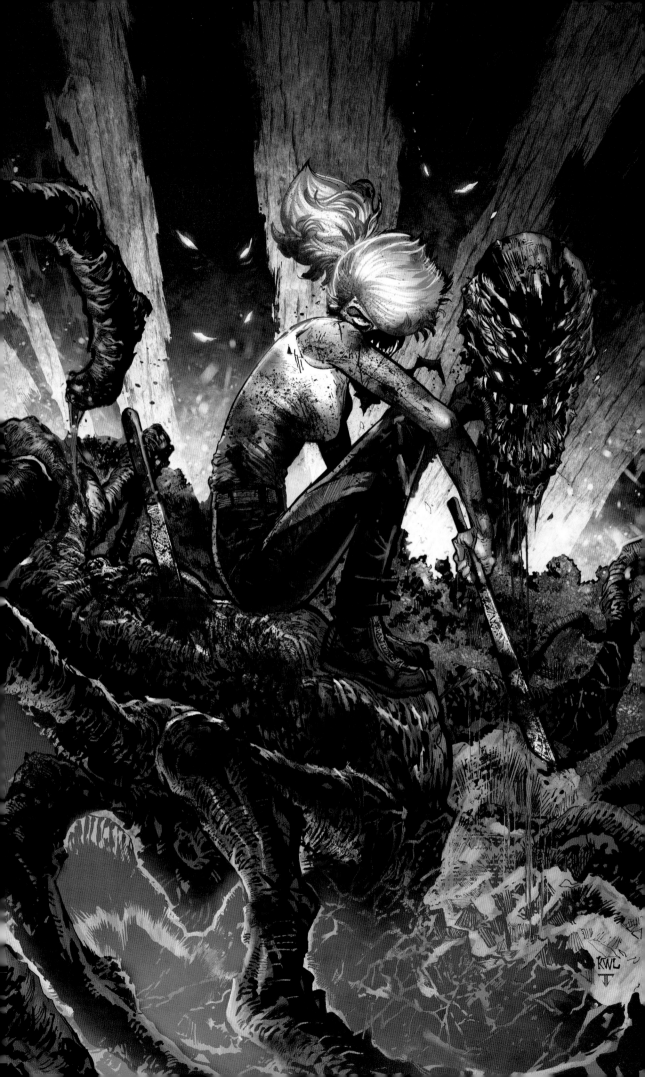

Page 20

SPLASH – We see THE HOUSE OF SLAUGHTER. It is in Chicago, in the richest neighborhood in the city, called THE GOLD COAST. We should be able to see the Willis Tower (formerly the Sears Tower) behind it... It should give off a strange feeling, of an ornate mansion that should not be right in the middle of the busiest part of the city. I think it should be all in black marble... The gates should have ornamental dragons on top of the pillars, and a big crest above the second-floor balcony should have the symbol of the Order of St. George.

This is where Erica was trained, and is the regional headquarters of the Order of St. George. There are probably two other houses in America (one on the East Coast, one on the West Coast), and more in Europe and Asia. Each of these houses would have a different "family" name.

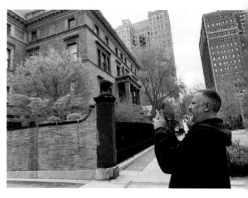

ABOVE
WERTHER VISITS THE HOUSE OF SLAUGHTER

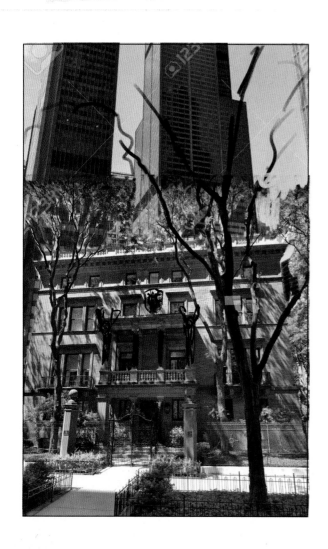

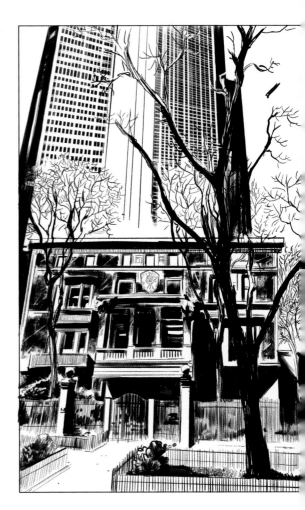

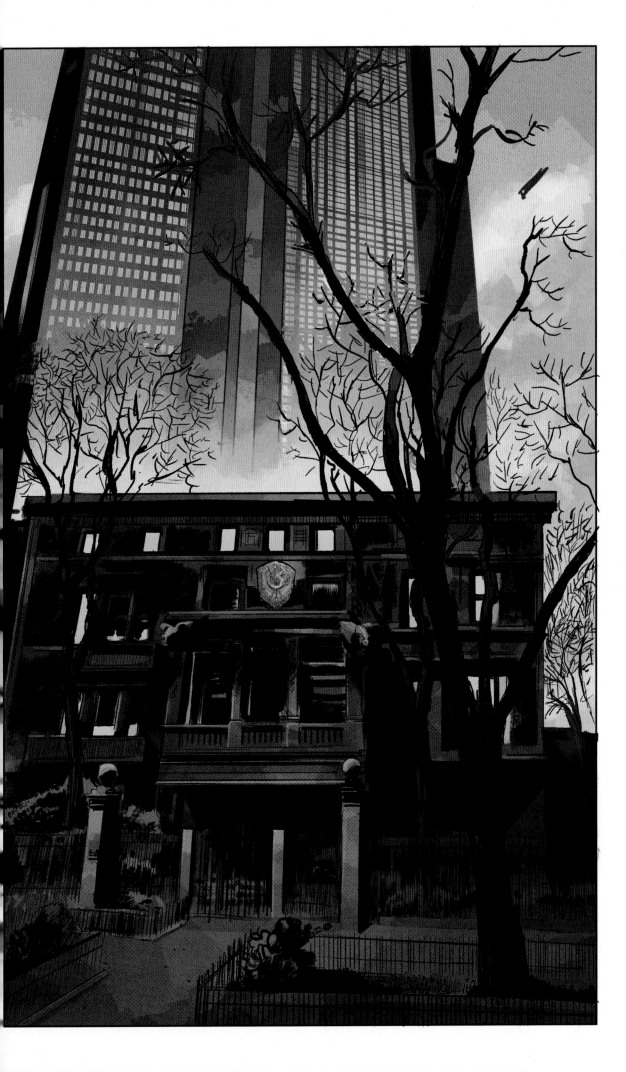

1.
AARON follows CECILIA down the hall.

AARON: There's been a decision, then?

2.
We get a sense that CECILIA is also very no-nonsense.

CECELIA: Yes. The Old Dragon's having a town car pulled around for you now.

CECILIA: You're heading north.

3.
AARON is upset at this turn of events, as he follows CECILIA down the stairs.

AARON: I'd like to speak with him directly.

CECELIA: That's too bad.

4.
CECILIA.

CECILIA: He's angry, Aaron. Angry that you've kept her on this loose a leash.

5.
AARON, irritated by all of this.

AARON: He remembers how well she follows orders, then?

6.
CECILIA turns on him, angry that he's trying to pass the buck.

CECILIA: She was a girl. Now she's not. He expects her to be a grown-up about this. He expects you to be one as well.

7.
AARON follows CECILIA into the foyer of the House of Slaughter. A note – the foyer has portraits of the current active members of the House of Slaughter, all in their formal monster-hunting gear. All wealthy-looking and ornate. The largest portrait is of their leader. The Old Dragon.

AARON: Do I get a driver, at least?

CECILIA: No, you don't get a fucking driver.

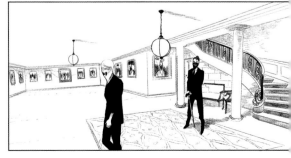

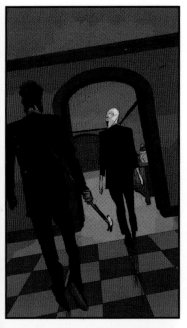
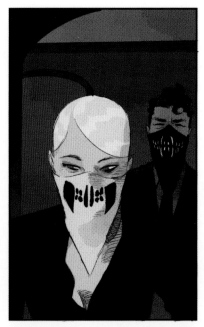

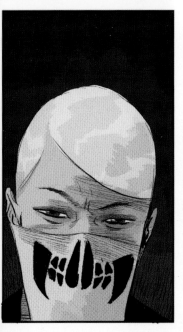
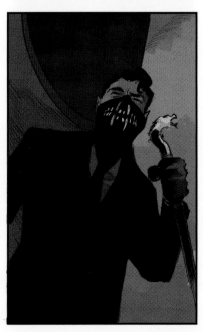
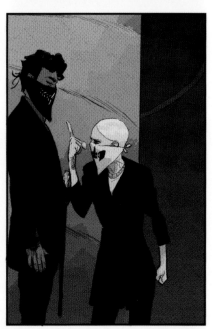
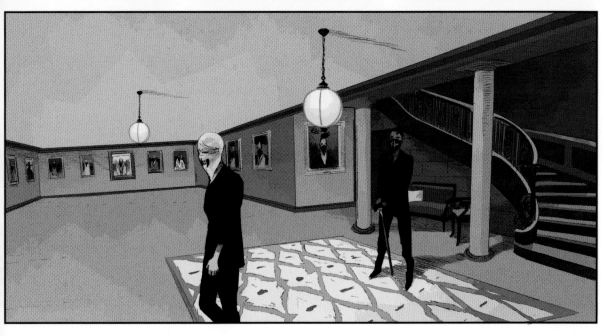

1.
CECILIA gives her orders.

CECILIA: You will relieve her of duty, and send her back home to the
House of Slaughter. And then you will finish the job.

2.
AARON, serious.

AARON: She won't come back to this place.

AARON: We both know she won't.

3.
TIGHT on CECILIA'S EYES.

CECILIA: Our official position to the rest of the Order is that
you are responsible for Erica's failure and overreach in the North
Woods.

CECILIA: Any further breaking of Order protocol will rest on you.

4.
AND AARON's EYES.

AARON: And what about the young man. Tommy Mahoney?

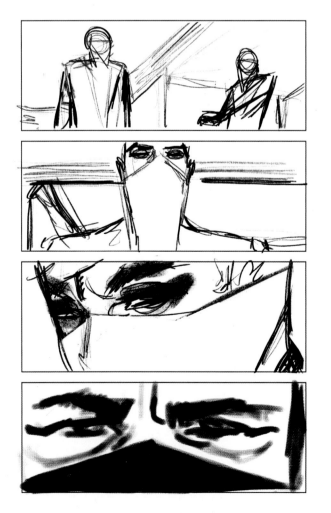
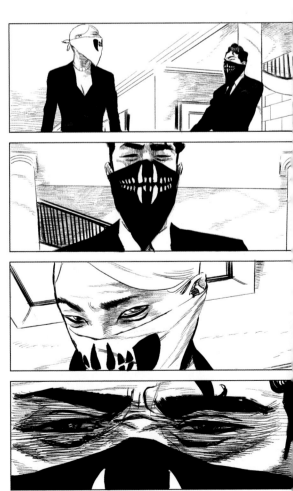

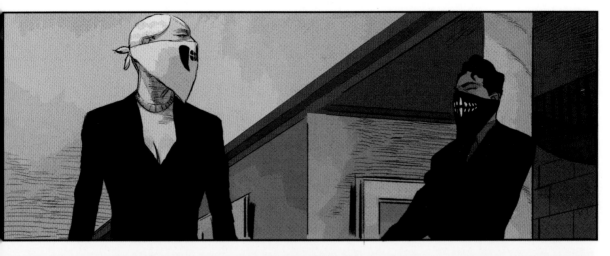
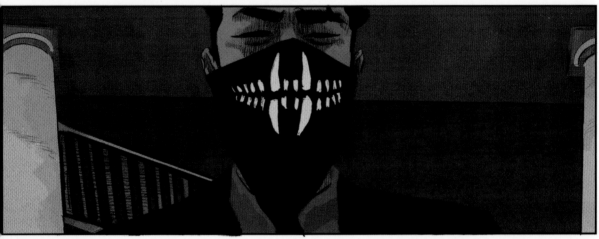
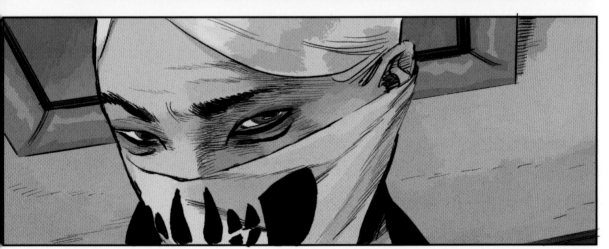
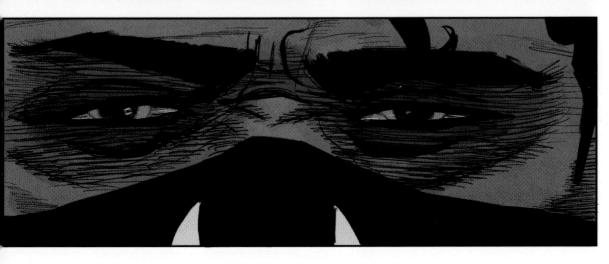

1.
CECILIA eyes a PORTRAIT on the wall...

2.
And turns back to AARON, who sees what SHE'S looking at.

CECILIA: He dies, of course.

3.
And we see the PORTRAIT... It's of a YOUNGER ERICA SLAUGHTER,
as a teenage girl. In something closer to a formal school girl
uniform. This was her, in her formal outfit, when she was living
in the House of Slaughter. She looks like a different person, but
it's still absolutely her.

CECILIA: The House of Slaughter has learned its lesson about
picking up strays.

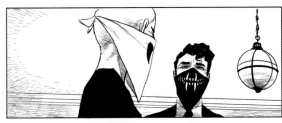
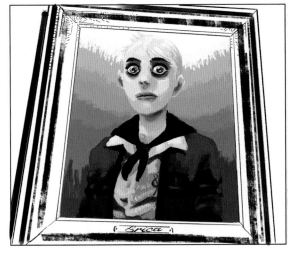

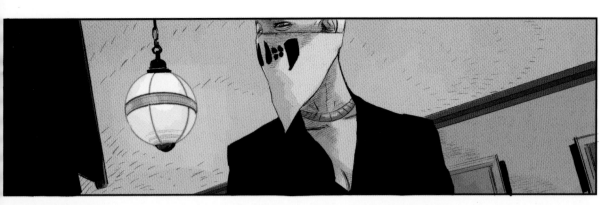

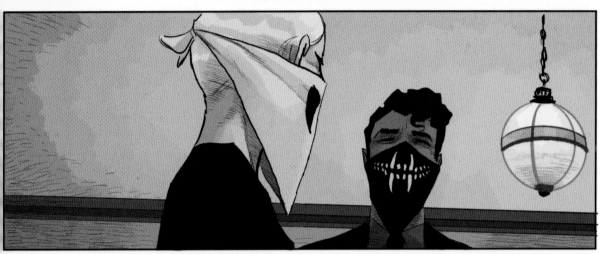

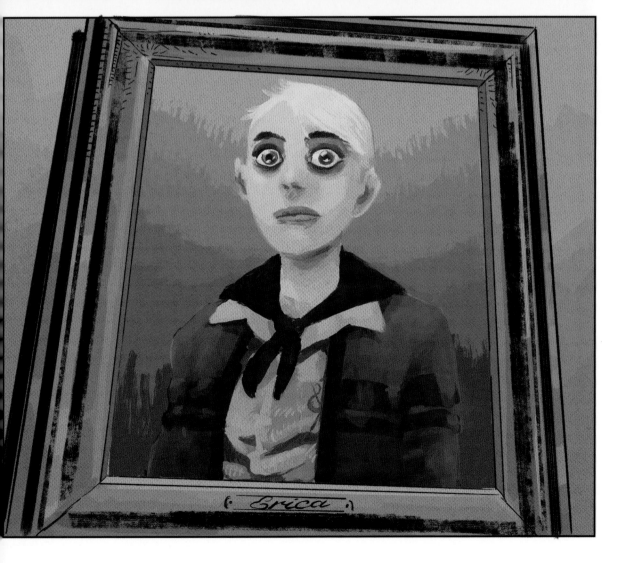

Erica

A GAME OF NOWHERE

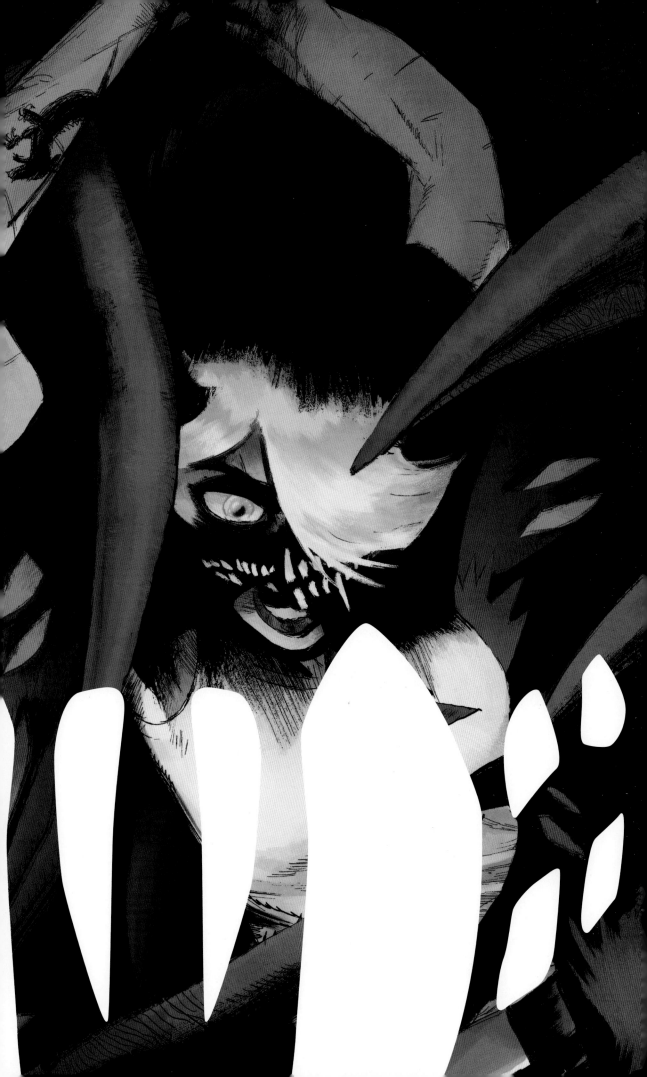

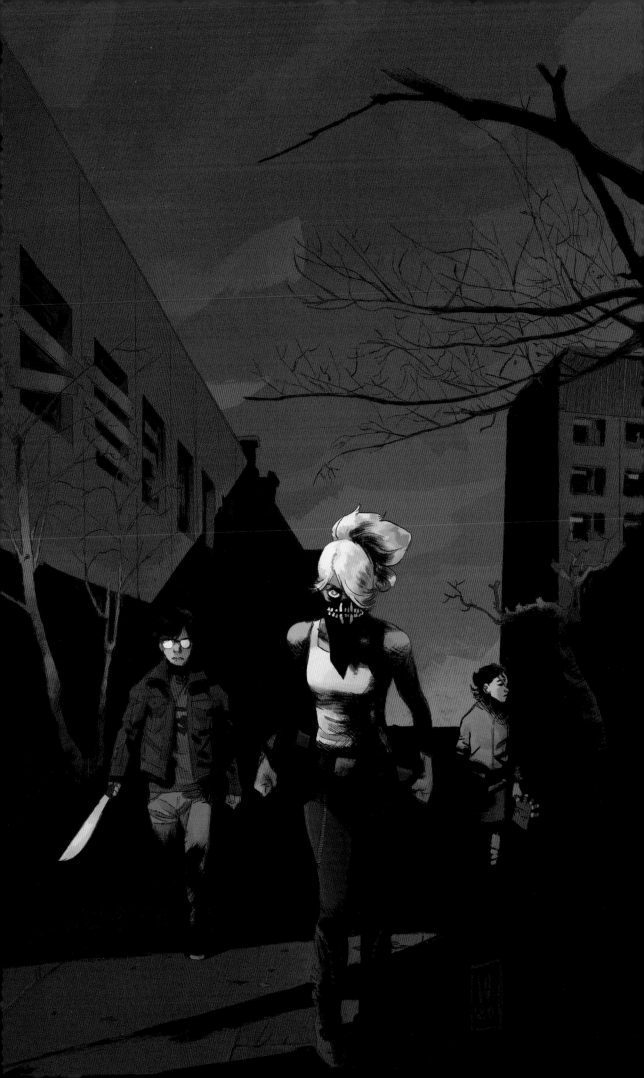

ON THE ARCHER'S PEAK SAGA

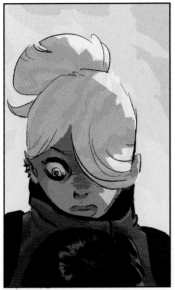

ABOVE
ISSUE #1 PAGE 18 PANELS 5-7

❝ With Archer's Peak, I was tapping into a lot of my childhood and my own experiences growing up outside of Milwaukee, Wisconsin. I think we imply that Archer's Peak is a few hours up the coast of Lake Michigan from Milwaukee, but it's still that kind of general upper-middle-class suburb of a larger metropolitan area.

That's why you get that upper Midwest middle school/early high school vibe from the character of James, who's very obviously based on me. When I started the saga, I used filler names for the other characters, who were pretty much based on my friends. But when it came time to come up with his name, I was just like, no, that character's name is James and we're just going to lean right in for the whole thing. It is amazing, thinking back, how much of that story kind of told itself to me rather than the other way around.

This was a moment in my career when I had been operating on very tight outlines for my work in superhero comics, particularly at DC Comics. *Something is Killing the Children* was my chance to avoid all that. Because I started writing thinking it was a five-issue thing, and then it became a 15-issue thing, I allowed myself to find the story, find the characters, and let them dictate the narrative rather than the other way around.

So, for the first few issues, it was me laying down all of these pieces that made sense to lay down, but I didn't know how they would all come together. And it was really around writing issue #6 that I finally sat down and understood what the rest of this story looked like. I understood what seeds I wanted to plant—and then, if people were still buying this book by the time we got to our second arc, hopefully we could just continue with the series. Because there was so much more left to explore.

And that's why the end of issue #15, where Erica leaves the Order of St. George, could technically stand on its own as the end of a complete story. The cycle speaks to all the central themes of the wider series, and had it ended there, there would have been a lot of mystery regarding Erica and the Order—but it would have been a full emotional story for the protagonist. The moment that we found out there would be more than 15 issues, though, is when we were *really* able to start building. **❞**

-JAMES

LEFT
ISSUE #11 COVER BY WERTHER DELL'EDERA & MIQUEL MUERTO

FOLLOWING, LEFT
ISSUE #14 VARIANT COVER BY MIRKA ANDOLFO

FOLLOWING, RIGHT
ISSUE #21 VARIANT COVER BY DAN MORA

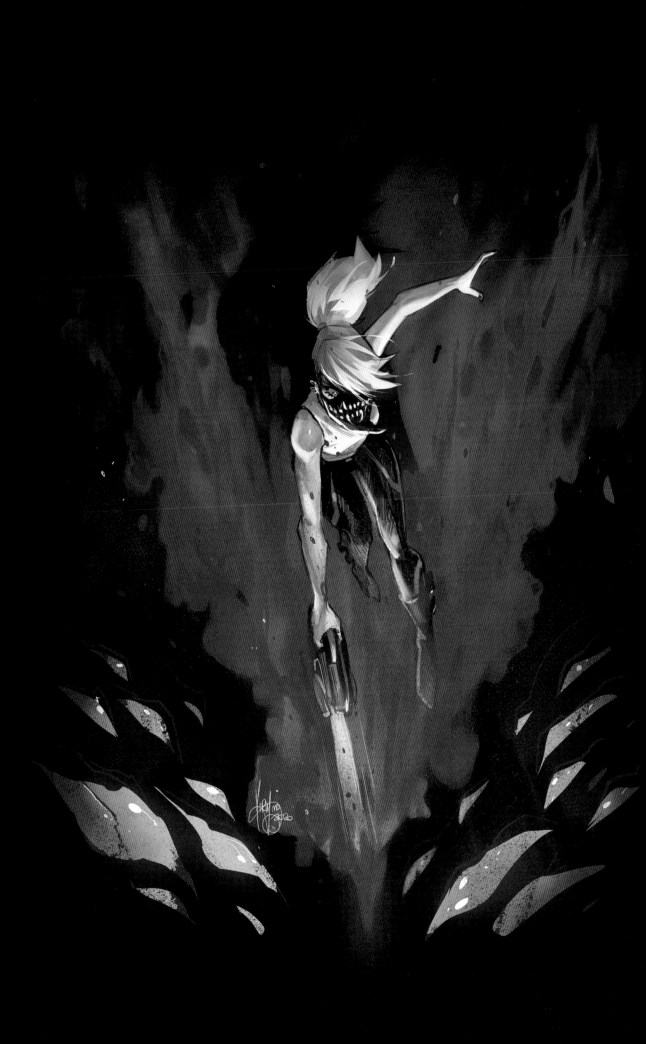

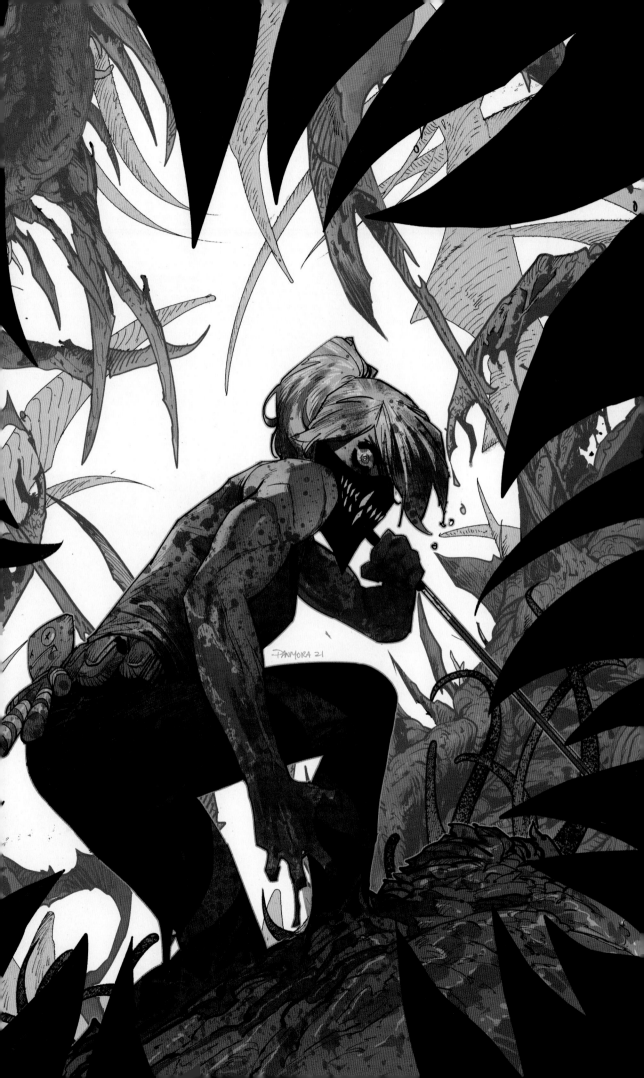

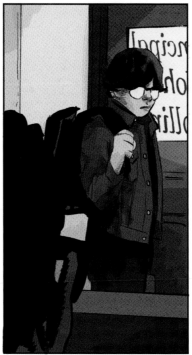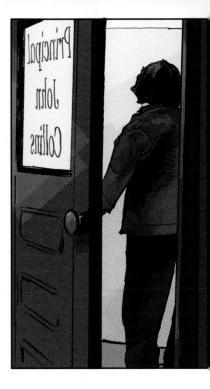

ABOVE
ISSUE #1 PAGE 14 PANELS 5-7

❝ Working on the Archer's Peak storyline was obviously a crazy experience! When we started out, it was meant to be a five-issue series—but by the third issue, James realized what he had on his hands was a story that needed more room, so we extended the cycle to 10 and then 15 issues.

The setting was forming issue by issue, with new characters coming into the story and Erica moving through the pages of this horrific situation in which children kept dying horribly. All drama and pathos. I loved drawing every single part of this story arc. I had a lot of fun with the sheriff—I actually asked James for the sheriff, because I have a soft spot for Westerns of all shapes and sizes. The sheriff's office, for example, is inspired by the one in *Longmire*. Have you seen it? I absolutely loved it! *Lone Ranger* with a modern twist, Robert Taylor and Lou Diamond Phillips, fantastic! The first episode is a blast! But so is *Justified*...!

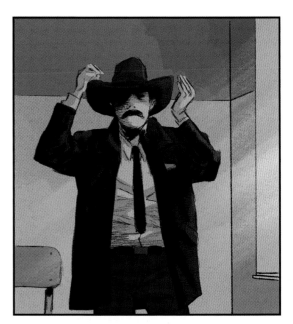

ABOVE
ISSUE #8 PAGES 2-3 PANEL 15

Okay, I'll stop. We were talking about Archer's Peak. When I think back to Archer's Peak, one of the first things that comes to mind is the school principal, in issue #1. I loved drawing that sequence. There are so many characters and moments in this story arc, sometimes I find myself thinking I want to go back there to see what life was like after Erica and the House of Slaughter left town. Like, what happened to Tommy? I developed a fondness for those places and characters, as if they were real. ❞

-WERTHER

RIGHT
ISSUE #12 COVER BY WERTHER DELL'EDERA & MIQUEL MUERTO

FOLLOWING, LEFT
ISSUE #21 VARIANT COVER BY ADAM HUGHES

FOLLOWING, RIGHT
ISSUE #13 COVER BY WERTHER DELL'EDERA & MIQUEL MUERTO

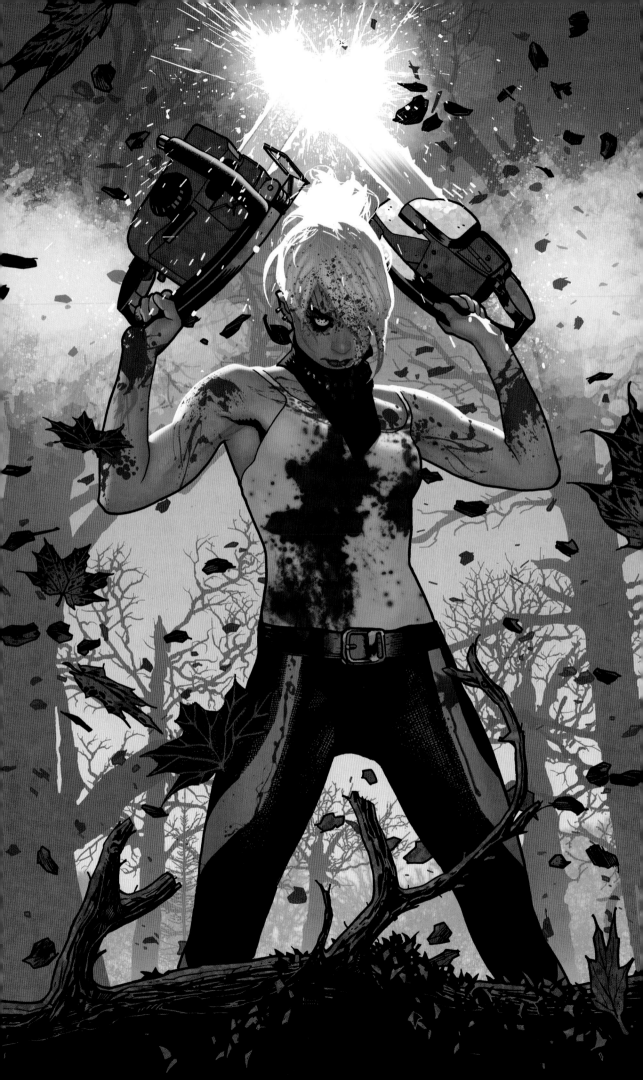

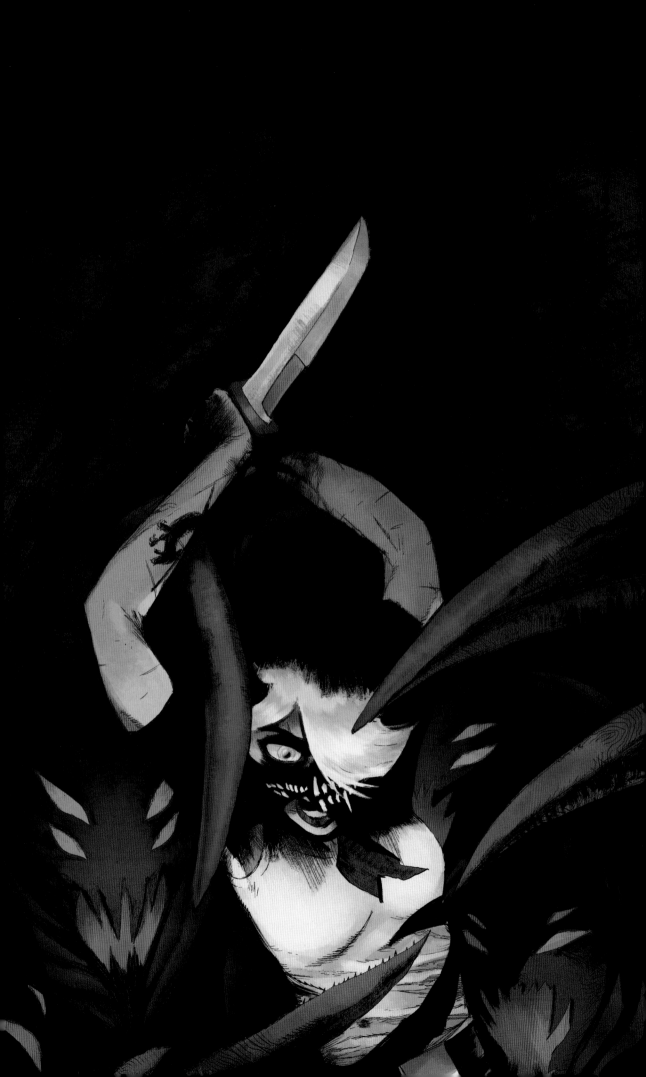

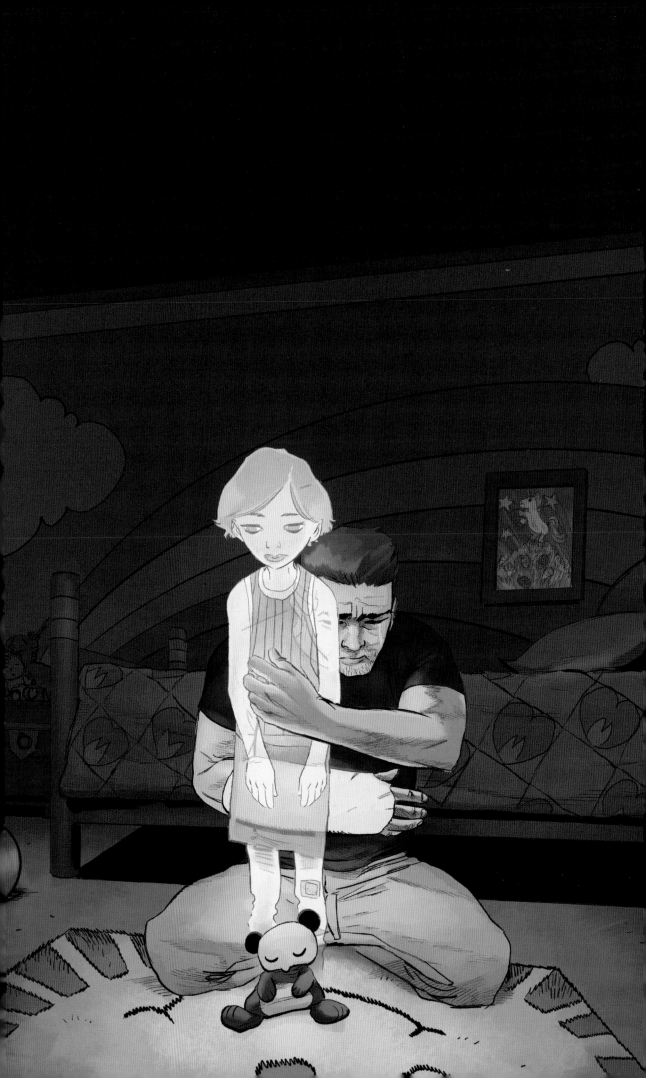

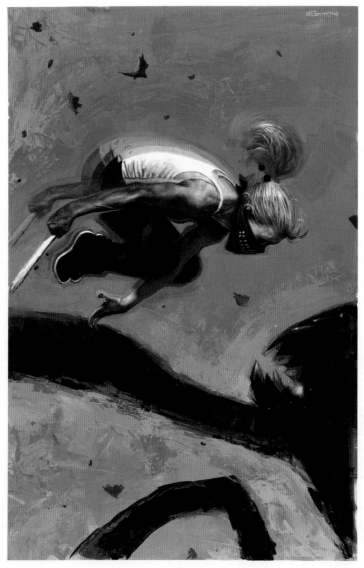

JAMES:

When you start designing a new character, particularly one of the smaller characters who might only appear for a scene or two, where do you start? Has there ever been a character you designed and then they become much more frequent than you expect and you wish you had designed them differently?

WERTHER:

Of course, I always start from the description given to me. It is my bible! In the case of secondary characters, I almost always create the character directly on the page. This is something I find useful for two reasons: first for a matter of timeliness, and second because, on the page, the character is contextualized and I better understand them by tuning the appearance with the attitude. However, there are often elements of characters that I end up wishing I had done differently later on—haircuts or elements of clothing, those kinds of details can challenge me.

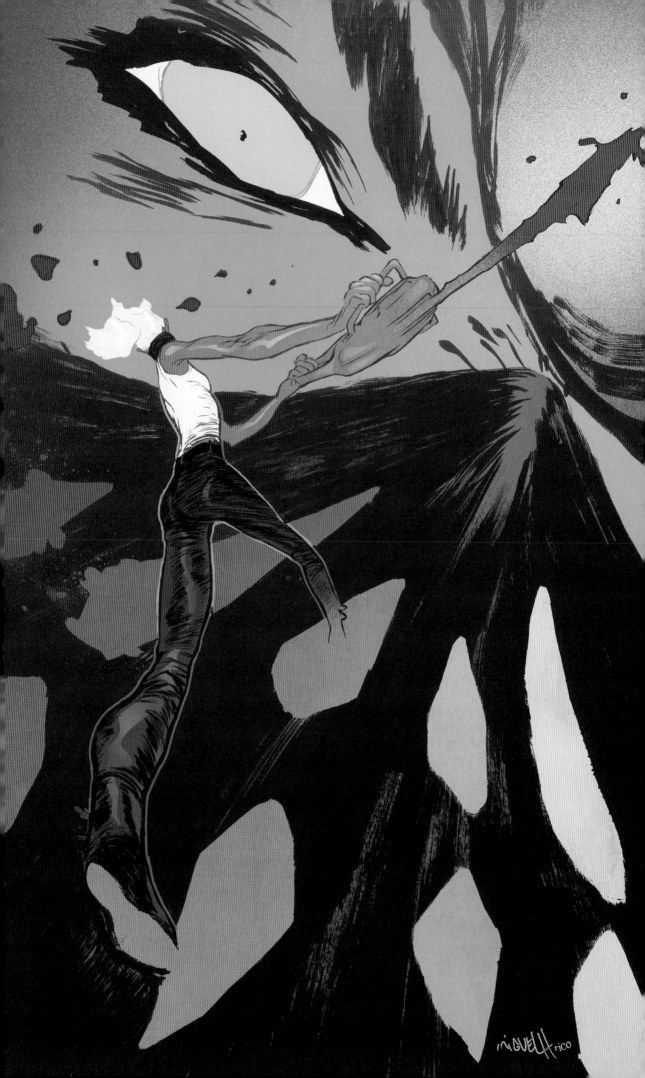

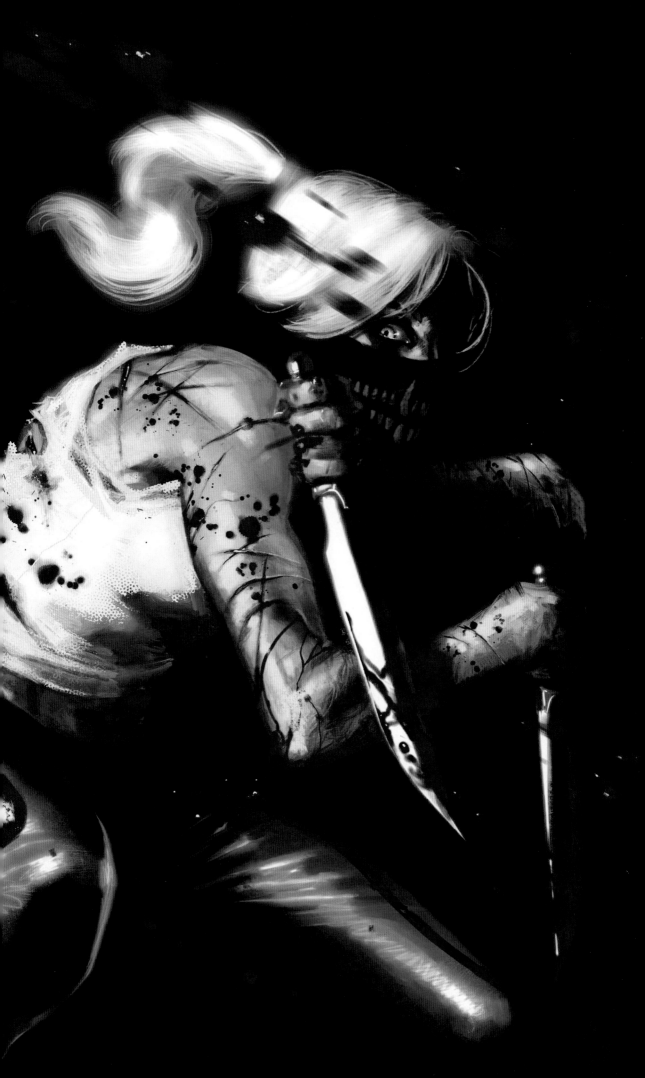

WERTHER:

Something I really appreciate, and not just in *Something is Killing the Children* but your work in general, is your ability to inject disruptive and topical themes in a very natural way. I never find it sensational or forced. Instead, it gives me the feeling of a quiet revolution, of getting used to change organically. How do you achieve that? Do you do it consciously, or is it just an inherent part of how you tell stories?

JAMES:

I think it's a little bit of both. I think I used to be a lot more conscious about it because I think I was a lot more anxious about putting my thoughts out there about the world as it is. But honestly, so much of my writing is me trying to work through my own struggles with the world and my own questions about the world. My primary genre is horror, and horror always reflects what society is afraid of at that moment.

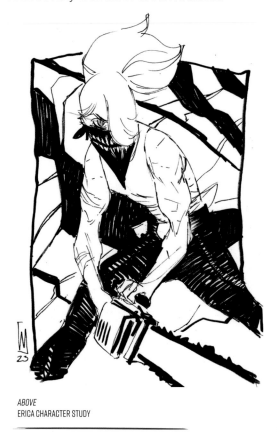

ABOVE
ERICA CHARACTER STUDY

Horror does that by reflecting what the creators are afraid of. And so there are very specific things that I'm afraid of in the world. And these series are all extrapolations of that. *Something is Killing the Children* is not directly about gun violence, but it is about the fact that there's an entire generation of children that are growing up in a world of abstract fear that is taking form and putting their lives at risk and that the systems that were designed to protect those children are not only not actually looking out for them anymore, but in fact actively resisting attempts to protect those children. And so it's the story of all of those abstract fears, but it's also an action-adventure horror comic. So it's not an all-consuming center to this story. I always consciously ensure that I keep the true nature of the story very much driven around the characters and all that.

But it's all colored by how I view the world. And I think the most central theme that I come back to over and over is this idea of a kind of systemic decay. It's the idea that there are all of these systems that exist in the world that were designed to protect us and keep us safe, and they don't work anymore. But there's no other option—we have to continue existing in a world where none of those systems work. And we have to struggle with how we face that, and what we have to become in order to face that. I come at that theme over and over in a lot of my different stories.

So I'm very happy that it seems to resonate with people. And I think beyond anything, beyond the specificity of what scares me and what the stories are talking about, it's also just the fact that it's me, in an honest way, talking about things that matter to me. I think that when these topics appear in the comics, they don't feel like I'm trying to preach to an audience. I am trying to work through something in myself. And I think that kind of honest self-expression allows readers to come along for the ride without feeling like I'm dragging them someplace they don't want to go.

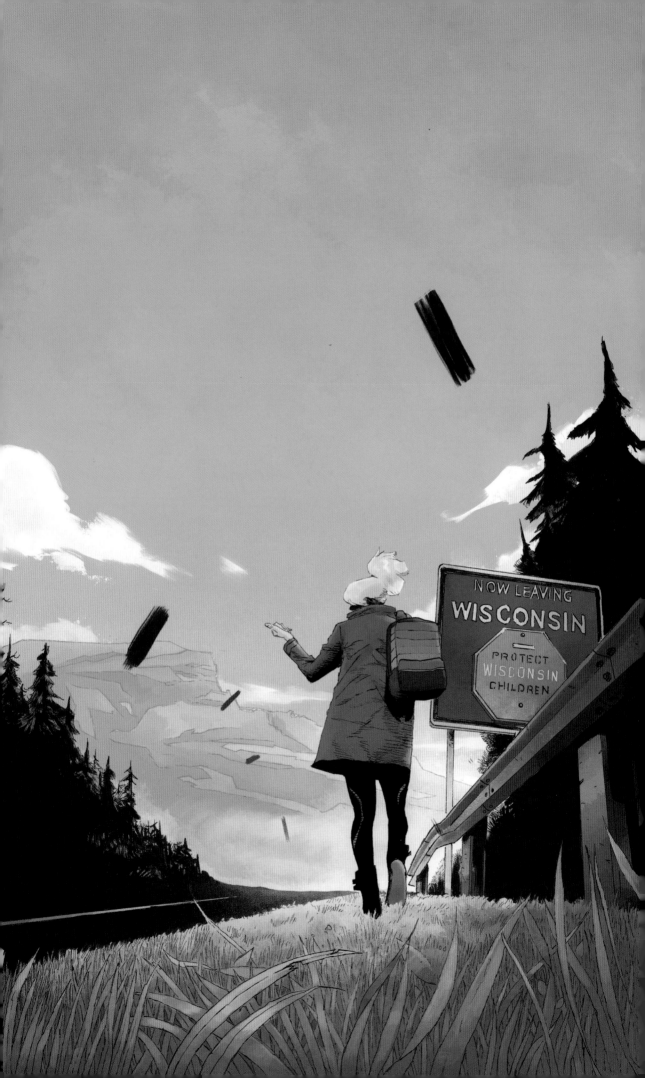

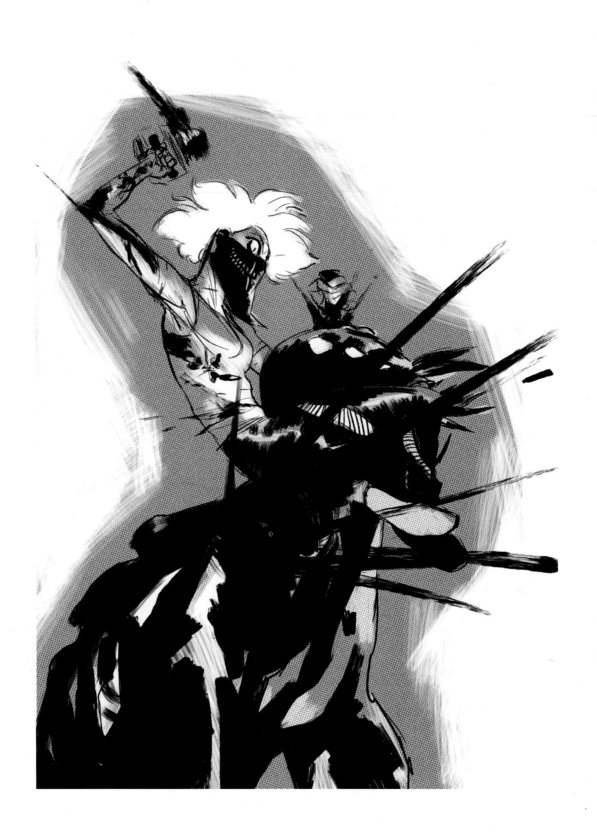

RIGHT
ISSUE #21 VARIANT COVER BY JEEHYUNG LEE

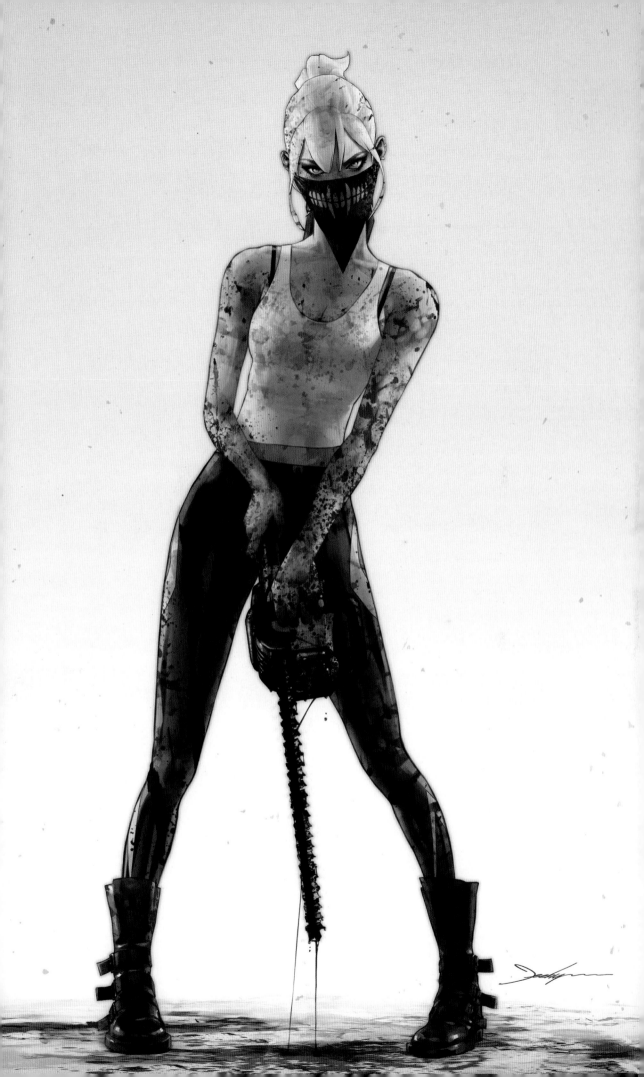

Page 17

1.
THE MONSTER turns to ERICA... Transforming back into his true form.

OCTO: They're coming.

2.
ERICA's eyes are out into the forest. She's waiting for them.

ERICA: I know. I can feel their eyes on me.

3.
OCTO grins, cruelly.

OCTO: They're going to kill you.

4.
ERICA has no time for his bullshit... Her knife is at the ready.

ERICA: Shut up, and get back into your octopus.

5.
ERICA looks ANGRY, and brutal.

ERICA: I need to work off some anger.

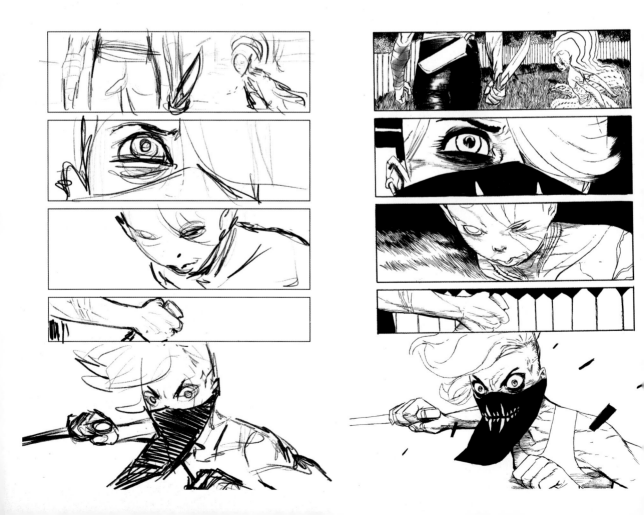

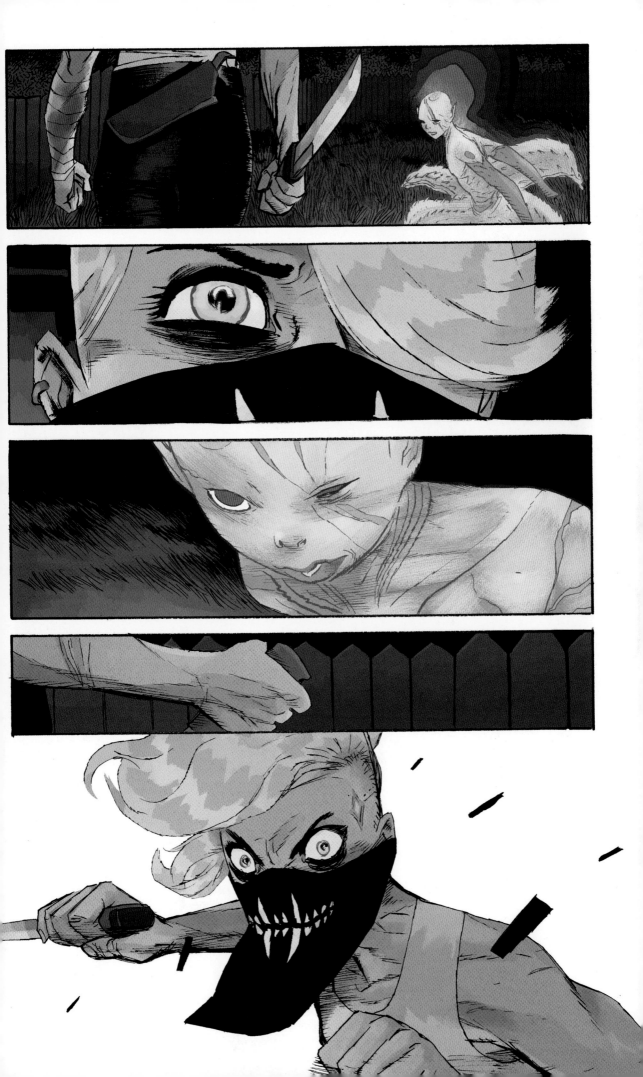

Pages 18-19

DOUBLE-PAGE SPLASH — ERICA is in the backyard, surrounded
by the MONSTERS. There are THREE of them left. They are
towering over her... hungry.

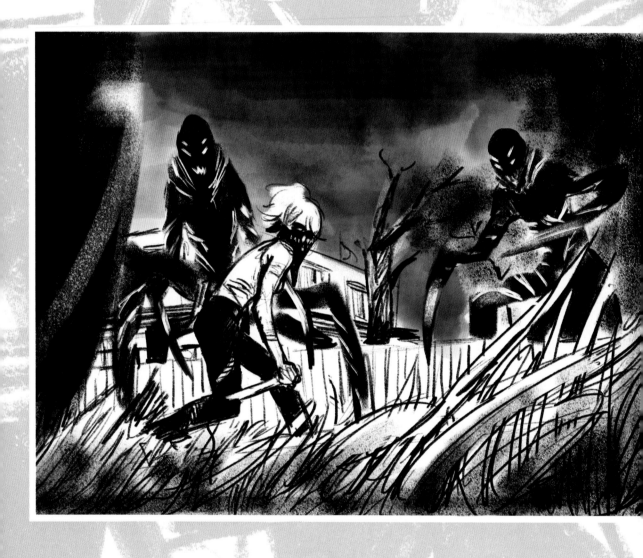

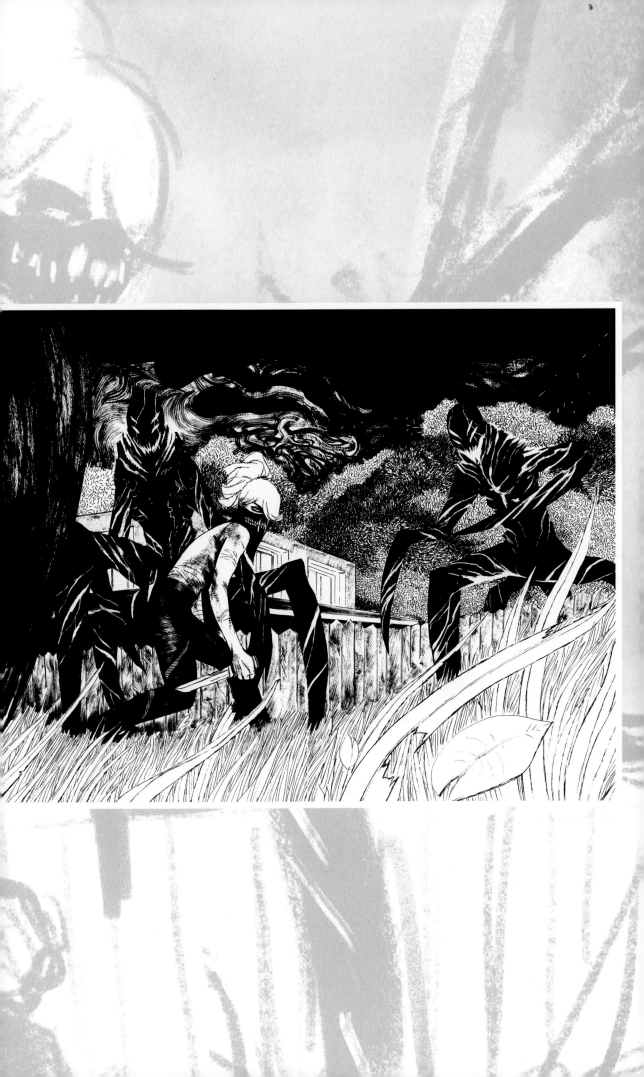

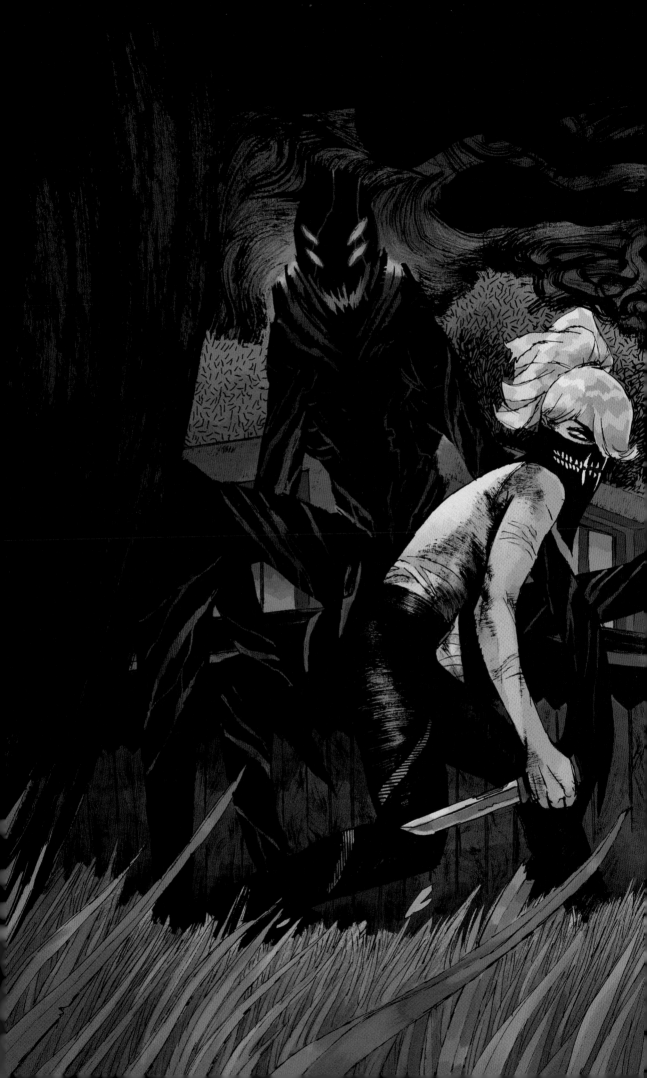

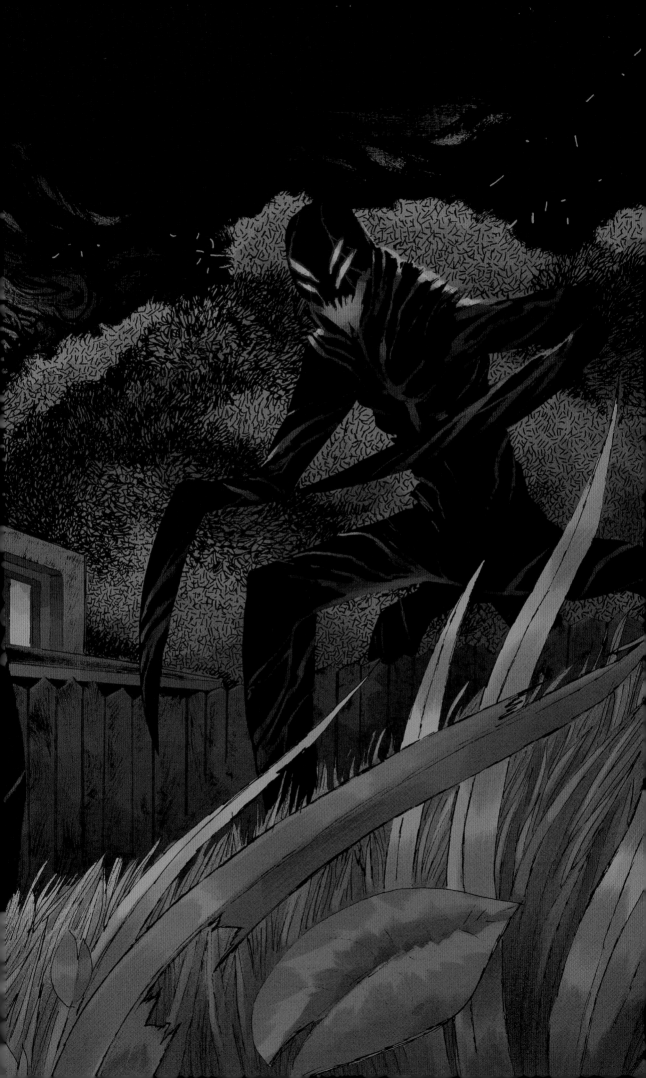

Pages 20-22

ERICA DIVES INTO ACTION — Werther, I'm happy to lay this down in more detail, but honestly, I'd love to see you go to town with this. This is Erica showing exactly how bloody and efficient she can be… This should all be BLOODY…

We see her take down one of the monsters…

Another monster takes a bite out of her, and she gets its legs and takes it down…

The last one is coming after her now. She is READY for it…

But she might not survive.

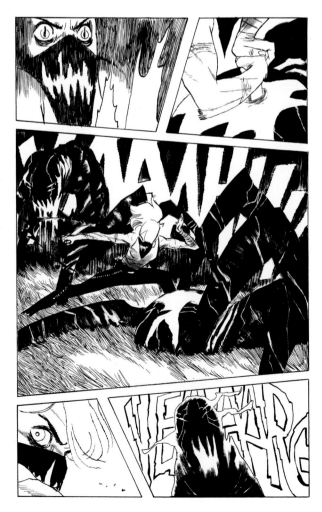

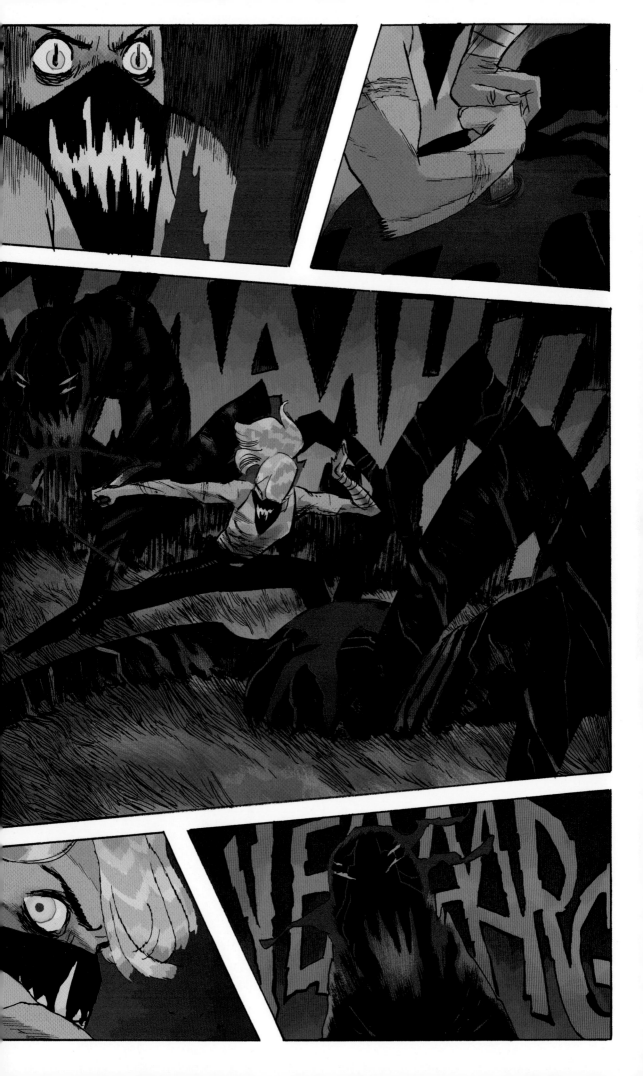

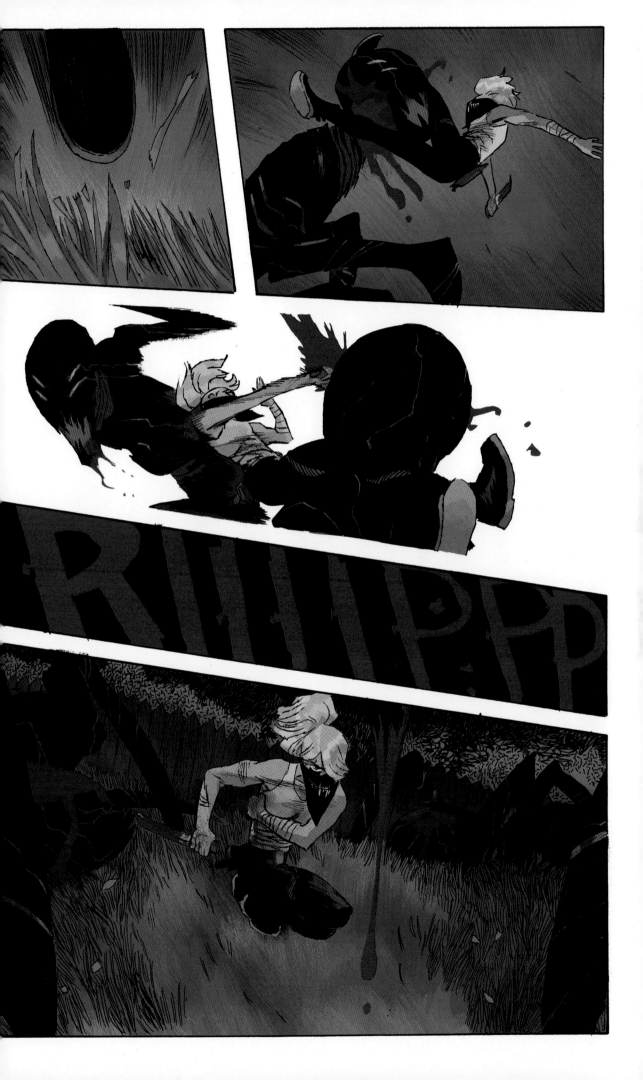

ME
AND MY
MONSTER

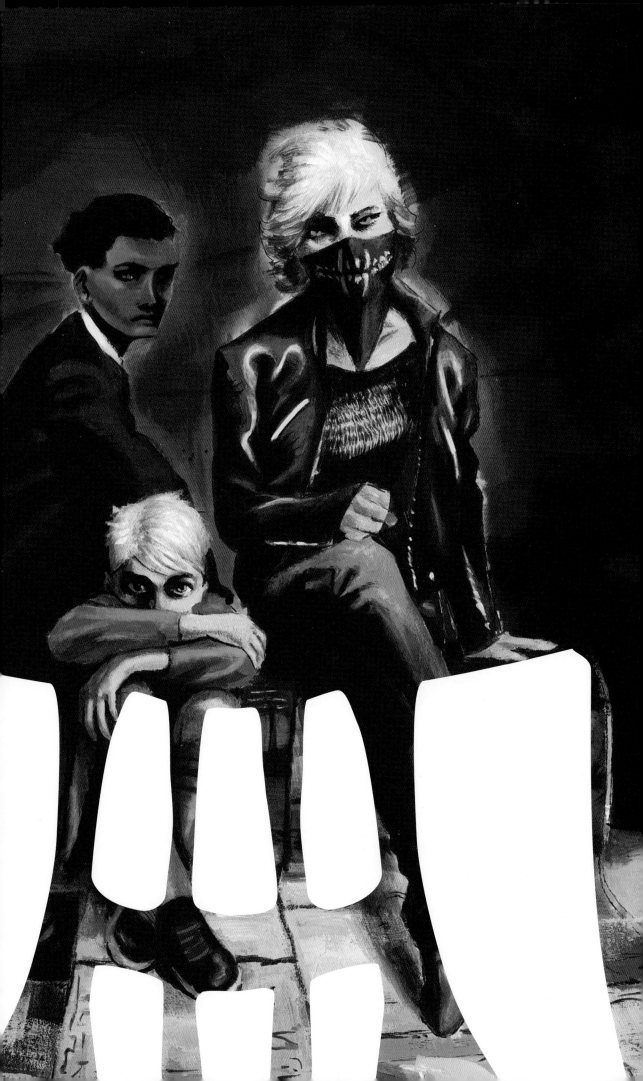

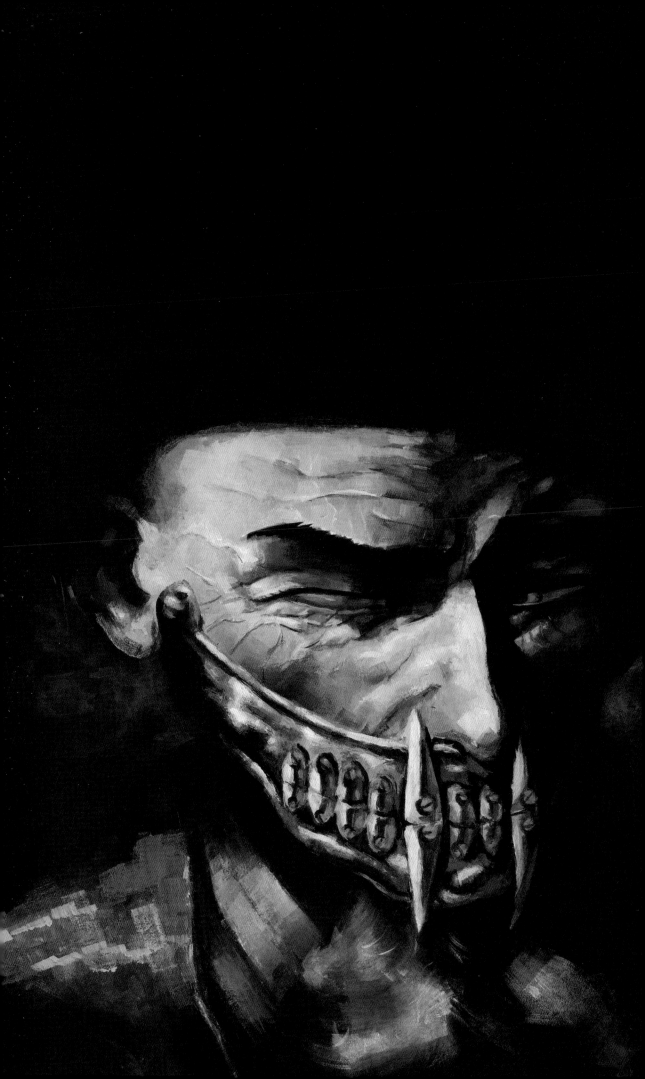

MONSTER DESIGN & DEVELOPMENT

❝ The monsters in this series function as personifications of abstract fear. We tap into this idea a lot in the first arc, where we live in a world with so much abstract fear around us.

Central to the idea of the Order of St. George is that one hundred, two hundred, or however many years ago, when monsters first came into form, they had much more defined shapes. They were more like the monsters of myth and legend. Each of those monsters represented a more concrete fear of a very specific thing, but as the world has gotten scarier and more complicated, the fears that a young child might experience have started to become a lot more formless.

And that's sort of what brought us to the idea of the Oscuratype, the kind of shadow monster that is the most common monster in the world of *Something is Killing the Children.* These are built out of abstract fear, and they are formless and extremely dangerous. An Oscuratype is what killed Erica Slaughter's parents, and that's the monster that lives inside of Octo. This is what gives her a leg up over some of her peers in the Order of St. George—she has a sort of communion with the abstract, dangerous fear that's destroying real kids' lives out in the world. ❞

-JAMES

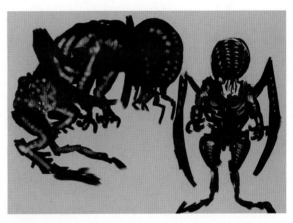

ABOVE
MONSTER SKETCHES

LEFT
ISSUE #18 COVER BY WERTHER DELL'EDERA

FOLLOWING, LEFT
ISSUE #16 VARIANT COVER BY JAE LEE & JUNE CHUNG

FOLLOWING, RIGHT
ISSUE #16 VARIANT COVER BY JAE LEE & JUNE CHUNG

95

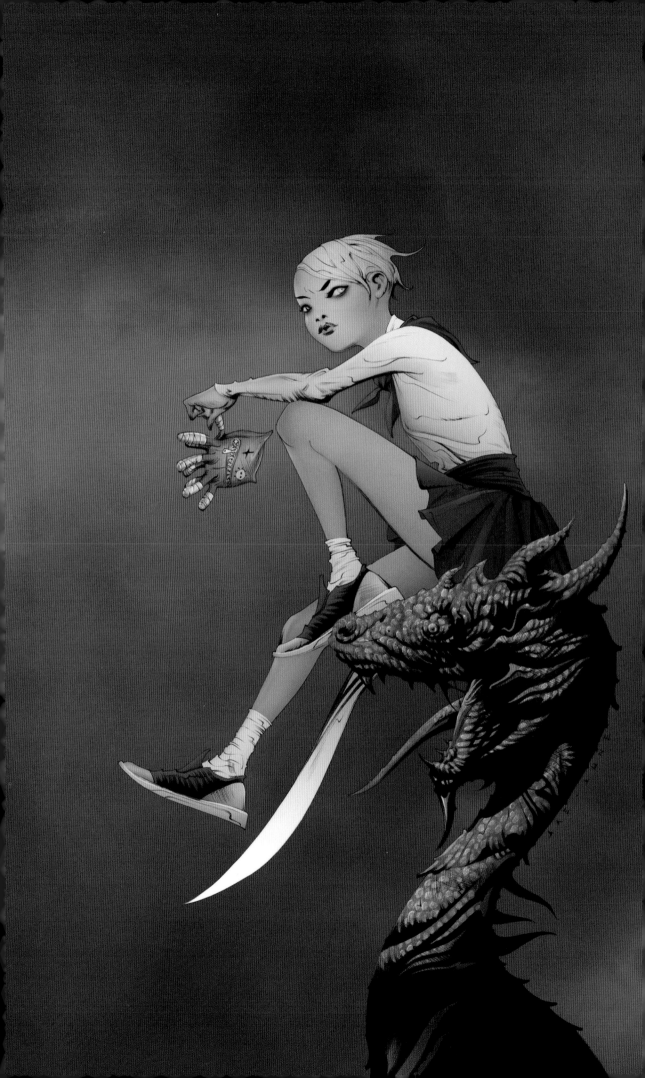

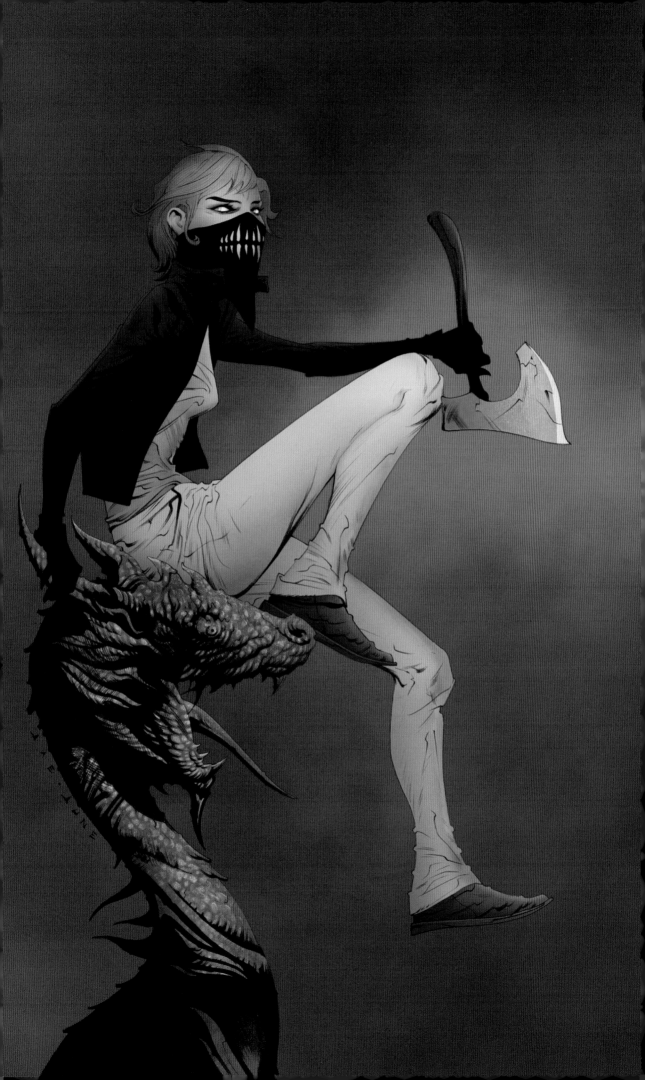

" The monsters of the first story arc had a strange genesis. When I think back on it, I'm not very convinced of the outcome. I feel a bit like they might be the weak point... yet they became iconic!

In any case, they were going in the direction I wanted, but looking back on them I feel like there is still something missing from the design. Now, I'm not sure what I would redo about the design—maybe the torso, or maybe the fact that they are so dark black? Maybe I wouldn't make them completely black, and instead leave some horrible bodily details visible. For example, I already like the Duplicitype in the second story arc better—its transformations are really creepy, and generally seem to work very well for me. Who knows, maybe in the next story cycle, if the Oscuratypes come back I can try to modify them a bit... I have to talk to James and Eric about it!

We've also shown glimpses of a few other new monsters: dragons in *House of Slaughter* and vampires in *Book of Butcher*. However, you always have to strike a balance between what you can do, what you want to do, what you have to do, and the time you have to do it. "

-WERTHER

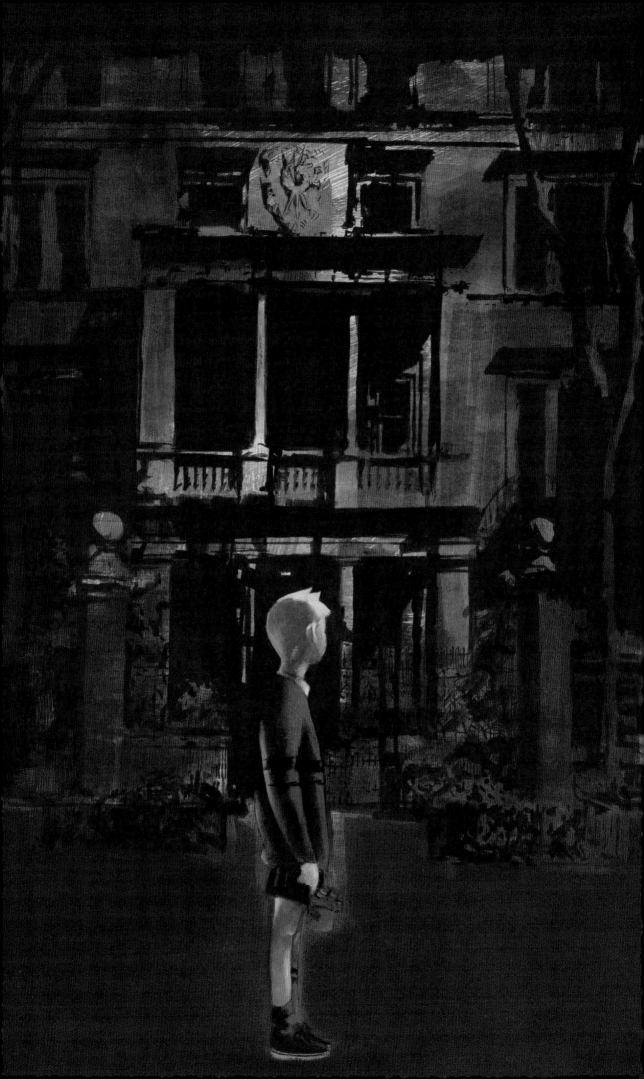

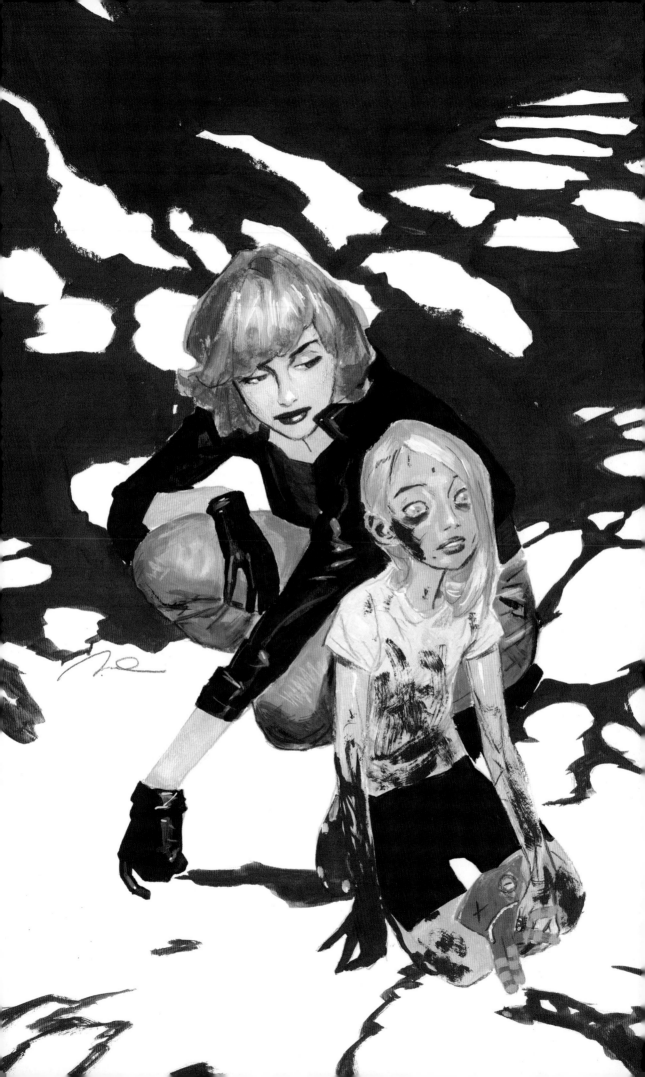

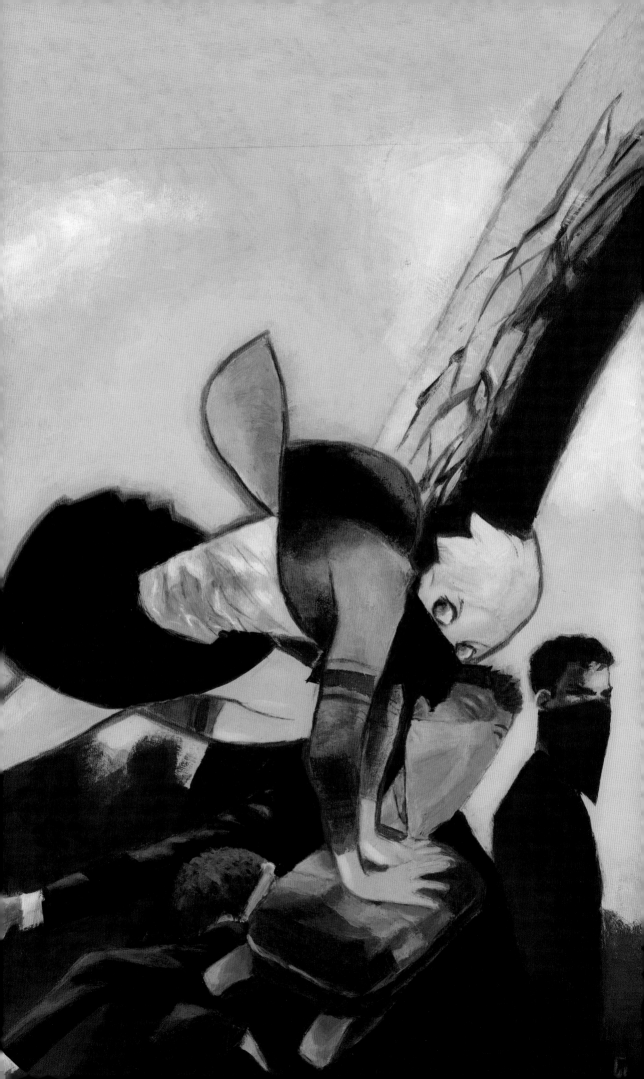

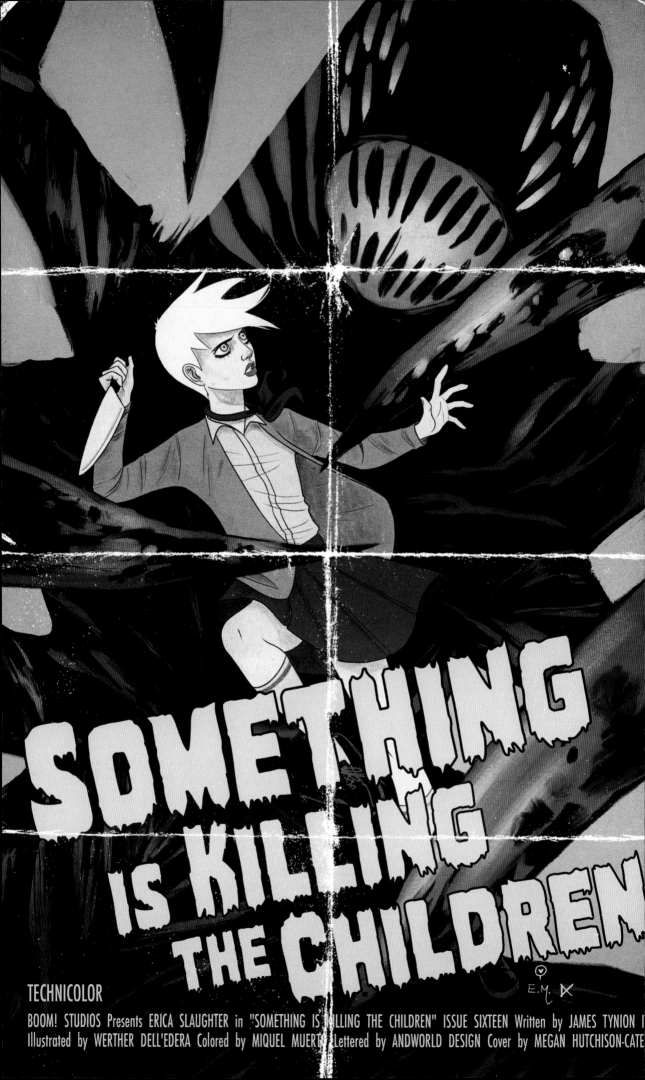

SOMETHING IS KILLING THE CHILDREN

TECHNICOLOR

BOOM! STUDIOS Presents ERICA SLAUGHTER in "SOMETHING IS KILLING THE CHILDREN" ISSUE SIXTEEN Written by JAMES TYNION I
Illustrated by WERTHER DELL'EDERA Colored by MIQUEL MUERTO Lettered by ANDWORLD DESIGN Cover by MEGAN HUTCHISON-CATE

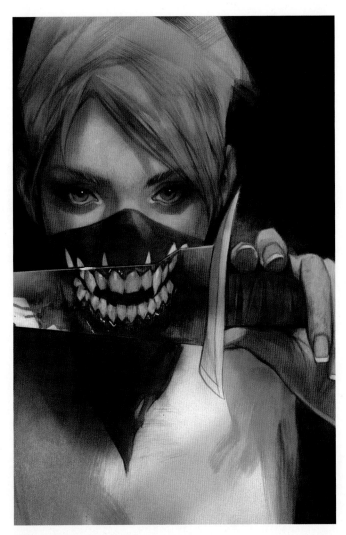

ABOVE
ISSUE #18 VARIANT COVER BY BEN OLIVER

WERTHER:

Which character in the series is your favorite so far and why?

JAMES:

That's a tough one. Two characters that come to mind first and foremost are Cecilia Slaughter and Big Gary Slaughter, and they kind of represent the two opposite ends of the forces that shaped Erica into who she is.

Like, Cecilia is a very cold character. She's a political animal who has done everything she can in her life to climb up the ladder of the House of Slaughter. She's ambitious, smart, and ruthless. She pretends that she doesn't care about people because she was built to not care about people, but then you see through her love of Jessica Slaughter, who is essentially a sister to her, that caring for another human being is still so essential to her.

And then Big Gary, on the other hand, is a naturally gregarious character. He's very warm in a way that no one else in the House of Slaughter is warm. Big Gary Slaughter is the sort of person that I kind of hope I grow up to become, and Cecilia is the kind of person I sometimes worry I'll turn into instead. They're both built around their love of Jessica and their relationship with Erica. And Big Gary is the one who knows it. He knows that a million contradictions exist in being a part of the House of Slaughter, and he knows that there are all of these awful things that you have to become in order to be an effective member of the Order. He's made his peace with it. However, he still tries to guide people towards being more human, even though he knows that it's dangerous to care about people working in this Order and that it can get you killed. That dynamic between Big Gary, Cecilia, and Jessica is what shaped Erica into who she is.

LEFT
ISSUE #16 VARIANT COVER BY MEGAN HUTCHISON

FOLLOWING, LEFT
ISSUE #19 VARIANT COVER BY DANNY LUCKERT

FOLLOWING, RIGHT
ISSUE #19 COVER BY WERTHER DELL'EDERA

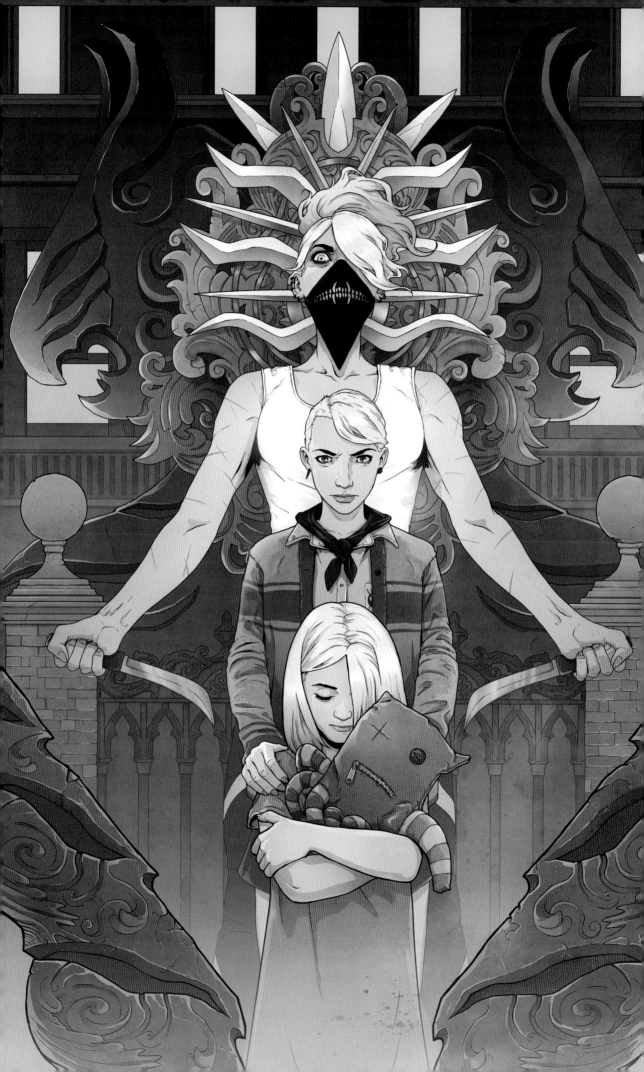

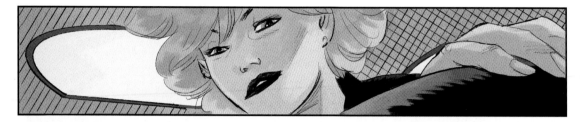

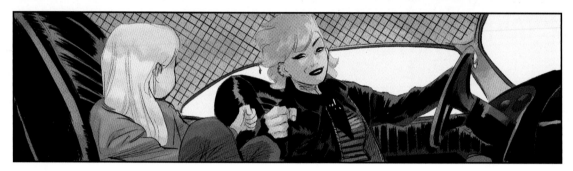

JAMES:

When we talk, you've always been very much in love with the character of Jessica Slaughter. What is it about her character that speaks to you? Are you excited to get to draw more of her in the coming arcs?

WERTHER:

Jessica! (Heart-eyes emoji)! Jessica is a wonderful character, and she is crucial because she is the one who made Erica who she is. She has shown Erica strength and tenderness, more than Erica is able to show her own feelings (and at times, even too much). But if she had not been there, maybe Erica would not have learned empathy for the weakest among us, for those who need help... even to the point of her own detriment/sacrifice. It is fundamental, the most important lesson to learn.

That's what makes me love Jessica's character so much. That and her fragility. We have already seen this in the story arc about Erica's past. The pain she carries and the strength with which she tries to push it back. I empathize with her suffering—that's what makes her absolutely human, to the point of breaking her. Also, I think she looks beautiful. Visually, I mean. I drew her from the wonderful Debbie Harry. I wanted her to have that appeal. That she was attractive in the same way, but also sweet and cozy.

I'm very happy with the result, as with Erica's design. Then again, it couldn't have been any other way. Jessica is Erica's mentor, so for me she had to be equally great. That is why I gave her an old European car, an Opel GT. I absolutely love the line of that car and it looks perfect on the character. I can't wait to be able to tell her story with you, James; it will be epic for me to draw her. I already know I'm going to be so moved. I hope I will be able to wring tears from the readers as well!

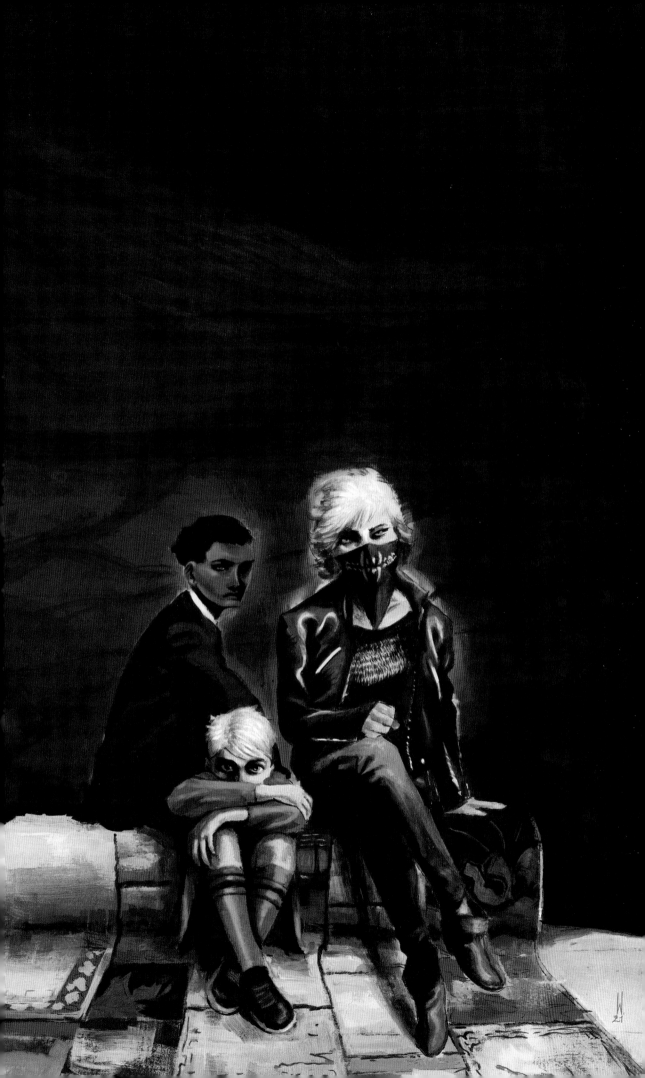

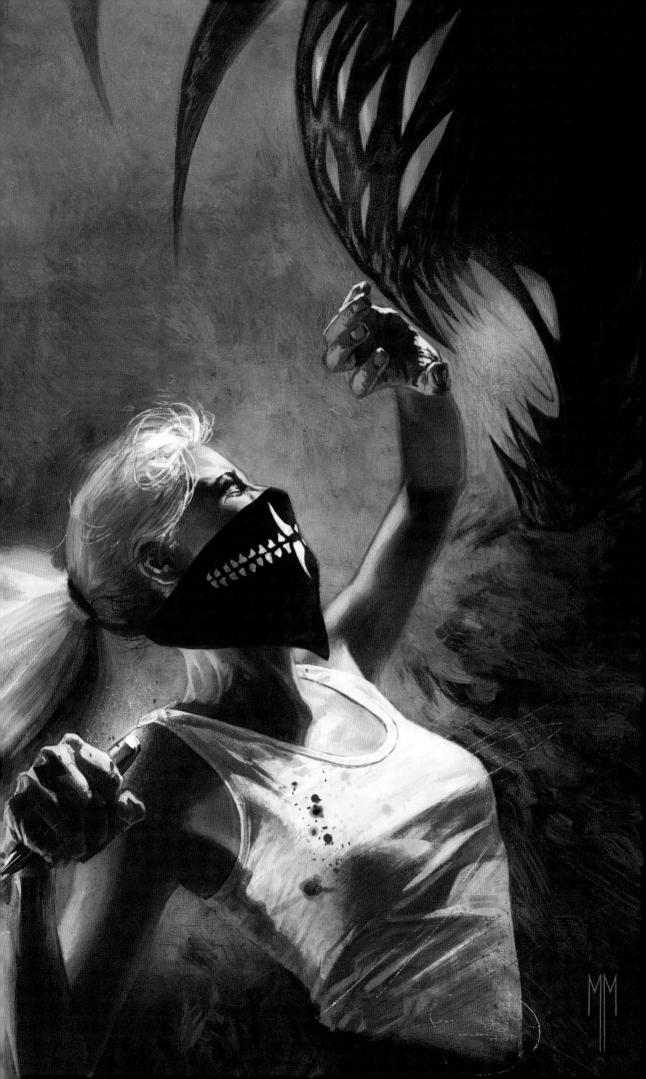

Page 1

SPLASH – We see ERICA SLAUGHTER, Age 12, sitting on the
bench in front of the Old Dragon's office where we saw
Aaron Slaughter sitting back in issue #6, under the giant
painting of St. George slaying the Dragon. The tupperware
is placed on the bench next to her, far enough away from
her to keep her from getting too nervous. She is wearing
her mask (no teeth). She's been waiting on that bench for
a long time.

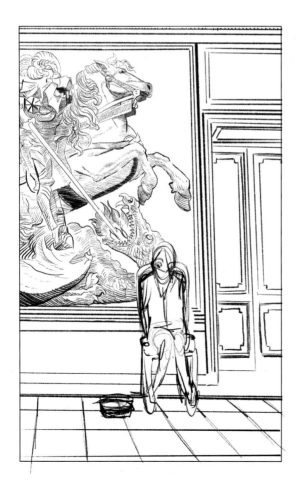
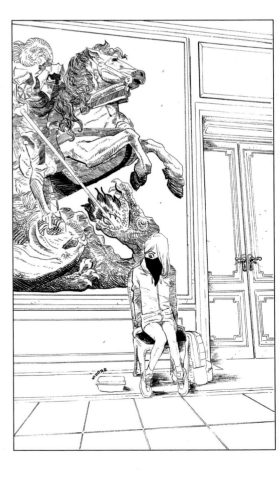

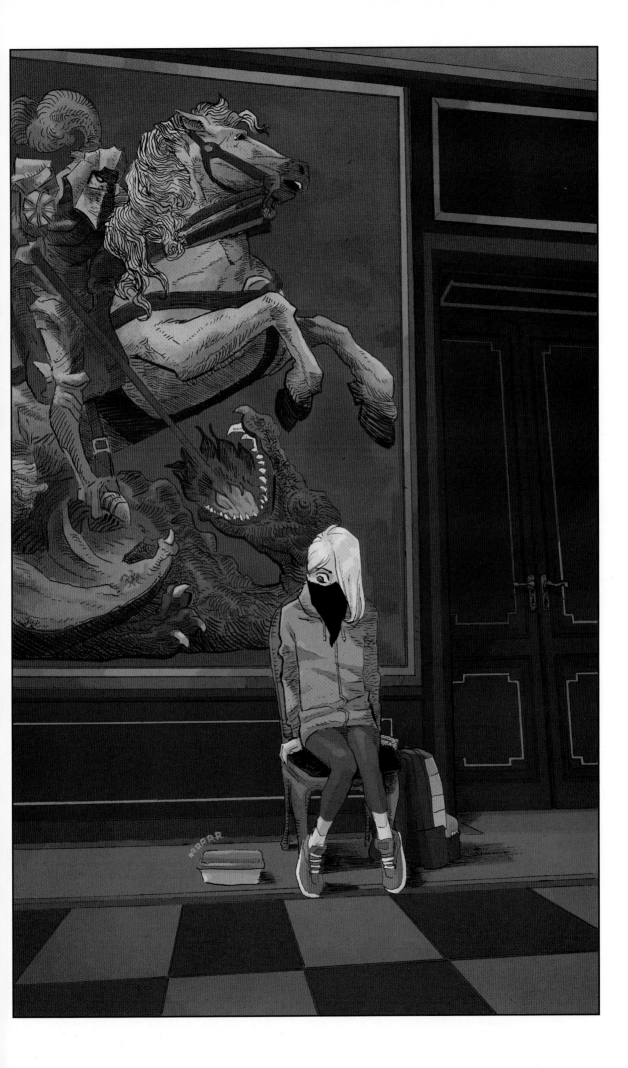

Pages 2-3

1.
ERICA turns to look at the
TUPPERWARE.

2.
SCARY MONSTER NOISES COME OUT OF
THE TUPPERWARE…

3.
But then she hears a voice.

AARON (off): They're shouting in
there.

4.
SHE looks up to see a young AARON
looking at her… AARON has his mask
on, too. His mask also doesn't have
teeth on it yet.

ERICA: I can hear them.

5.
AARON, smug. Trying to lord over
her.

AARON: She wasn't supposed to
recruit you like she did. There's a
whole process.

6.
ERICA, matter of fact. Kind of
ignoring him.

ERICA: That's what they're shouting
about.

7.
AARON, a bit petulant. Insistent.

AARON: You're supposed to pass a
test before you can come to the
House of Slaughter.

8.
ERICA looks down.

ERICA: I don't like tests.

9.
AARON, glad he's getting under her
skin.

AARON: I don't think anybody likes
tests. But that's not the point of
tests. They're not there for you to
like. They're there to prove you're
good enough.

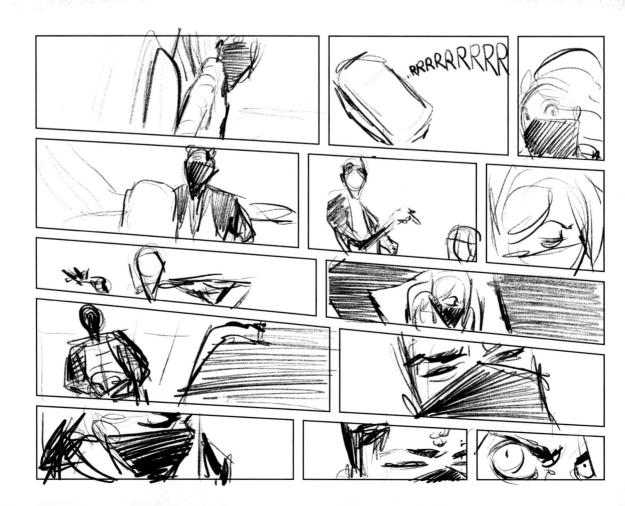

10.
He pushes further.

AARON: Everyone else in this House?
They were good enough to pass that test
and get in.

11.
ERICA trying to ignore him. Trying not
to get angry.

ERICA: Just leave me alone.

12.
But AARON pushes it one step too far.

AARON: If they let you stay, it's only
because Jessica felt sorry for you.

13.
And we see the RAGE in little ERICA's
eyes.

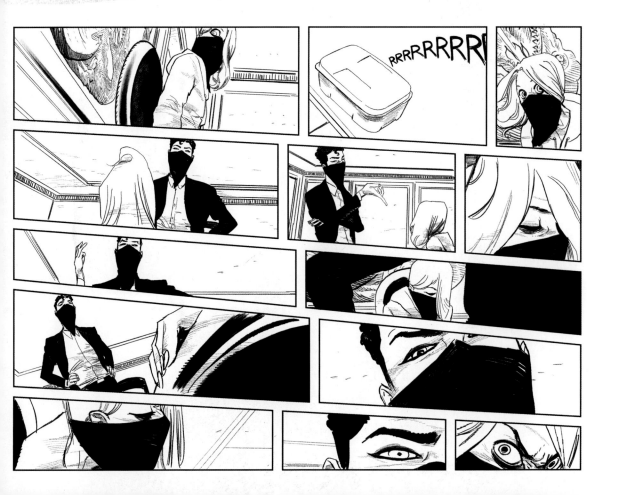

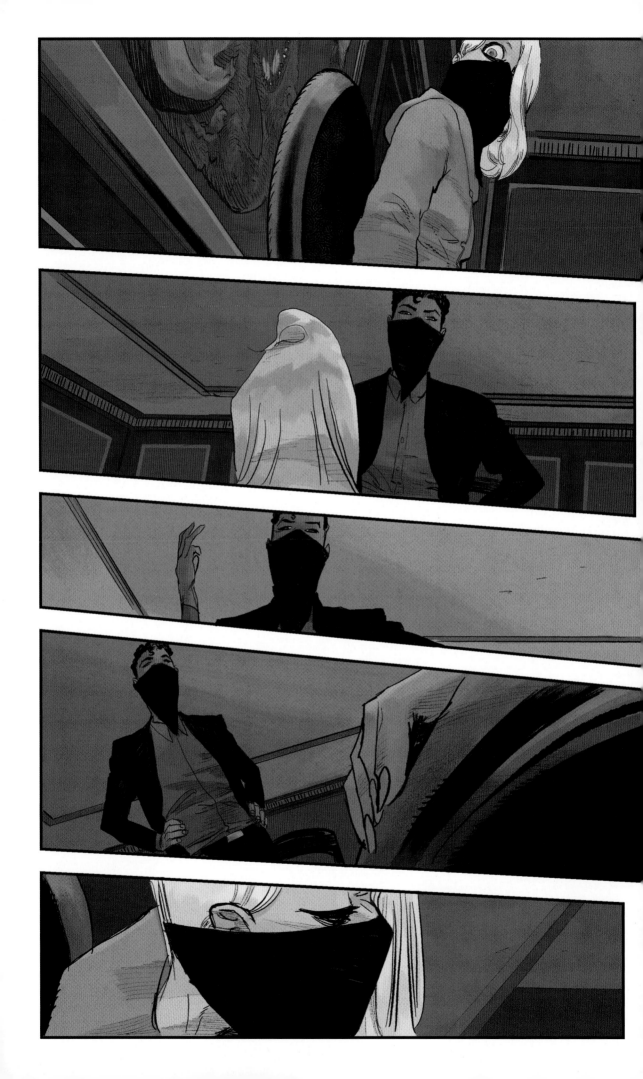

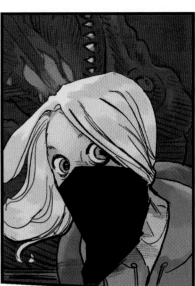
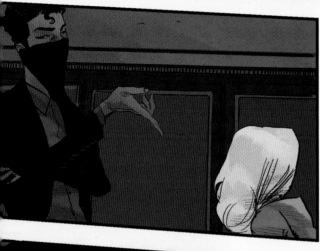

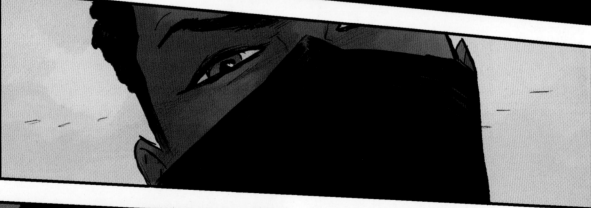
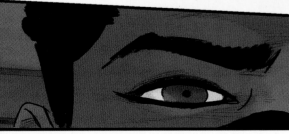
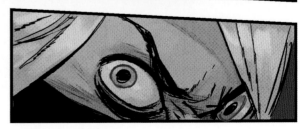

Page 4

1.
EXTERNAL SHOT – THE HOUSE OF
SLAUGHTER.

AARON (off): AIIIIEEEEEEEEEEEE!!!!

2.
CECILIA and JESSICA burst out of the
door to the Dragon's Office.

CECILIA: What on Earth is going on
out here?

3.
AARON is curled up on the ground
clutching his crotch. ERICA is
standing, looking back over her
shoulder.

AARON: She kicked me IN THE BALLS!

4.
JESSICA laughs HARD, even though
she knows she shouldn't. She can't
help herself. CECILIA is stern and
disapproving.

JESSICA: Hah!

CECILIA: For the love of god.

5.
But then ERICA sees something... And
her eyes go wide.

6.
WE SEE THE OLD DRAGON through
the crack in the door... Watching.
Impatient.

7.
And the door SHUTS.

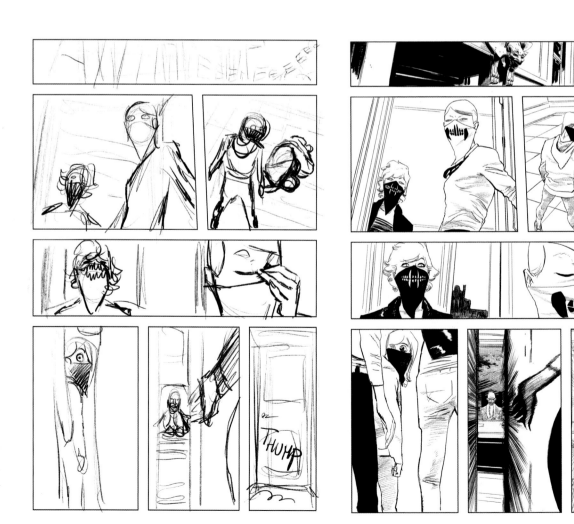

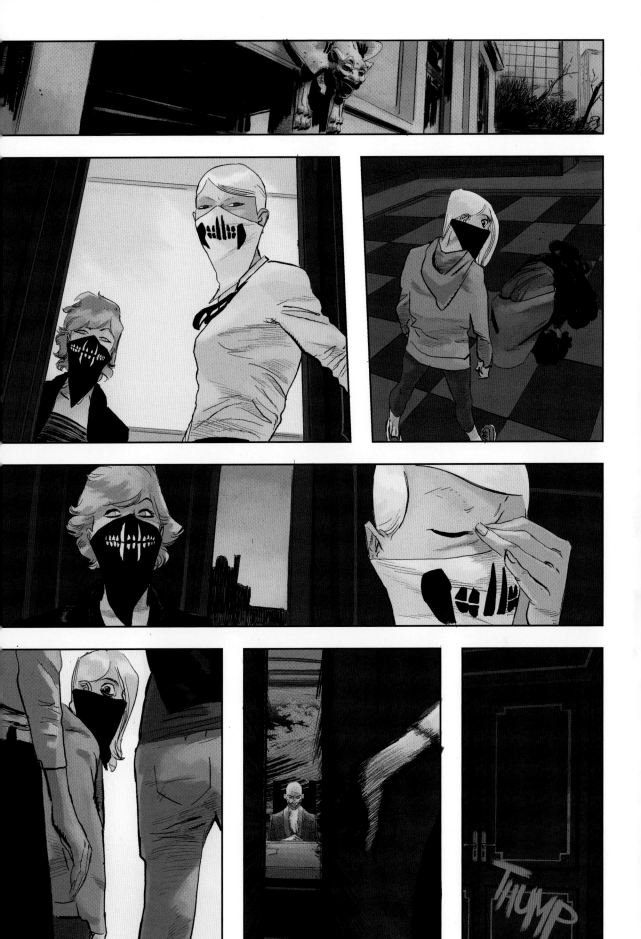

THUMP

Page 5

1.
ERICA looks up at JESSICA, partially
apologetic.

ERICA: You said I could bully him.

JESSICA: I meant more like you can
make fun of him a little, once you
get to know him.

ERICA: Oh, okay.

2.
JESSICA helps AARON off the ground.
ERICA grabs the tupperware from the
bench.

JESSICA: Both of you, follow me back
to our room.

3.
AARON is still angry and disheveled.

AARON: I don't want to go anywhere
with her.

4.
JESSICA does not have time for that.

JESSICA: Cut it out, Aaron. I'm not
in the mood.

5.
CECILIA stands, arms crossed by the
door to the Dragon's Office.

CECILIA: The car will be ready at
6:00 A.M. tomorrow to take her to
the Farm.

6.
TIGHT on JESSICA'S stressed face.

JESSICA: Yeah.

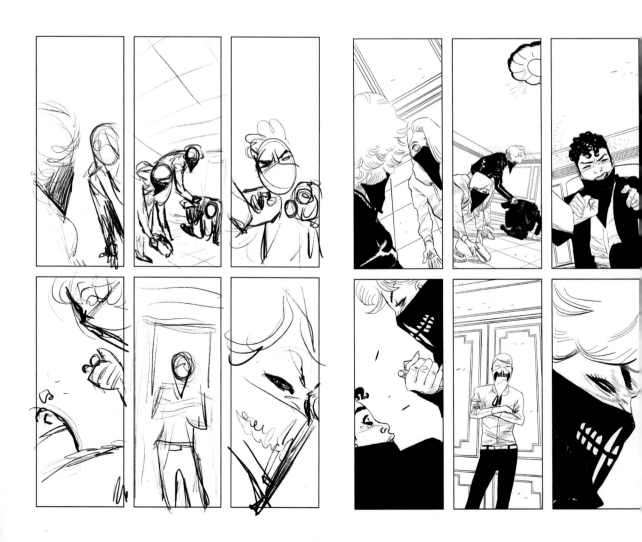

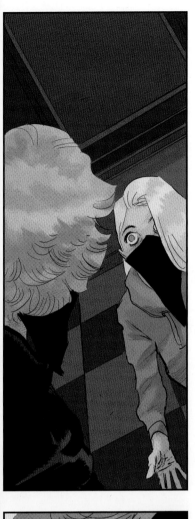
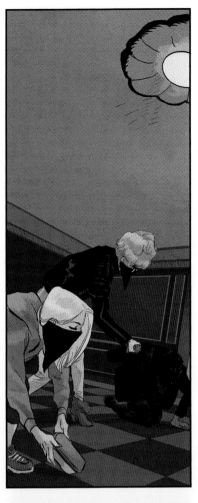
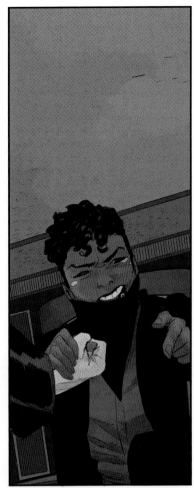
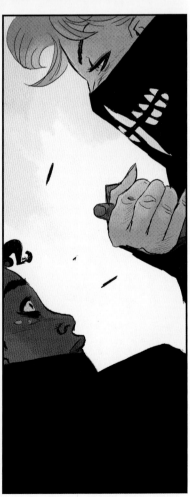

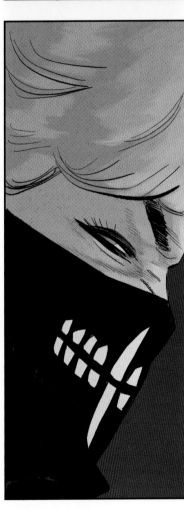

THE ROAD TO TRIBULATION

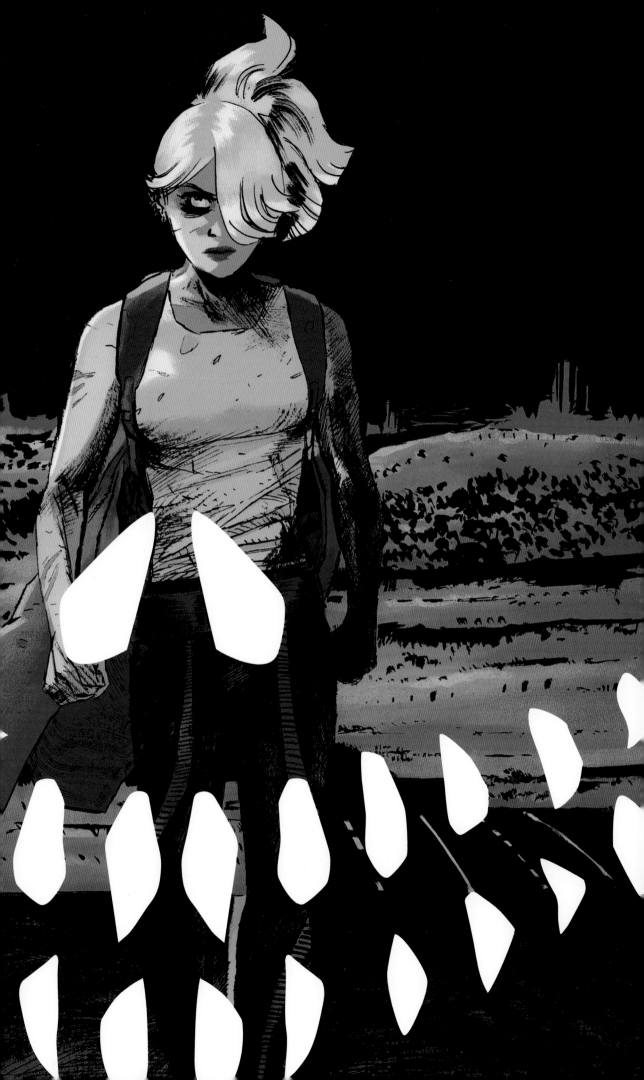

ON CREATING CHARLOTTE CUTTER

ABOVE
ISSUE #24 PAGE 22 PANEL 5

❝ One of the big things that we started talking about when building up towards our second big story cycle, the Tribulation Saga, was how to create the perfect opposite to Erica.

Obviously, this is funny because I have so much history with Batman, but I never thought of it in Batman terms—I always said, *Erica Slaughter is our Wolverine and it's time to give us our Sabretooth*. Who can be a version of Erica that is just so twisted, and so, so much her opposite in every possible way, that they are this absolute inversion?

And that was a really fun prompt, because at that point we had seen all of these characters from the House of Slaughter, and we had seen how they operate as a reflection of Erica. Erica represents the common people and doesn't give a shit about the Order; they represent wealth and power and adherence to the Order. She cares about human lives and she's willing to break all the rules to care for people.

Cutter is also a character who is willing to break all of the rules, but she does not care about human life. She does not care about *any* life. She is a very dangerous psychopath who enjoys hurting people and enjoys seeing the different ways that she can push them. Yet she is also one of the most capable Black Masks in the entire Order of St. George.

Cutter is our first glimpse of one of the international houses in the Order of St. George: the House of Cutter, which operates out of London, England. And she's this British character who comes from the upper-class world that is built into the Order of St. George—she is a creature of the "system," but even in being a creature of the system, you see that she needs to be handled and contained.

And that was a lot of the fun, building her into this dangerous opposite force to Erica that I knew we needed to elevate the second cycle. **❞**

-JAMES

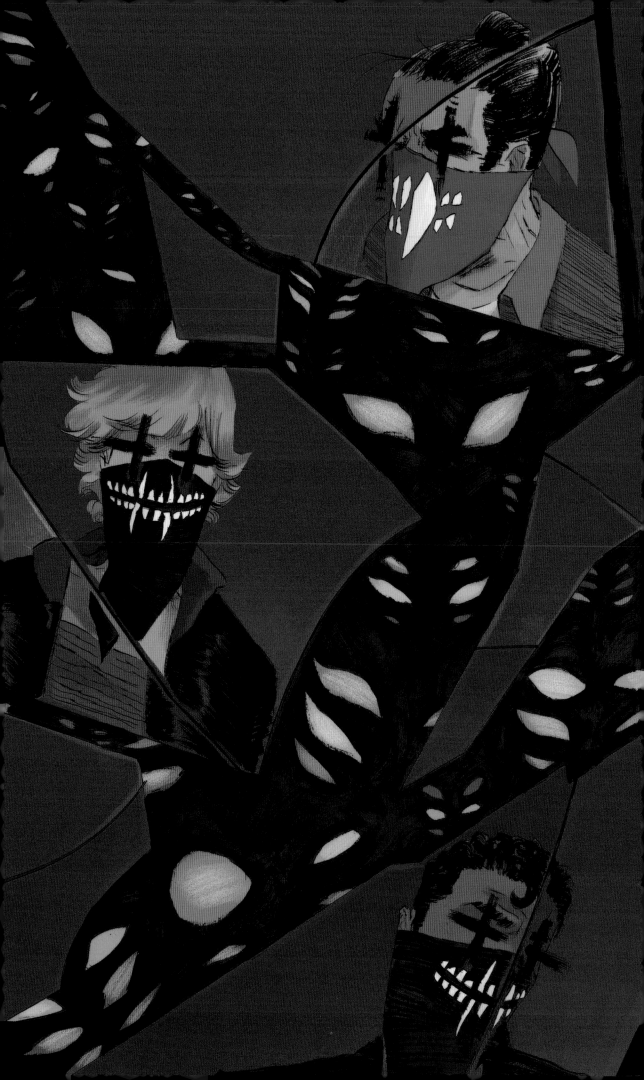

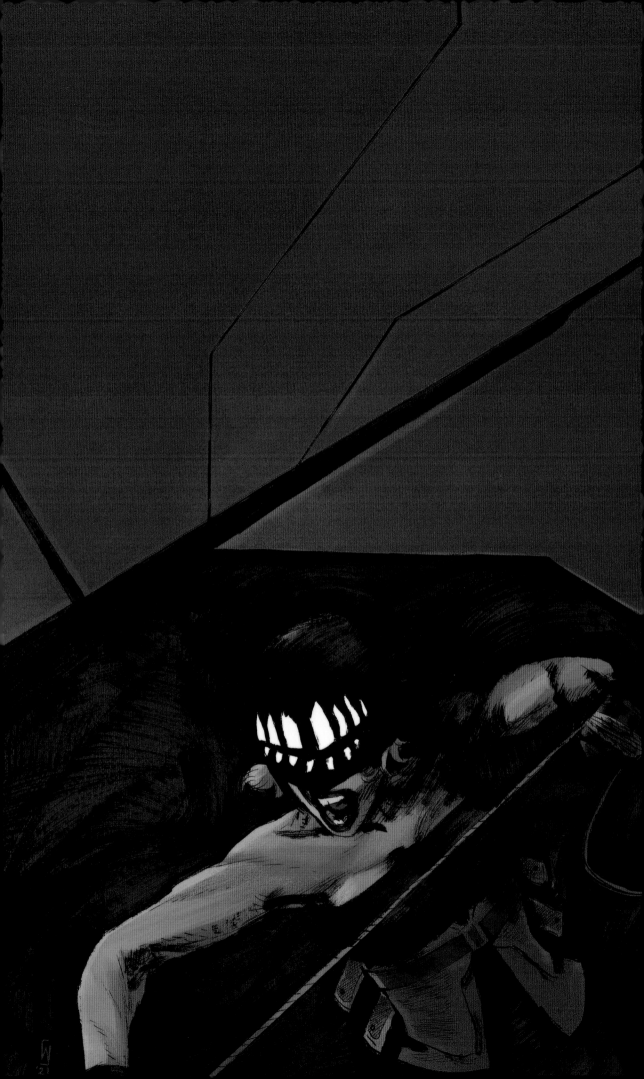

" Cutler, Cutler. What to say? She is truly a butcher. A cruel and treacherous character. Amoral.

The idea of the bandana over the eyes came to me while we were imagining a bandana for the House of Butcher in New Orleans. At first, I was pressing for it to be the HoB bandana, but James liked it so much he said, *No! We'll save that one for later, for the villain in the new story arc.* And that ended up being the case, so I just had to create the character around the mask.

I worked on her more than a lot of the other characters. I was trying to give her a face, a posture, a vibe that didn't have anything friendly about it, but was still a little bit attractive even if it was in a saucy way. One of those people who kind of attract you but when you get close you realize it's too late to turn around and leave. It was fun to draw her, especially in her more feral expressions. "

-WERTHER

 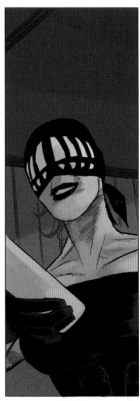

RIGHT
ISSUE #23 COVER BY WERTHER DELL'EDERA & MIQUEL MUERTO

FOLLOWING, LEFT
ISSUE #21 COVER BY WERTHER DELL'EDERA & MIQUEL MUERTO

FOLLOWING, RIGHT
ISSUE #21 VARIANT COVER BY PEACH MOMOKO

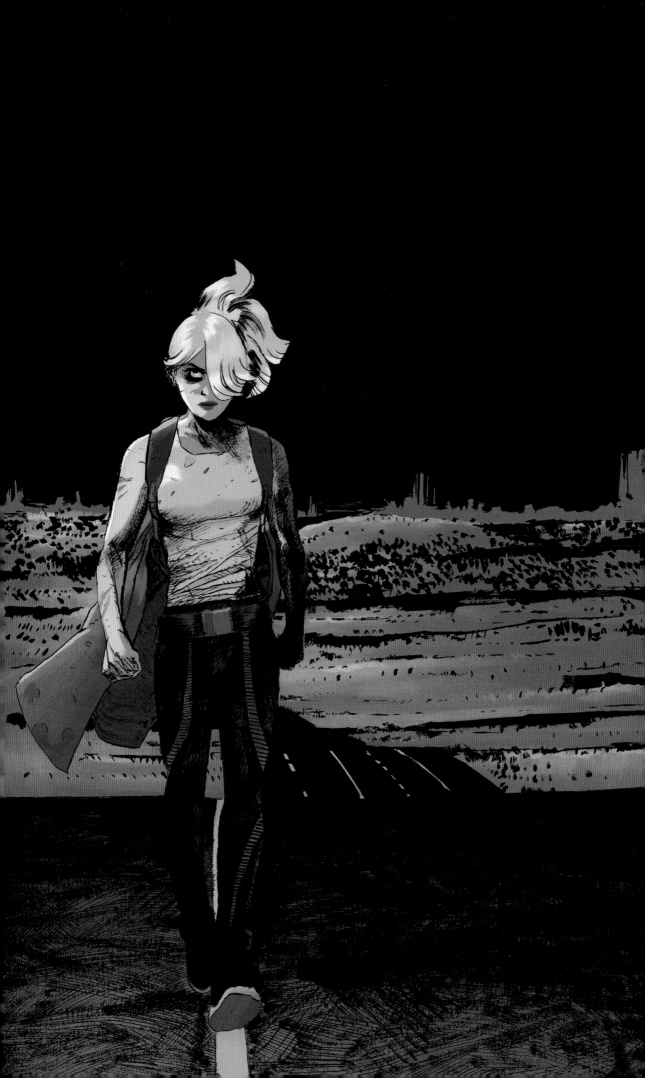

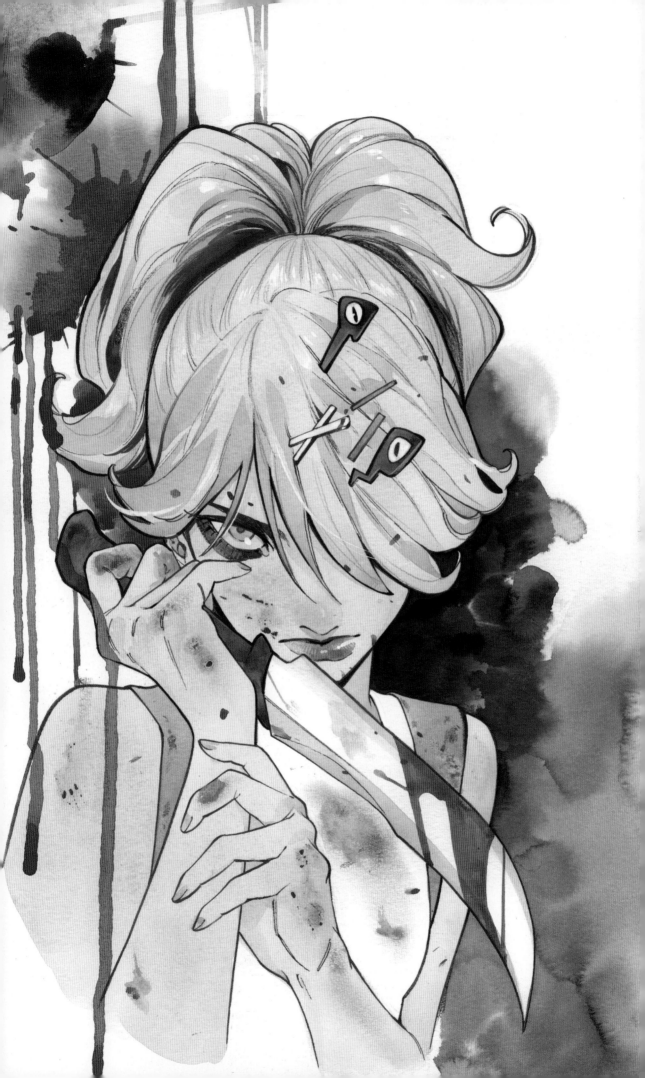

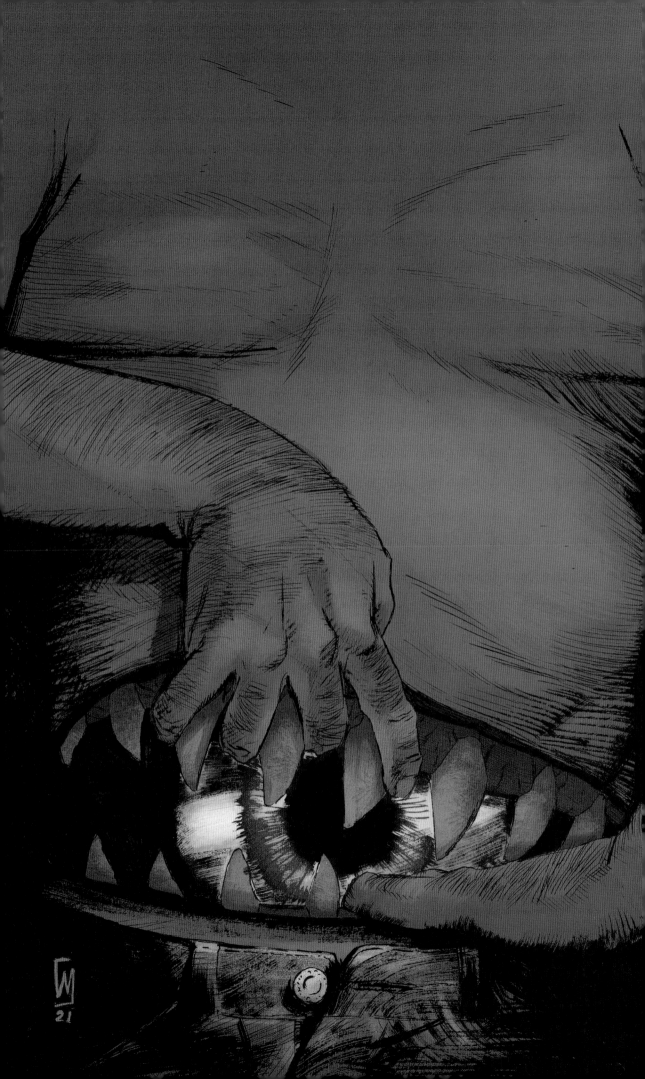

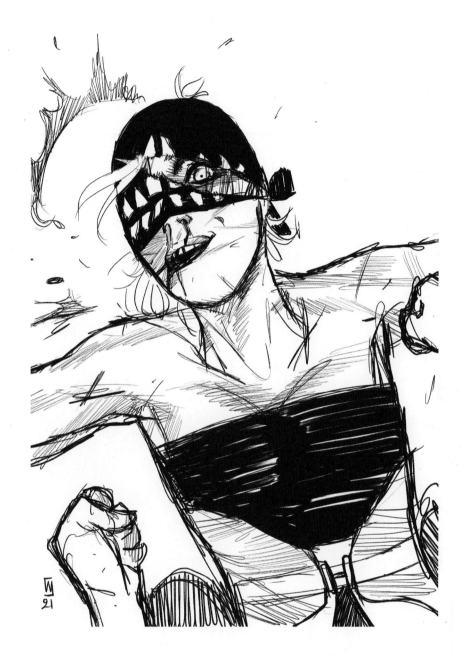

" WHO CAN BE A VERSION OF ERICA
THAT IS JUST SO TWISTED, AND SO,
SO MUCH HER OPPOSITE IN EVERY
POSSIBLE WAY, THAT THEY ARE THIS
ABSOLUTE INVERSION?**"**

-JAMES

LEFT
ISSUE #24 COVER BY WERTHER DELL'EDERA & MIQUEL MUERTO

FOLLOWING SPREAD
ISSUE #25 COVER BY WERTHER DELL'EDERA & MIQUEL MUERTO

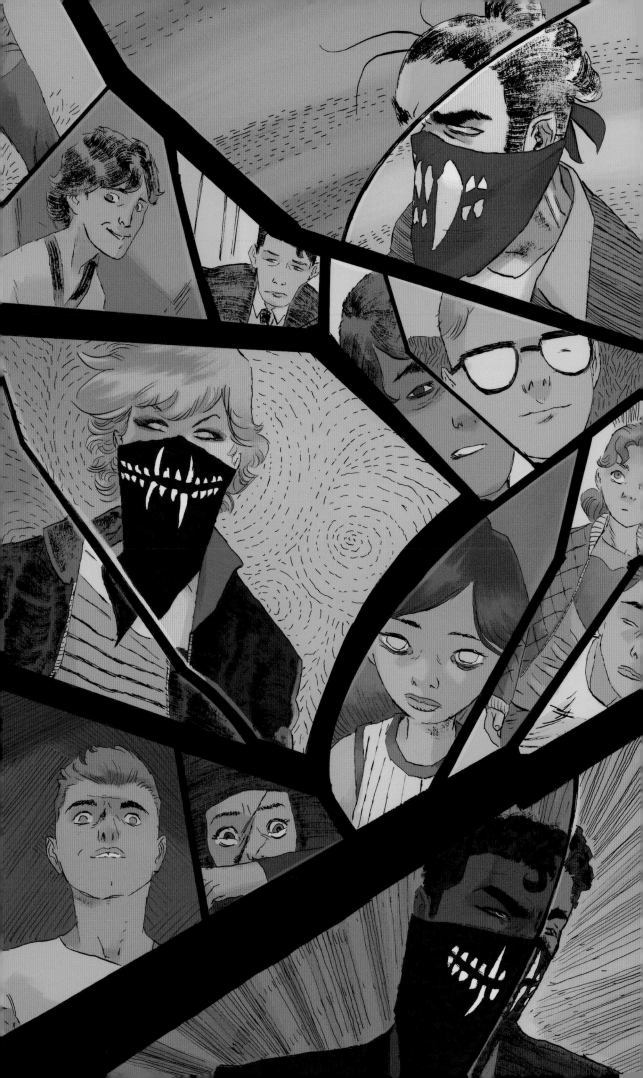

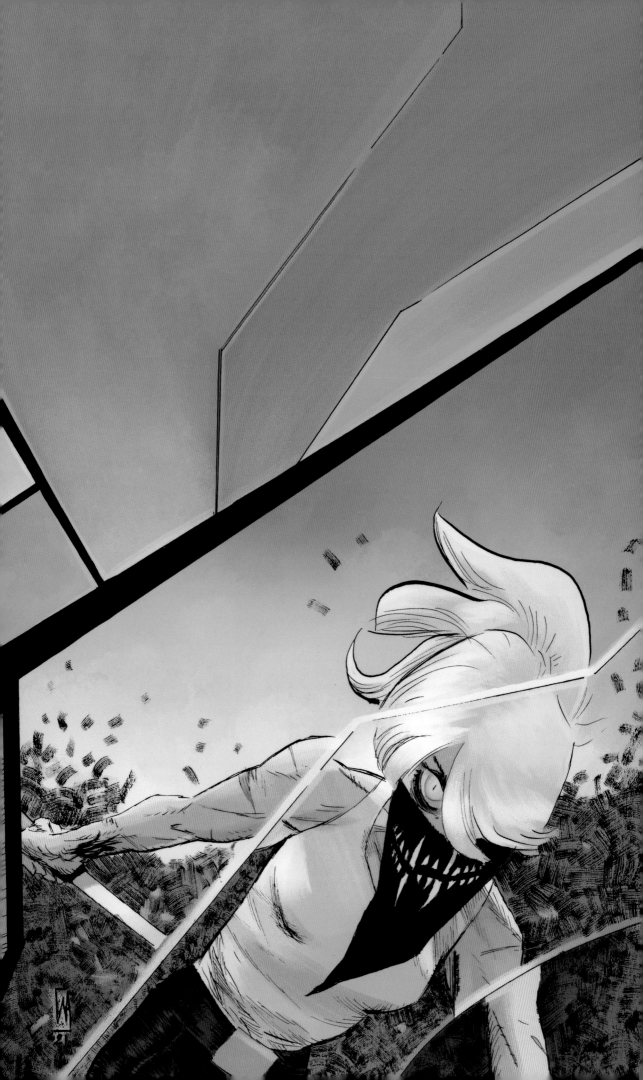

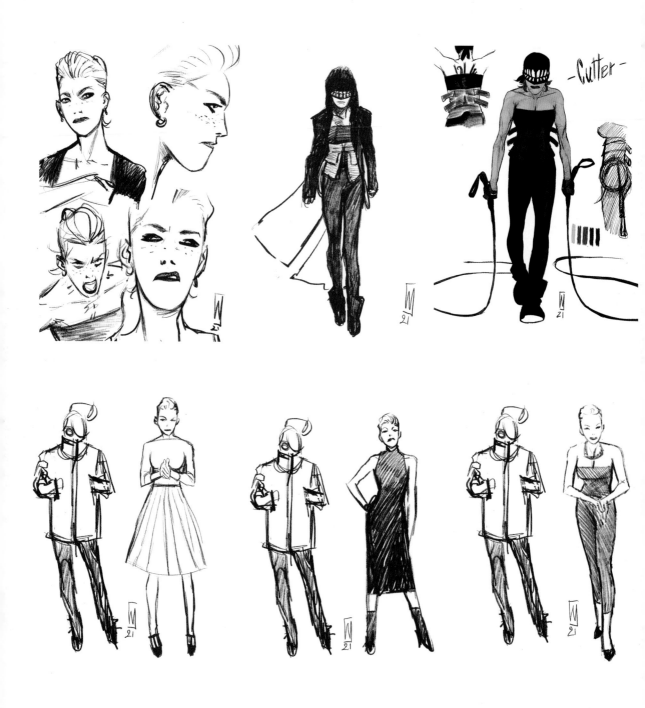

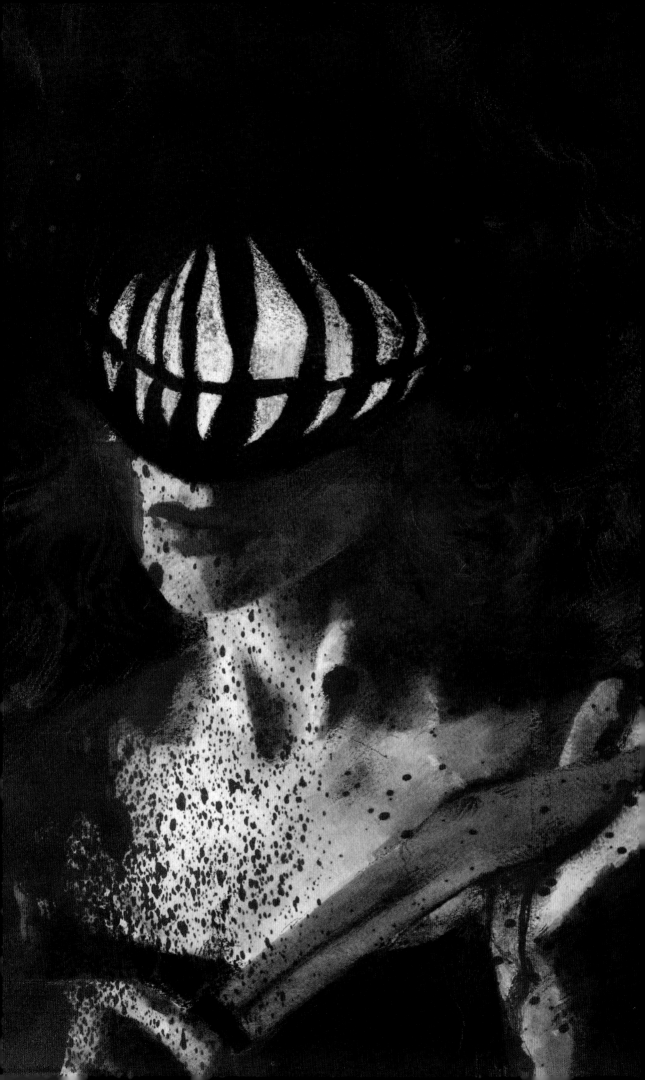

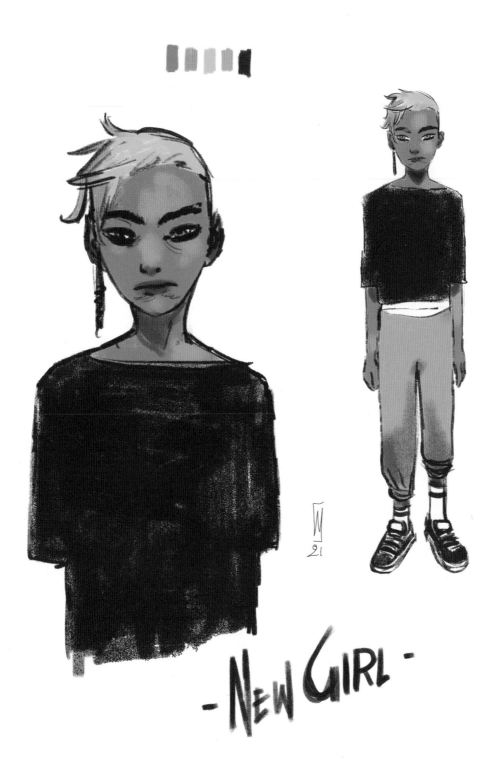

- NEW GIRL -

RIGHT
ISSUE #25 SECOND PRINTING COVER BY WERTHER DELL'EDERA

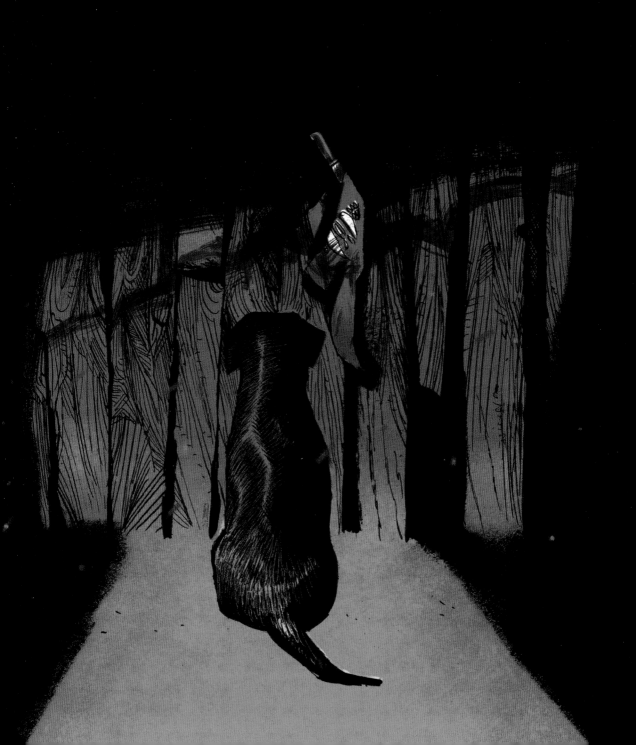

Page 16

1.
We see GABI walking along the back fence behind one of the hot springs.

2.
OCTO speaks up.

OCTO: It's in there.

3.
GABI looks at the fence.

GABI: Yeah?

OCTO: It's still feeding. You can still get it if you're quick enough.

4.
GABI looking along the side of the fence...

OCTO: What are you looking for?

GABI: All these teenagers like to sneak into the different springs around town. I heard one of them say there was a bit of the fence you could pull back here.

5.
We see a little FROG painted on the fence.

6.
She pulls the fence forward.

GABI: Wouldn't want to just hop the fence and come face-to-face with whatever's on the other side, right?

7.
She starts climbing through.

OCTO: Of course. Good thinking, Gabi.

OCTO: Just be quick now.

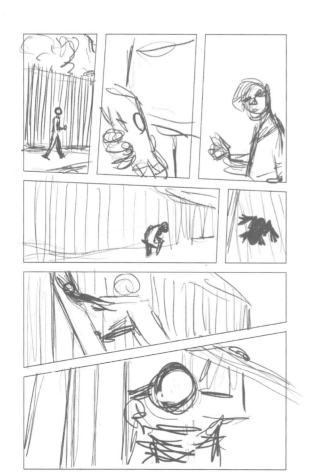

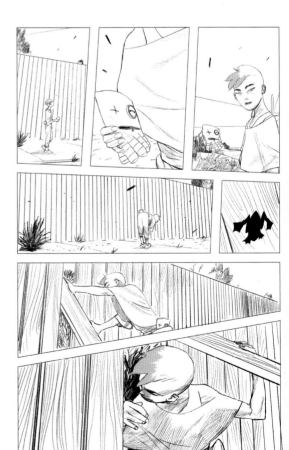

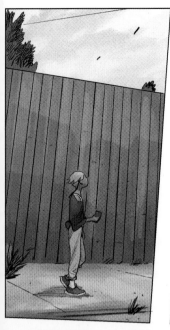
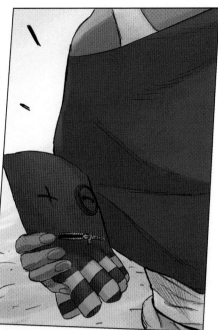
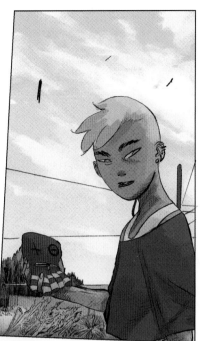

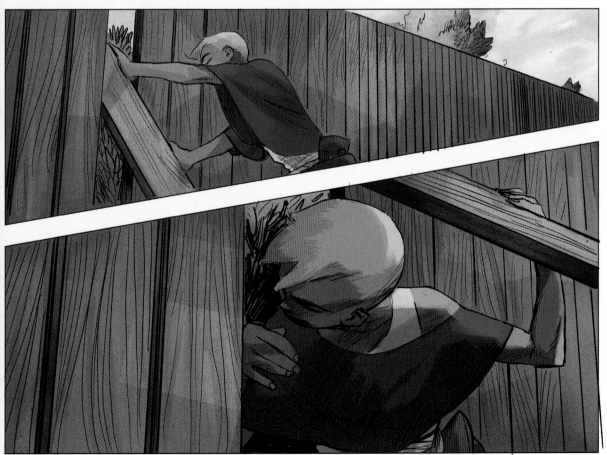

Page 17

1.
On the other side, she's in a bush...

2.
She stays close to the ground, crawling forward...

3.
She looks out...

4.
AND WE SEE THE DUPLICITYPE FEEDING ON ONE OF THE CHILDREN...
THE PARENTS ARE DEAD ON THE SIDE OF THE POOL... BLOOD IS
FLOWING INTO THE SPRING.

5.
GABI is HORRIFIED.

GABI: Oh fuck.

GABI: Fuck fuck fuck.

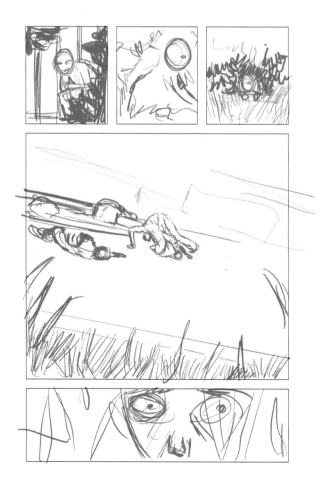
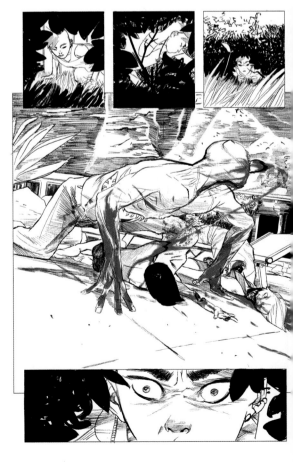

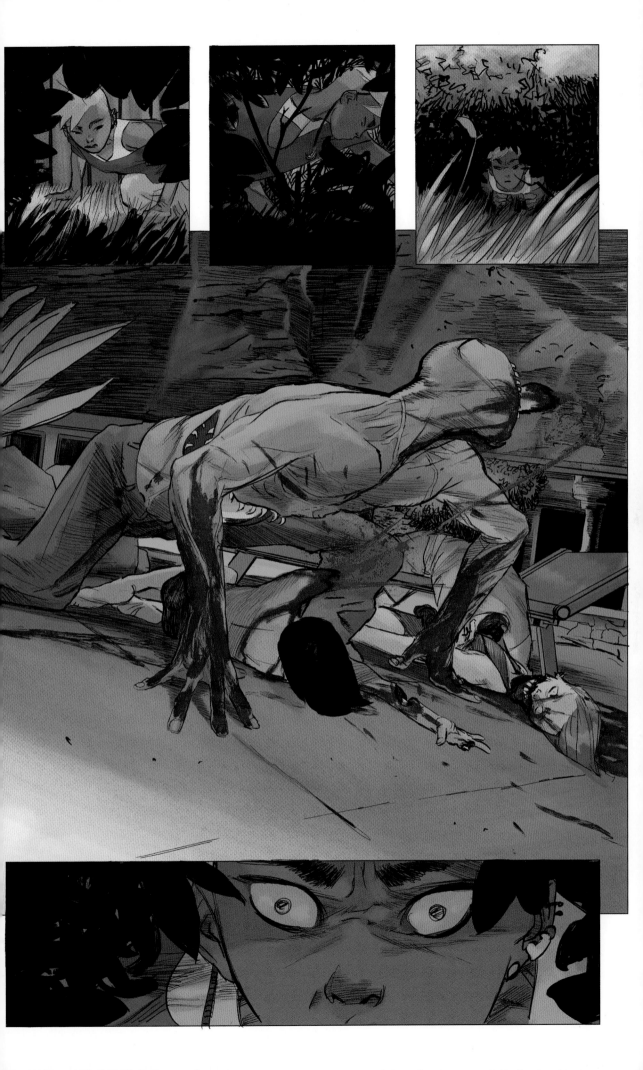

Page 18

1.
GABI holds up OCTO, desperate...

GABI: How do I kill it?

2.
BUT OCTO DOESN'T RESPOND.

3.
SHE SHAKES OCTO, ANGRY.

GABI: Why aren't you talking?!

4.
BUT THEN THE DUPLICITYPE LOOKS UP...

5.
AND TURNS TOWARD HER.

6.
GABI is SCARED OUT OF HER MIND.

GABI: Oh shit.

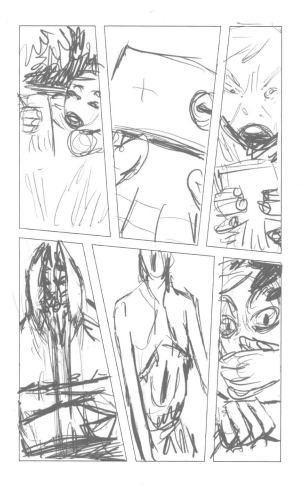

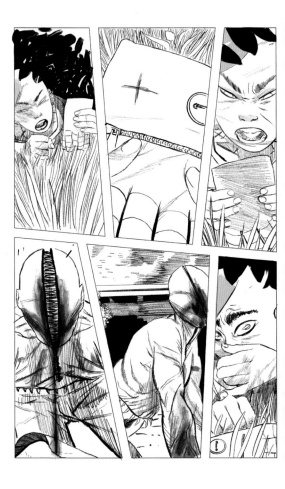

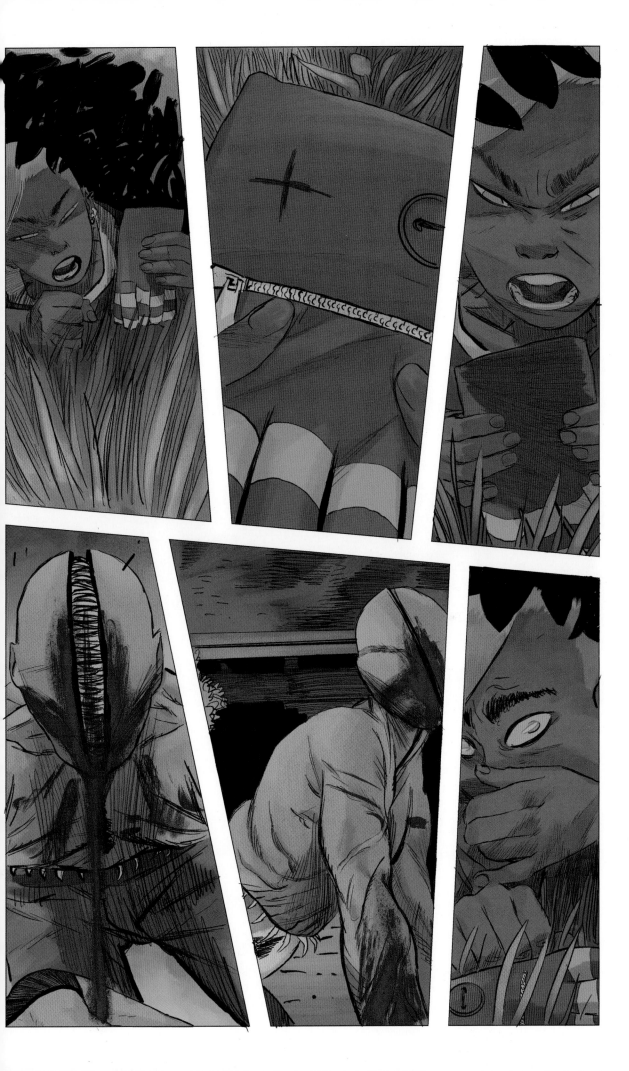

1.
It starts moving toward her.

2.
ITS MOUTH OPENS IN ITS TORSO.

3.
She's covering her mouth, trying not
to make any sound while she breathes.

4.
It's closer... Closer...

5.
She's convinced she's going to die.

6.
OCTO is watching, anticipating.

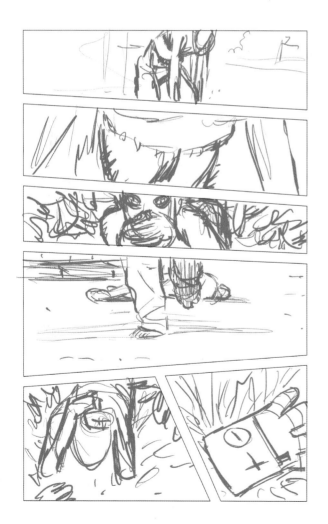

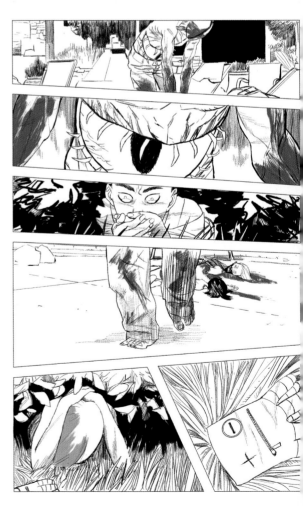

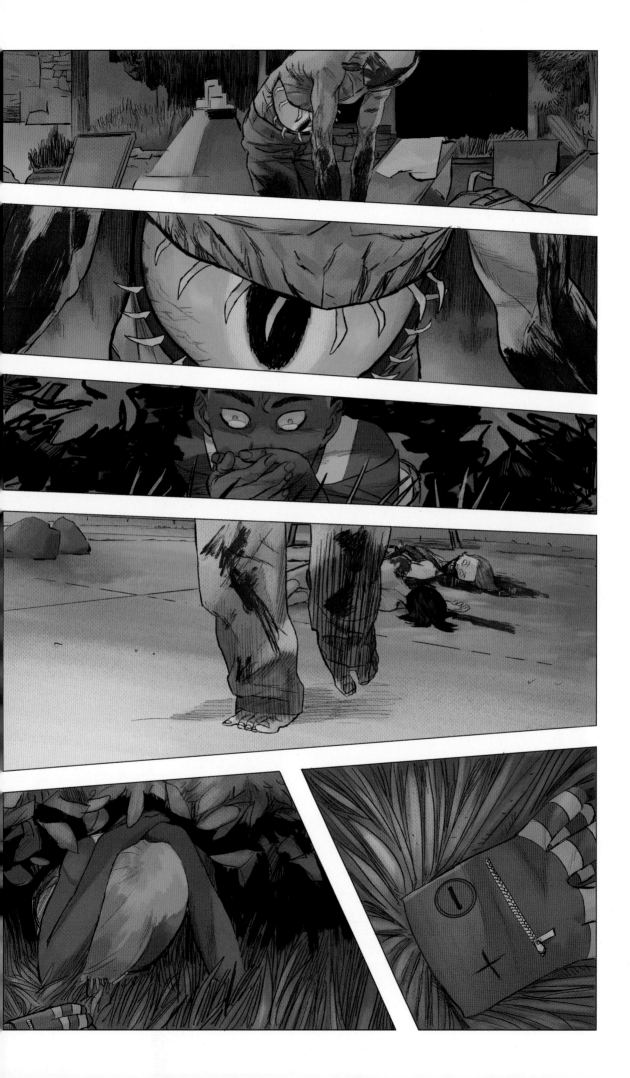

Page 20

SPLASH – ERICA ENTERS THE FRAY... SHE KICKS THE MONSTER
ASIDE. She is masked up, jacket off. LET'S GIVE THEM A
CLASSIC ERICA SLAUGHTER PAGE.

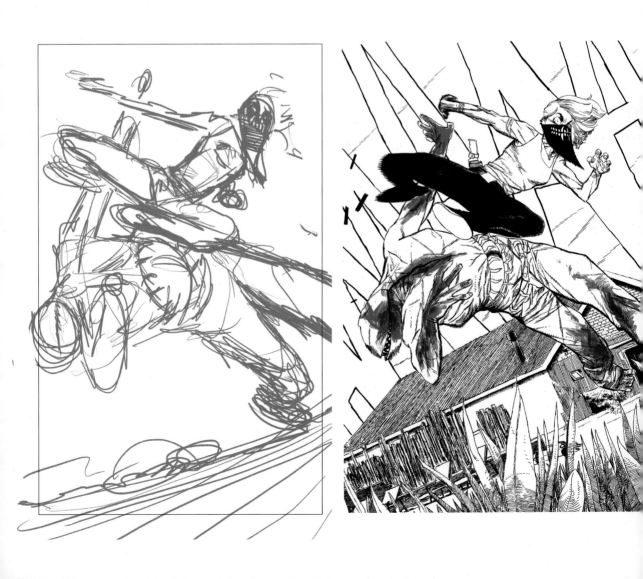

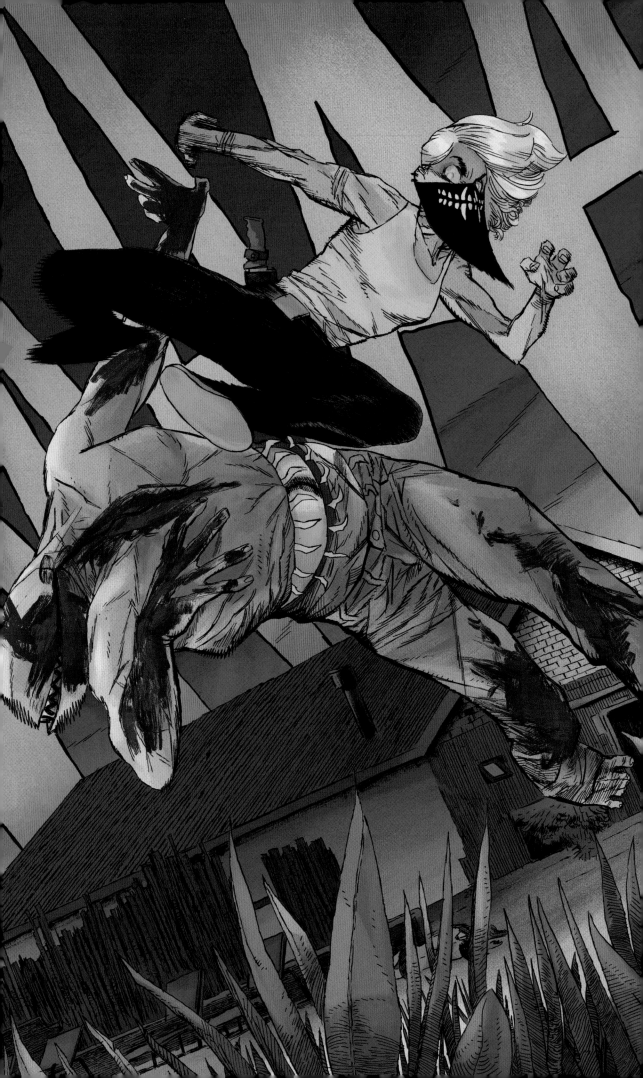

THE
GIRL AND THE
HURRICANE

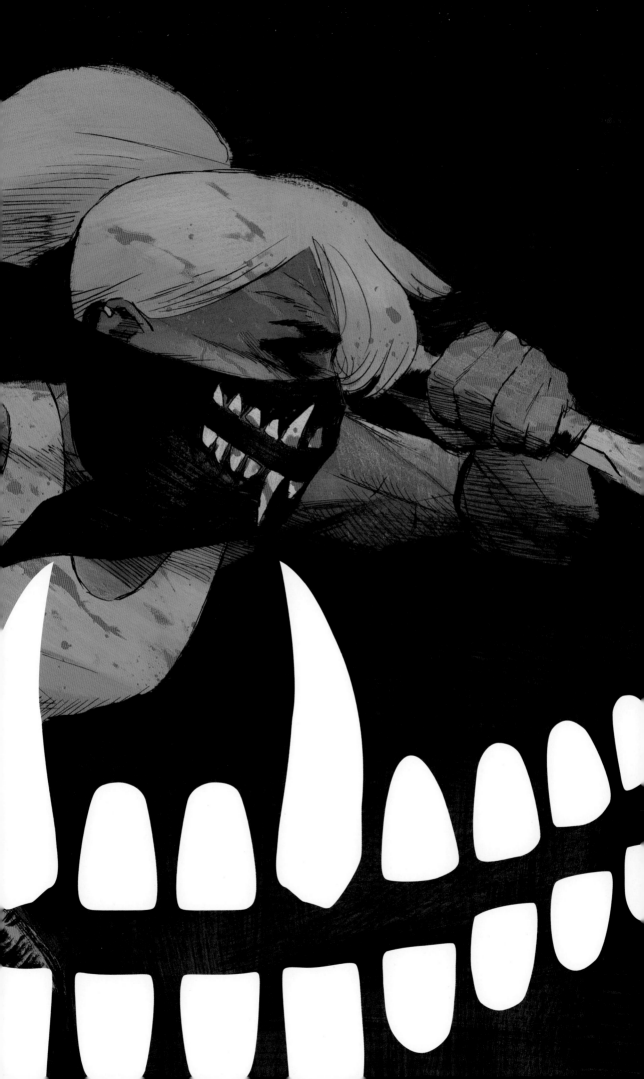

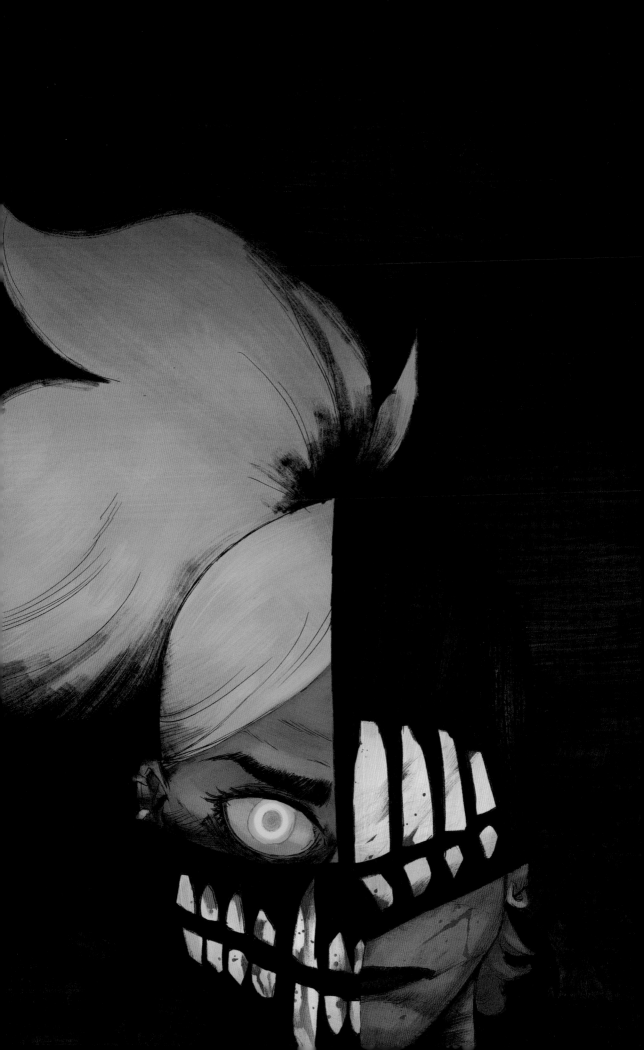

ON THE TRIBULTION SAGA

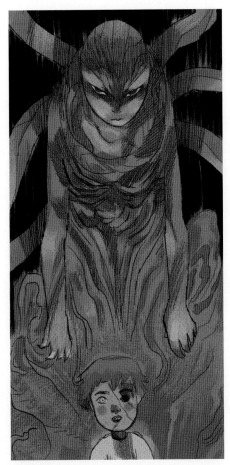

ABOVE
ISSUE #27 PAGE 19 PANEL 2

" One of the things that has always shaped my thinking about *Something is Killing the Children* is that I don't really see these as story arcs in a standard comic book way. I see each story cycle as a novel in and of itself.

Imagine that Erica Slaughter is the lead in a series of horror mystery novels. And each novel is meant to have its own setting. It's going to bring a new type of monster, and then a new threat, while continuing the larger story of Erica versus the Order of St. George. Yet the most important thing as we build all of that out is building the specificity of the location and the characters at play there. Because it's very easy, once you're deep into the mythology of the series, to take Erica and put her back front and center and just deal with her emotions and her life. But part of what made the first 15 issues of *Something is Killing the Children* work as well as they did is that it's much more James's story than it is Erica's. And so, when I was laying out the second story cycle, I decided to lean into that.

First, I talked to Werther about what we wanted to do with the setting, and Werther mentioned he loves Westerns. So that's where we got the idea of trying something in the American Southwest. We wanted to do something that could potentially put Erica on a horse, later in the story arc. And then we began to play with some of that imagery, and it really began to click that you can't get much further from the moody north woods of the upper Midwest than the wide open American Southwest.

And similarly, with Gabi, I wanted to create a character who was the furthest thing from James as we could possibly get. James is a kind of quiet, nerdy character—he just wants Erica's approval. With Gabi, I wanted to create a character who was going to be rude and who would push Erica back. Someone that Erica sees a lot of herself in. Someone who rejects authority as much as Erica does. And that's what Gabi is: someone who is so much like Erica that, naturally, Erica would have difficulty with her.

And through this, I was able to construct this entire world of Tribulation, New Mexico. And then, knowing that the central piece of the story is that Erica has now left the Order of St. George—and that the Order does not allow people to leave—they would need to deal with how dangerous Erica is as a rogue agent. And so they recruit one of the most dangerous hunters in the entire Order, Charlotte Cutter, and they unleash her on the American Southwest.

Alongside that, there is also an incredibly dangerous monster at play in the Duplicitype. The bigger danger, however, remains Cutter, and I think that's apparent from the first couple of issues. I really love the Tribulation Saga, and it obviously ends in a very dark place—it's sort of our *Empire Strikes Back* moment—but this is also a crucial point in Erica's larger journey. "

—JAMES

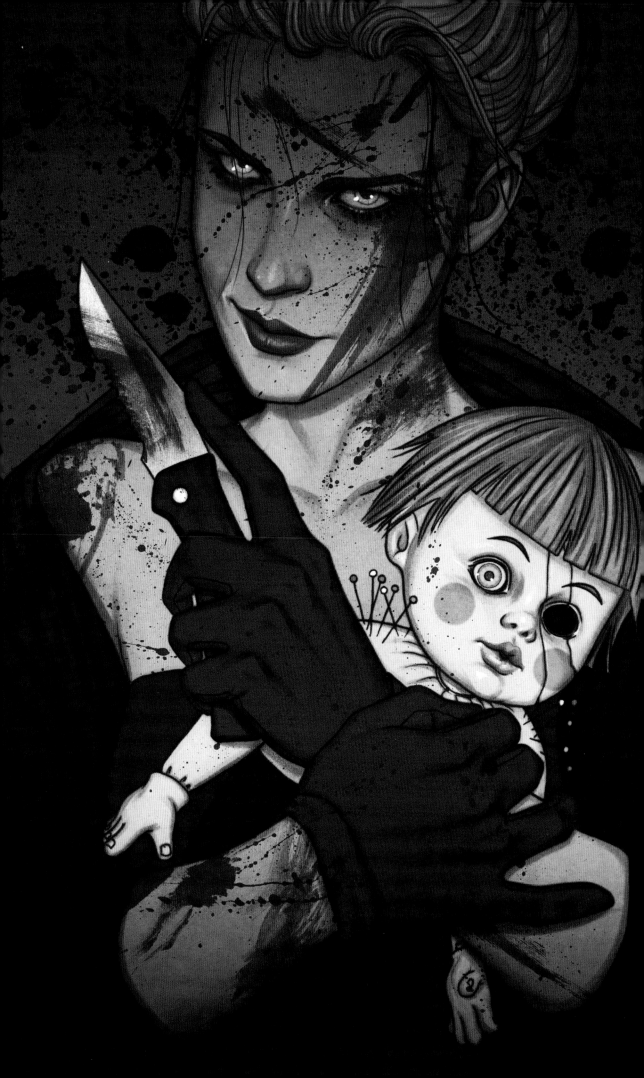

ABOVE
ISSUE #21 PAGES 6-7

BELOW
ISSUE #30 PAGE 12 PANEL 7

" Tribulation! I asked James if it was possible to set the second story arc somewhere reminiscent of a Western, maybe somewhere between Texas and New Mexico, and James was kind enough to accommodate me with the creation of Tribulation.

I had so much fun drawing the desolation of a place like this, and its empty, dusty streets. The big sky that seems to kind of crush you. Everything still alive, but at the same time a little dead. The hot spring waters. The worn-down houses. Everything a little out of time. One of those places where if you die, it takes people a while to realize you're gone from sight.

It's here that Erica faces something unimaginable that will cause a crack so deep that it will almost break her. It is a very distressing story arc. Oppressive. There is a new monster, in fact we might say there are two, and you don't know which is scarier. One is horrible and driven only by its predatory instinct, and the other is a creature of children's nightmares. It is a parable that shows once again how everything is capable of going wrong despite all the best intentions in the world. And whether pain is caused voluntarily or involuntarily, it's still something to be reckoned with, always. **"**

-WERTHER

RIGHT
ISSUE #26 COVER BY WERTHER DELL'EDERA & MIQUEL MUERTO

FOLLOWING, LEFT
ISSUE #28 VARIANT COVER BY ZOE LACCHEI

FOLLOWING, RIGHT
ISSUE #27 VARIANT COVER BY ZU ORZU

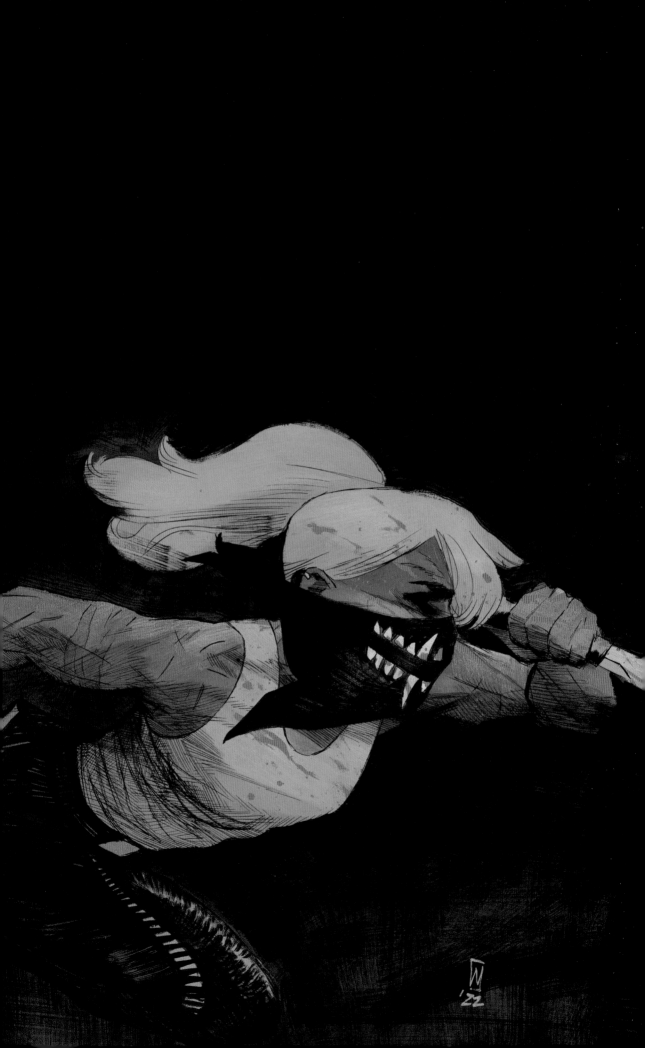

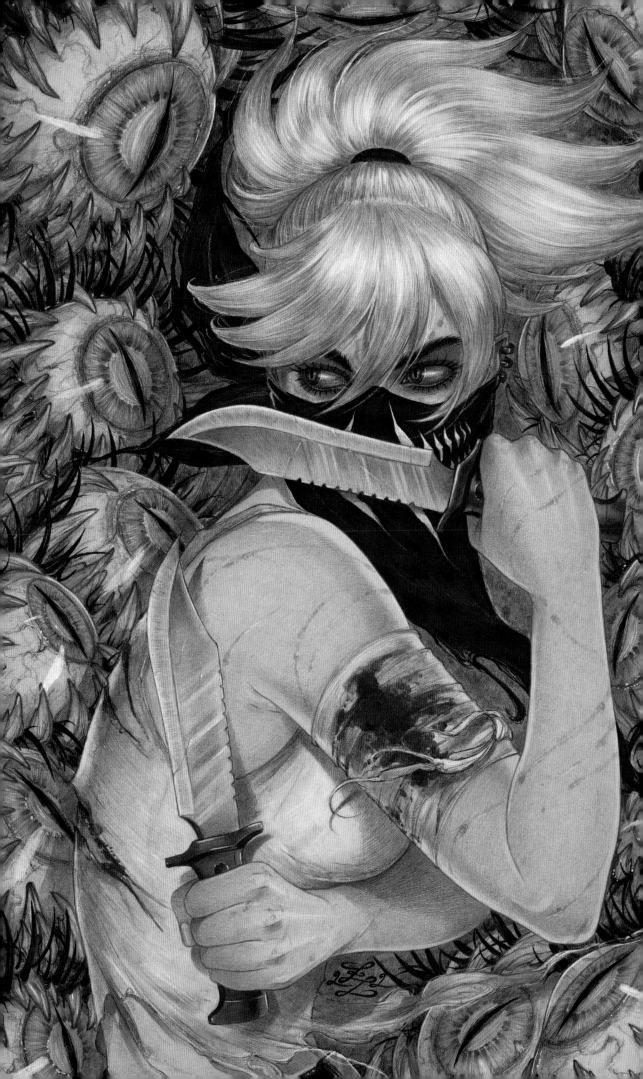

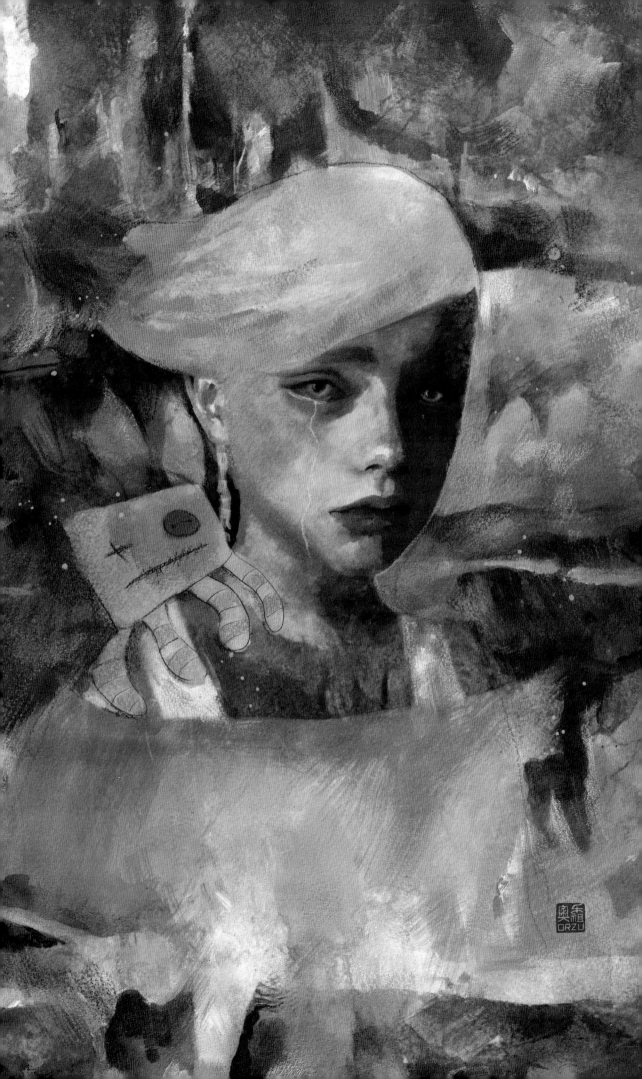

JAMES:

What moment in the series so far was the most emotional for you to draw?

WERTHER:

There are so many sequences in *SIKTC* that I found extremely exciting.
Erica's first appearance. The scene with the principal. The first chat between
Erica and James at the end of the first issue. Tommy's scenes, first with
his mother and then with his father. Tremendous, painful ones. Aaron's
and Cecilia's first appearances. Some of the fight sequences. There are so
many. Generally, the ones that excite me the most are the ones where the
characters are acting, the ones where acting and storytelling mix.

LEFT
ISSUE #27 COVER BY WERTHER DELL'EDERA & MIQUEL MUERTO

FOLLOWING, LEFT
ISSUE #27 VARIANT COVER BY FABRIZIO DE TOMMASO

FOLLOWING, RIGHT
ISSUE #29 VARIANT COVER BY MARCO MASTRAZZO

159

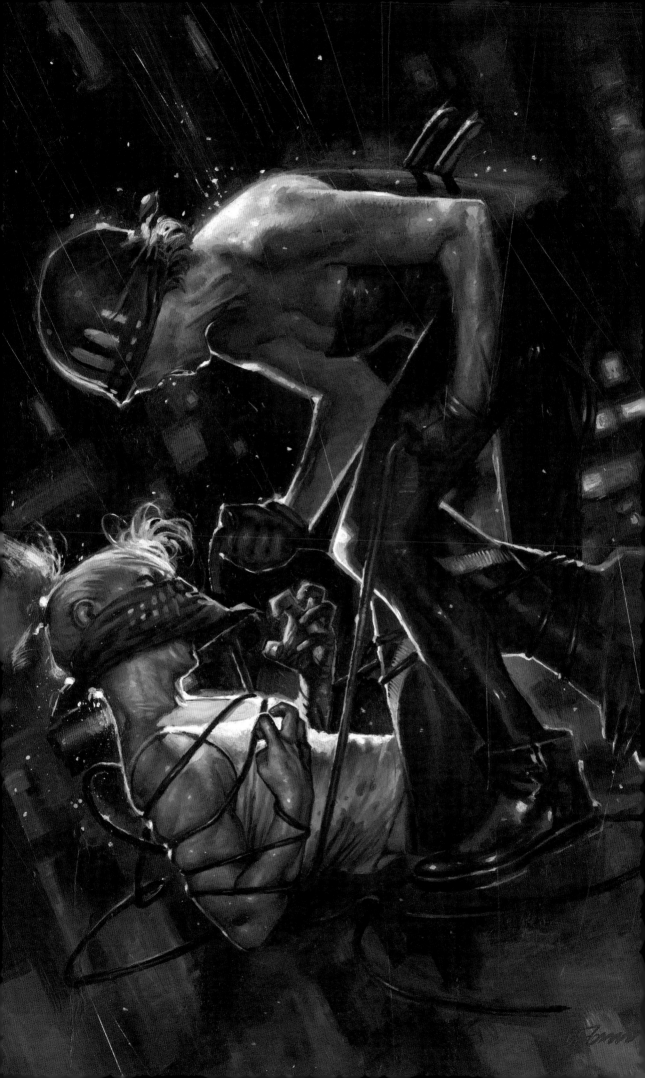

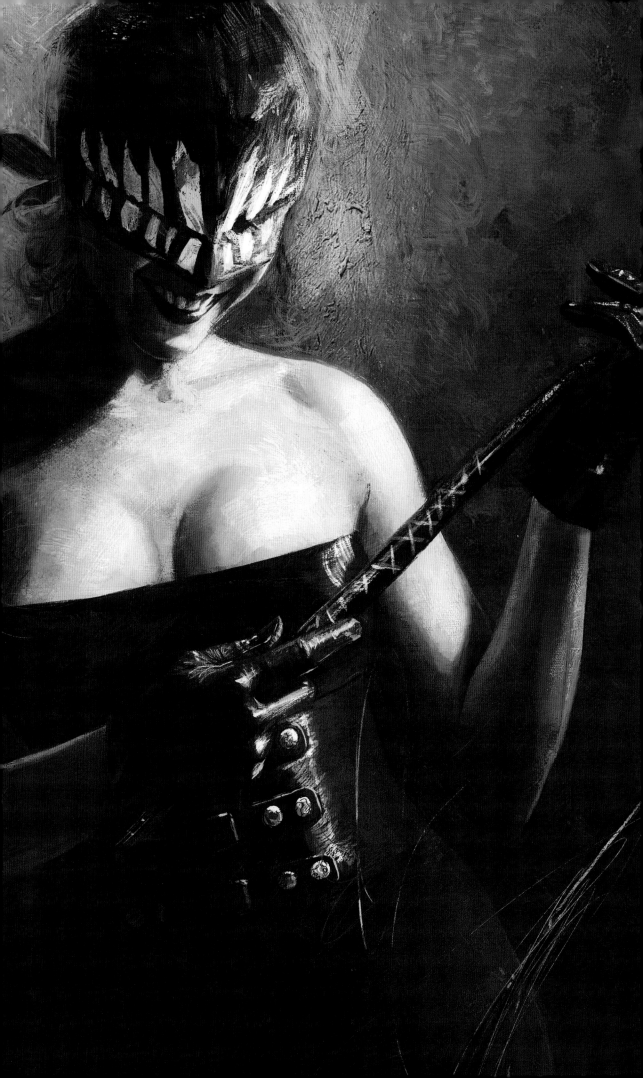

- CARTER THOMAS -

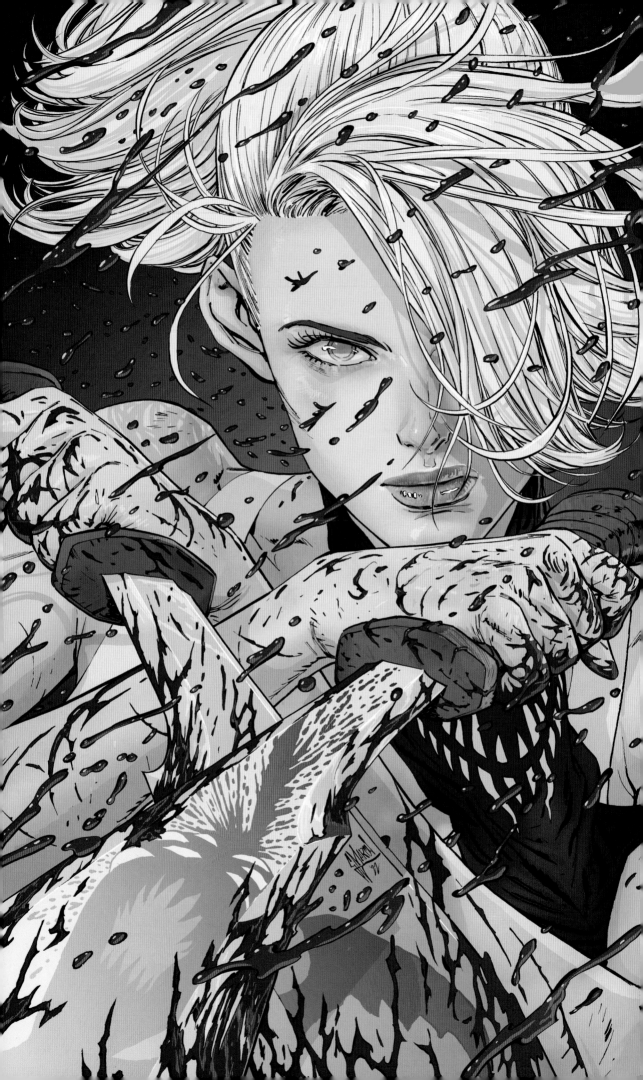

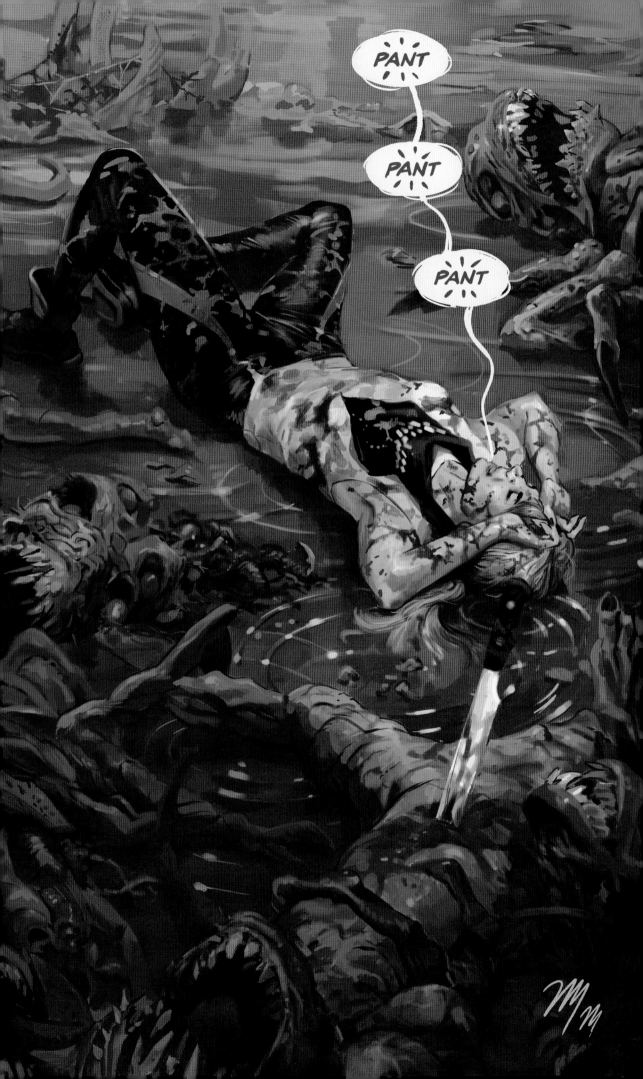

"IT IS A PARABLE THAT SHOWS ONCE AGAIN HOW EVERYTHING IS CAPABLE OF GOING WRONG DESPITE ALL THE BEST INTENTIONS IN THE WORLD."

-WERTHER

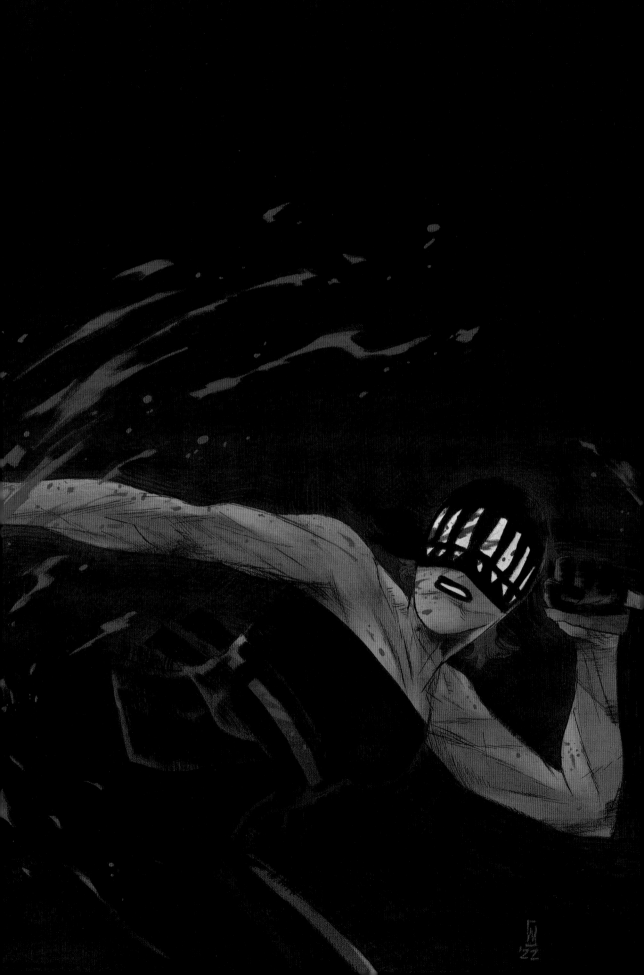

Page 15

1.
WE CUT TO A DARK ROOM... and see a YOUNG
BOY, whose mouth has been DUCT-TAPED shut.
He's in his clothes, sitting in a hot tub.
The water is up to his chest and we can
see his body is tied up, too. He's afraid
for his life and he should be.

NOTE: We're in a hot spring here with
indoor pools, and the lights are off. It
should be VERY DARK and moody in here.
Heavy inks. We'll turn the lights on in a
few pages.

BOY: Mmmph

BOY: Mmmmmmph!

2.
CUTTER is pacing around the hot tub.
She's on her cell phone. She is NOT in
her "costume" --she's dressed in the same
outfit we saw her speak to Sheriff Thomas
in.

CUTTER: Oh, that's excellent news.

3.
She continues pacing around the child.

CUTTER: Hold her when she arrives
at the station. I'll be there very
shortly. Excellent work, Sheriff
Thomas.

4.
We see that DOLLY is seated on a chair
a few feet back from the pool.

DOLLY: It's near.

5.
THE BOY is trying to SCREAM through
the tape.

BOY: MMMMMPH!

BOY: MMMMMM!!!

6.
CUTTER scowls down at the kid.

CUTTER: I'm seeing to a related matter.
Don't you worry yourself. I'll be there
soon.

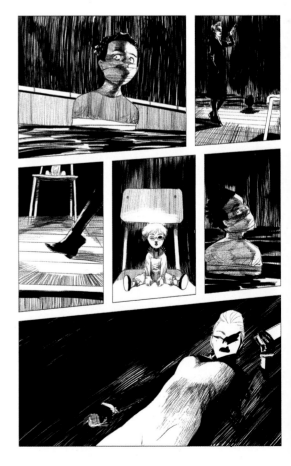

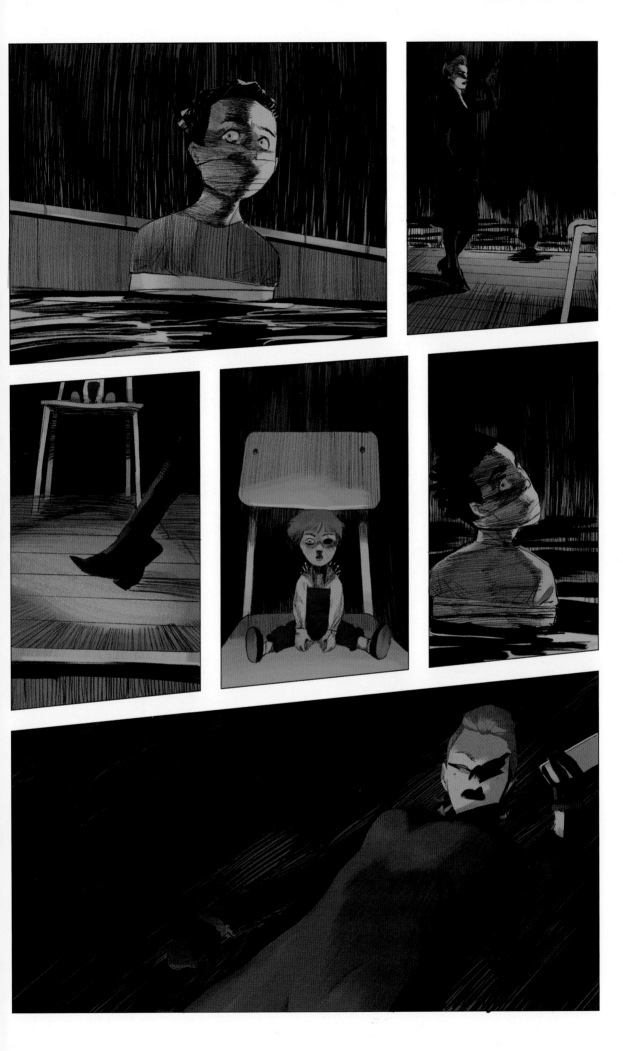

1.
SHE HANGS UP, addressing the boy.

CUTTER: What a naughty, naughty boy. I've told you all about what sorts of bad things happen when you misbehave.

2.
And then she crouches down behind him, to whisper in his ear.

CUTTER: Look. Over there in the shadows. Do you see it?

3.
We see the BOY's POV... Something MAN-SHAPED is moving through the shadows on the other side of the room. A DUPLICITYPE.

CUTTER: It knows every bad thing you ever did.

CUTTER: It's angry, and it's hungry.

4.
SHE WHISPERS IN HIS EAR, enjoying making him more and more afraid, and more appetizing for the monster.

CUTTER: And you're nice and warm, aren't you? Perfect to eat.

5.
THE BOY is giving up hope, more scared than he's ever been in his life.

CUTTER: Mommy and Daddy aren't coming. They won't even know you're missing until you're long gone.

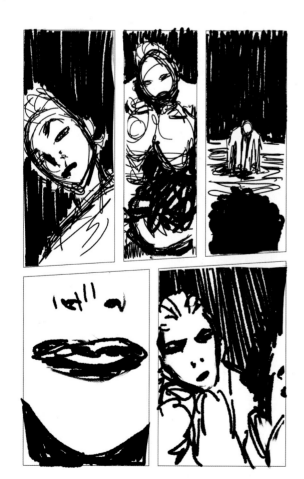

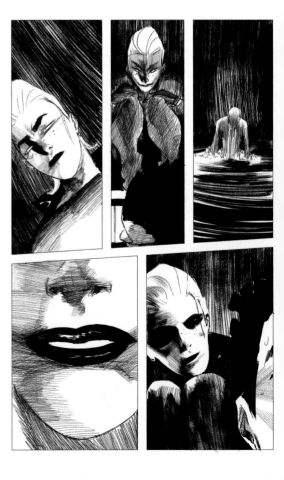

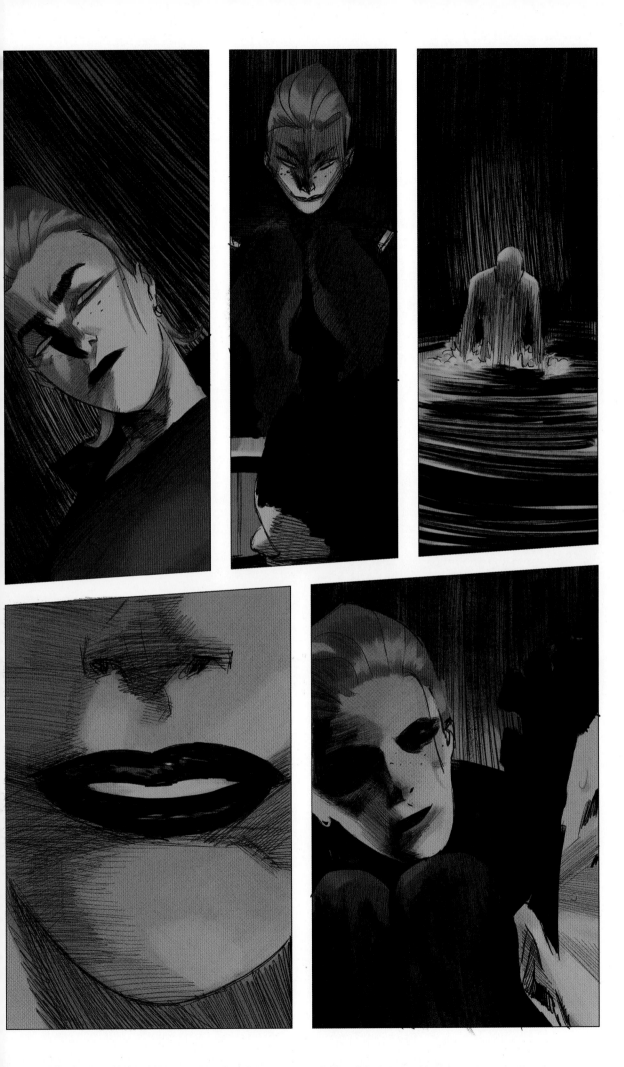

1.
THE BOY is SOBBING, looking on as the
MONSTER moves closer in the shadows.

2.
CUTTER steps back. Smiling. Waiting.

3.
The MONSTER enters the water.

4.
THE BOY looks up at it, wanting to plead
for his life. Wanting to run. But he
can't.

5.
CUTTER smiles.

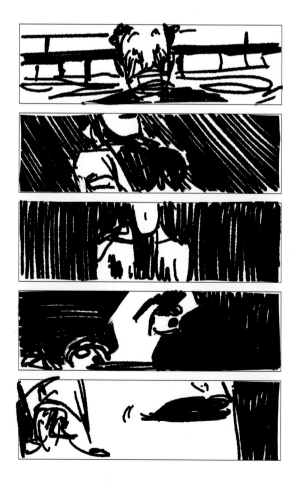
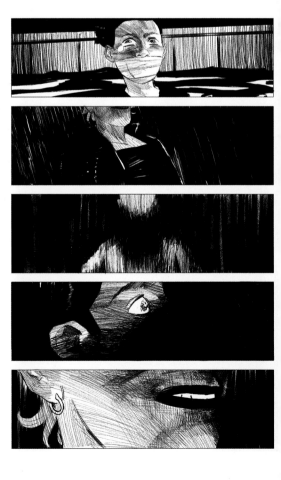

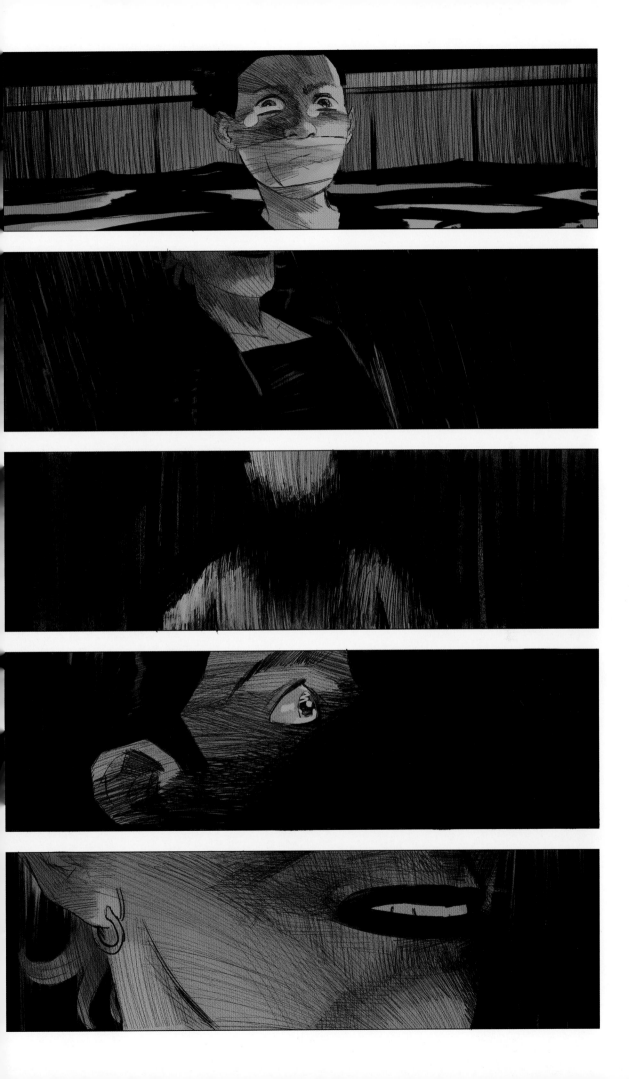

SPLASH - THE DUPLICITYPE'S CHEST OPENS, REVEALING
ITS MOUTH... IT'S ABOUT TO EAT THE BOY!

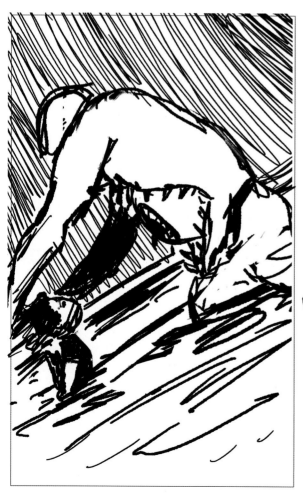
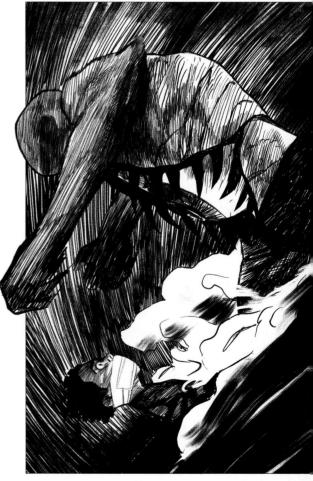

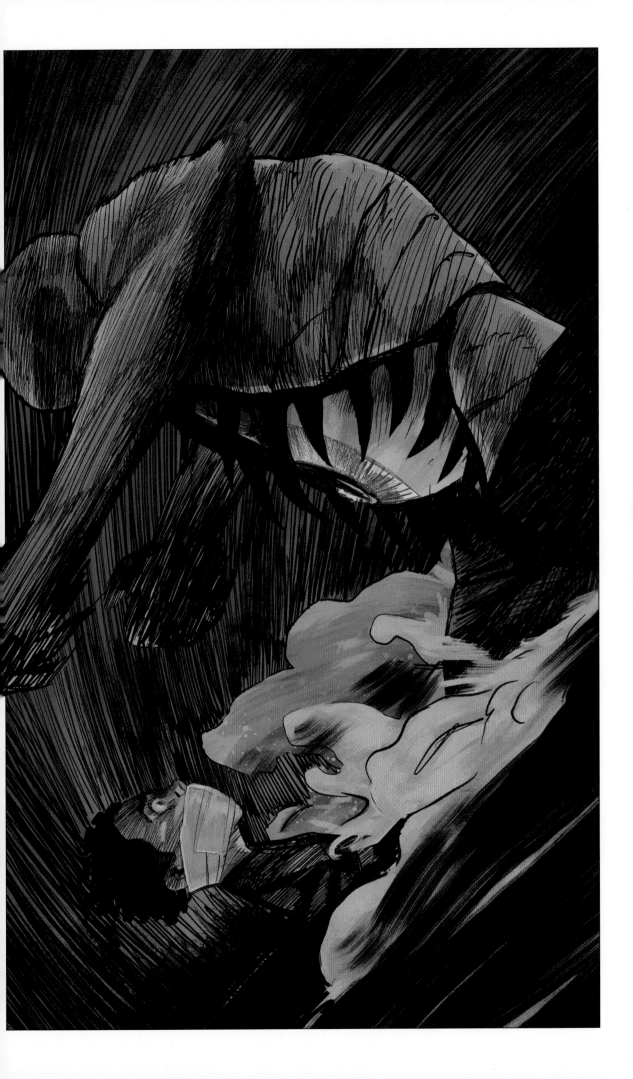

SHOWDOWN AT THE EASY CREEK CORRAL

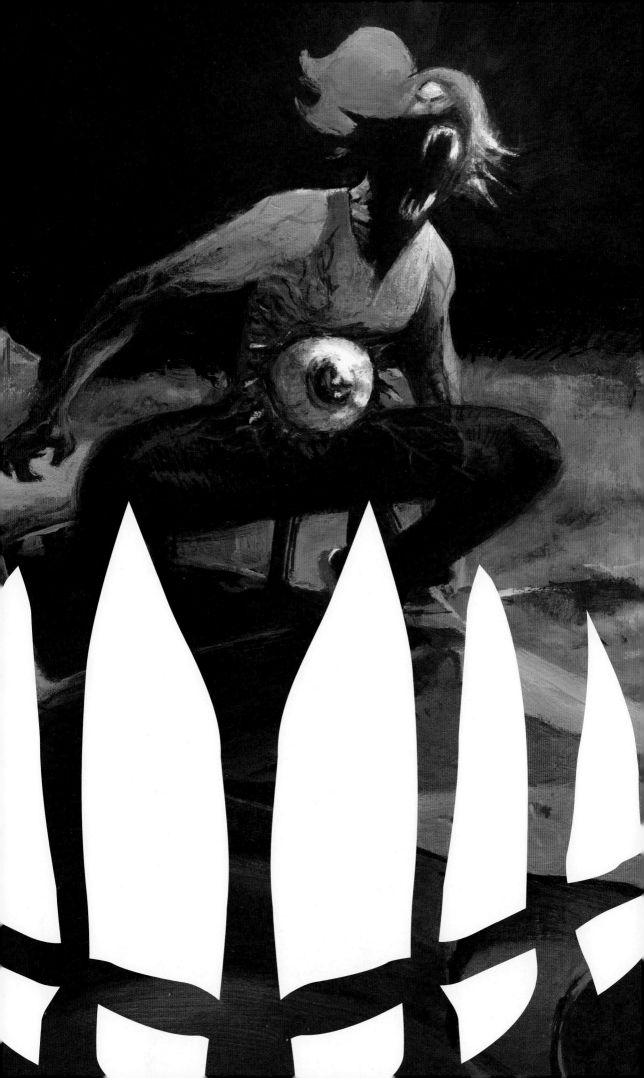

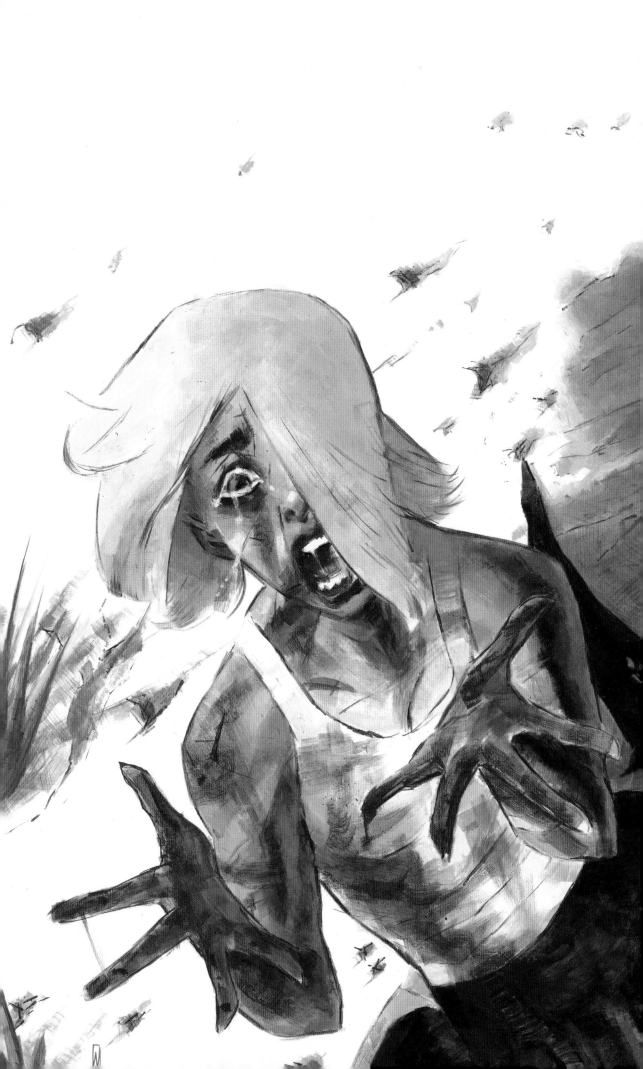

ON THE SUPPORTING CAST'S DESIGN & DEVELOPMENT

ABOVE
ISSUE #19 PAGE 5 PANELS 5 AND 6

❝ One of the things that's been rewarding as we've built out the entire universe is creating the characters who loom large in Erica's life from saga to saga, especially her family within the House of Slaughter itself. And as you probably know, the character who looms the largest in Erica's past is her mentor and the person who raised and trained her, Jessica Slaughter.

We are very sparing in the information we give the reader about Jessica, but over the next few years, people are going to finally learn more about that character and how she factors into the larger mythology. But even beyond that, you see the weight of her in Erica and why she doesn't cooperate with the Order.

So, you're learning about Erica from her relationships with different characters. Like her surrogate brother, Aaron Slaughter, or more specifically in the character of Cecilia. Cecilia Slaughter is maybe my favorite character to write in the entire series. And she is one of the chief antagonists for Erica Slaughter in the entire, larger Slaughterverse saga. She is everything that Jessica was not. Jessica is the one who taught Erica that you have to push back against the Order of St. George telling you that you can't care about other people, even if by caring you are opening yourself up to vulnerabilities.

Cecilia is cold. Cecilia has successfully burned so much of this out of herself, but you can tell that the one person she cared about more than anyone was Jessica. And Jessica was the character who was able to express all of that more directly, because even when Jessica was alive, Cecilia probably wasn't going to be very forthcoming about how she felt about anything.

Cecilia has never been forthcoming about anything she feels, but both she and Jessica do gravitate towards the character Big Gary Slaughter, who is another one of my favorite characters in the entire Slaughterverse mythos, and just such a deeply important character for helping provide the humanity that Erica requires to live. The only time we see Cecilia kind of break emotionally in the series is when Cutter oversteps and kills Gary Slaughter in the Tribulation Saga.

The benefit of the larger story we're telling with *Something is Killing the Children* is that we'll be going back into the past and to the different stages of Erica's development over and over and over again. So we're going to see a lot more moments in the history of Jessica and Cecilia and Gary, and then also in the training of Erica and the training of Aaron. There's just so much amazing soap opera that exists in the back of my head that I've been dying to get onto the page. And I'm really, really excited to be able to let the readers in. **❞**

-JAMES

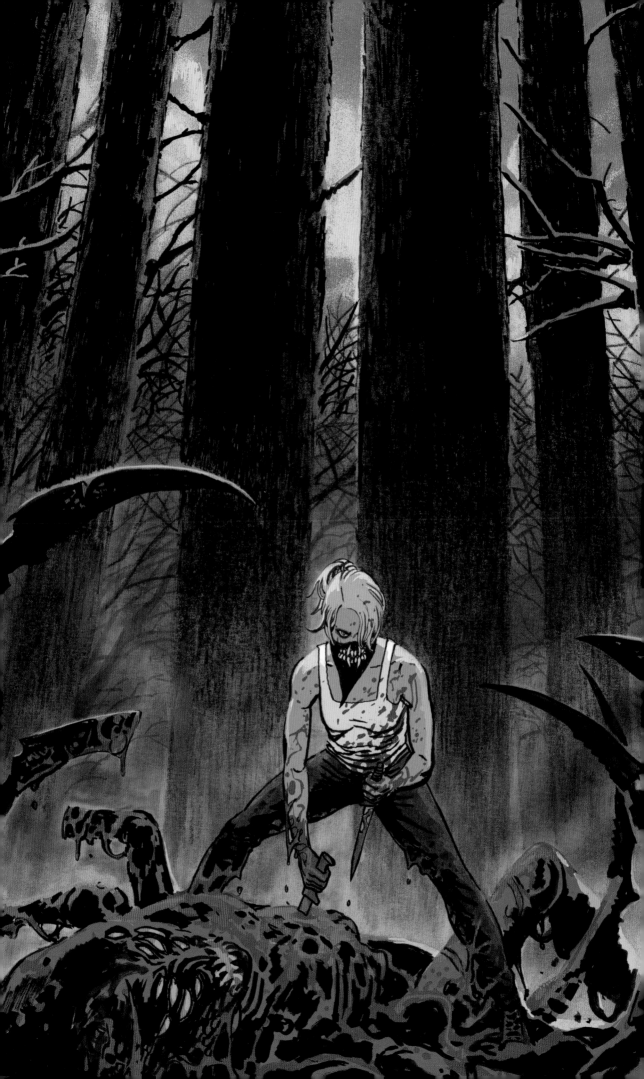

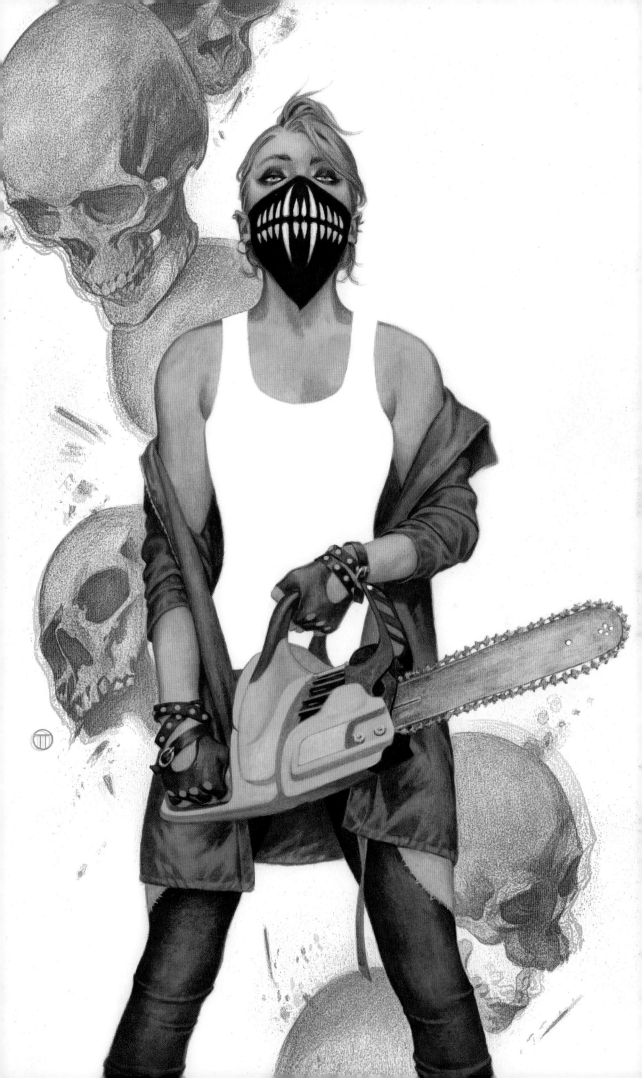

ABOVE
ISSUE #33 PAGE 16 PANEL 4

❚❚ The characters in Tribulation continue to revolve around the idea of the Western—there are Native Americans, a sheriff and his deputies, and even a horse!

Gabi and Riqui are two great characters, and I'm really proud of how they turned out. For Gabi I wanted to visually create a character with an unlikeable feeling, but unlikeable as only a teenager can be. A fake dislikeable, all posturing, who really just hides her own fragility behind the shield of dislike. Once you discover the game, you can't help but feel tenderness for such a character. Yes, I feel infinite tenderness for Gabi.

Another great character that I can't wait to draw again is Big Gary! (Yes, I know what happened, but it's comic books, baby! The great thing about storytelling is that it can move in whatever direction you like.) At first Big Gary was supposed to be huge. A big man! But I had already drawn an Azure Mask, which appears in Tommy's vision when Erica drills his temple in the first story arc. And he was the kind of character I had originally envisioned for Big Gary—but I didn't feel like making a duplicate of the first one. So I got the idea, why not draw him small and stocky? (At least compared to the other Azure Mask already drawn, Buck, who has since become the Farm's second-in-command.)

So "Big" might sound a bit like a cruel joke, a nickname that seems like a tease. But actually, the nickname was given to him by Jessica and Cecilia because Gary has a big heart—and only a few people know that, including Erica. At least that's what I tell myself as I draw them—the little stories that tell me about the characters are why I get so attached to some of them! ❚❚

-WERTHER

RIGHT
ISSUE #33 COVER BY WERTHER DELL'EDERA

FOLLOWING, LEFT
ISSUE # 31 VARIANT COVER BY JAMES HARREN

FOLLOWING, RIGHT
ISSUE # 31 VARIANT COVER BY DIKE RUAN

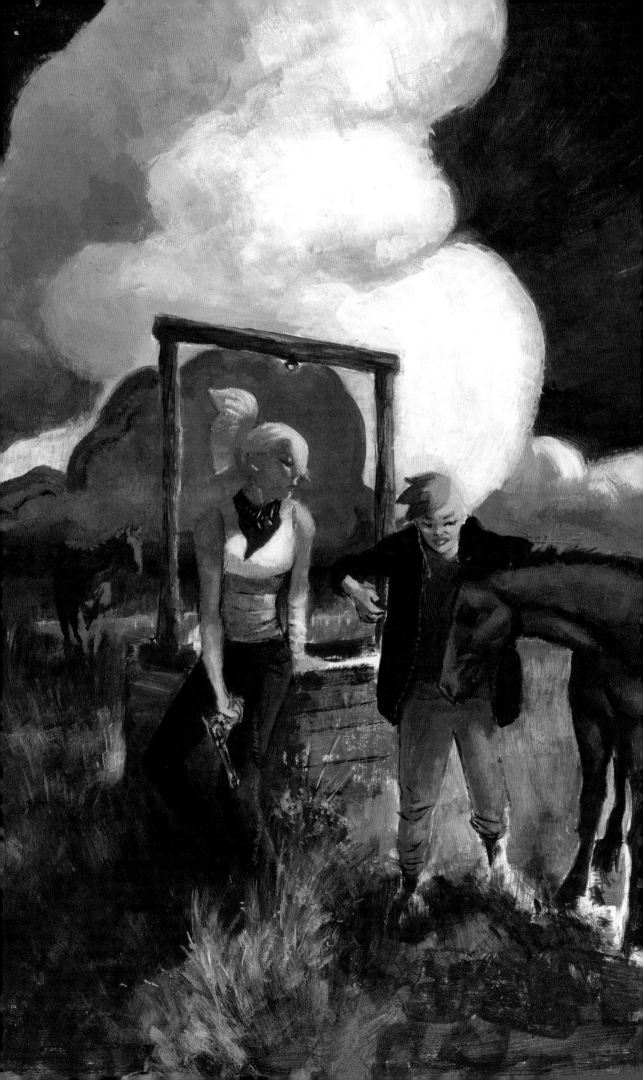

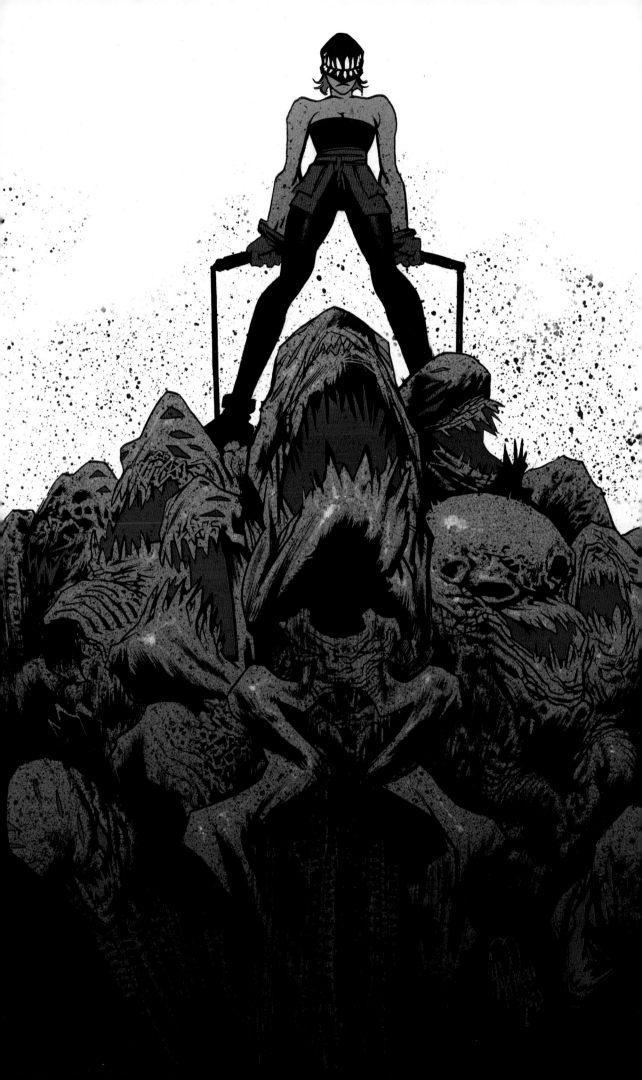

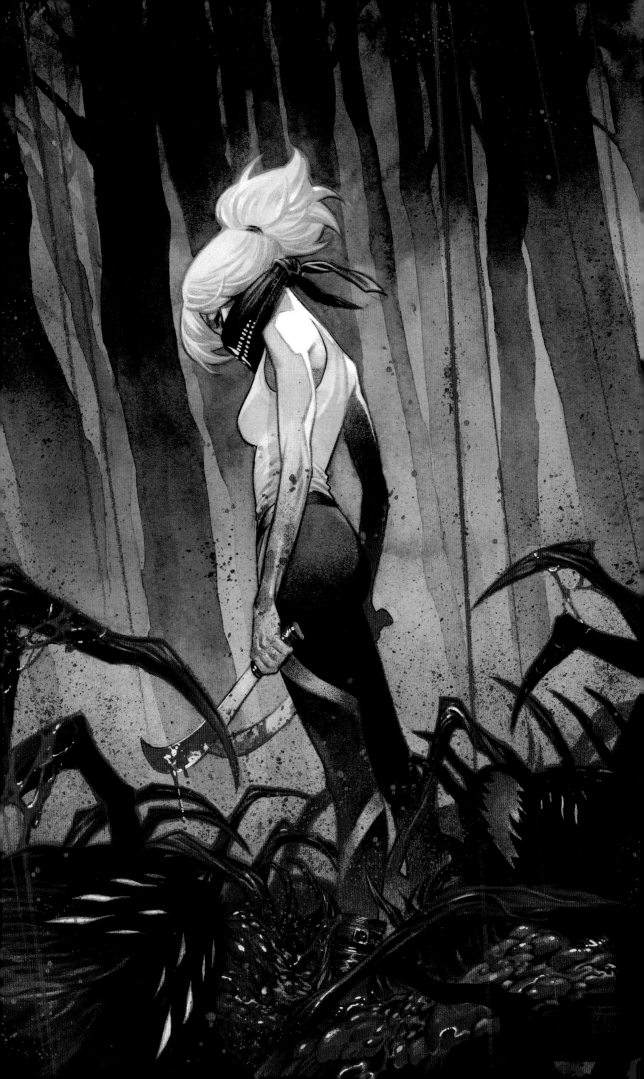

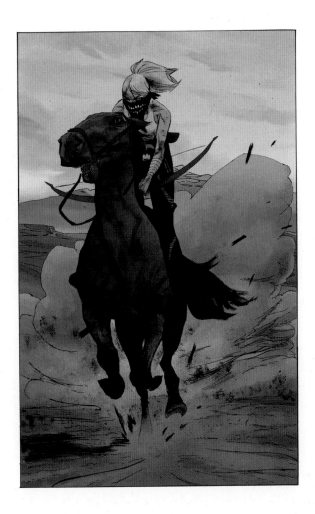

WERTHER:

We still have a lot of stories to tell in *SIKTC*. Avoiding spoilers, are there any aspects of Erica and the world of the series that you're looking forward to putting on paper?

JAMES:

So, honestly, this connects to the last answer, or several of the last answers—but as we move forward, we must go back. To explore how Erica becomes Erica, her relationship with Jessica Slaughter, and the dynamic between Jessica, Cecilia, Gary, and the Old Dragon. That's a rich, intricate story that we will very slowly reveal to the audience over time, but it is so clear in my head, and I am so thrilled to write it. It is a bit anxiety-inducing to think that there are moments that I'm not going to get to write for years that I know will make the readers of the series just absolutely sob to see, and I cannot wait.

LEFT
ISSUE #32 COVER BY WERTHER DELL'EDERA

FOLLOWING, LEFT
ISSUE #27 VARIANT COVER BY DAN MORA

FOLLOWING, RIGHT
ISSUE #29 VARIANT COVER BY TONČI ZONJIĆ

(187)

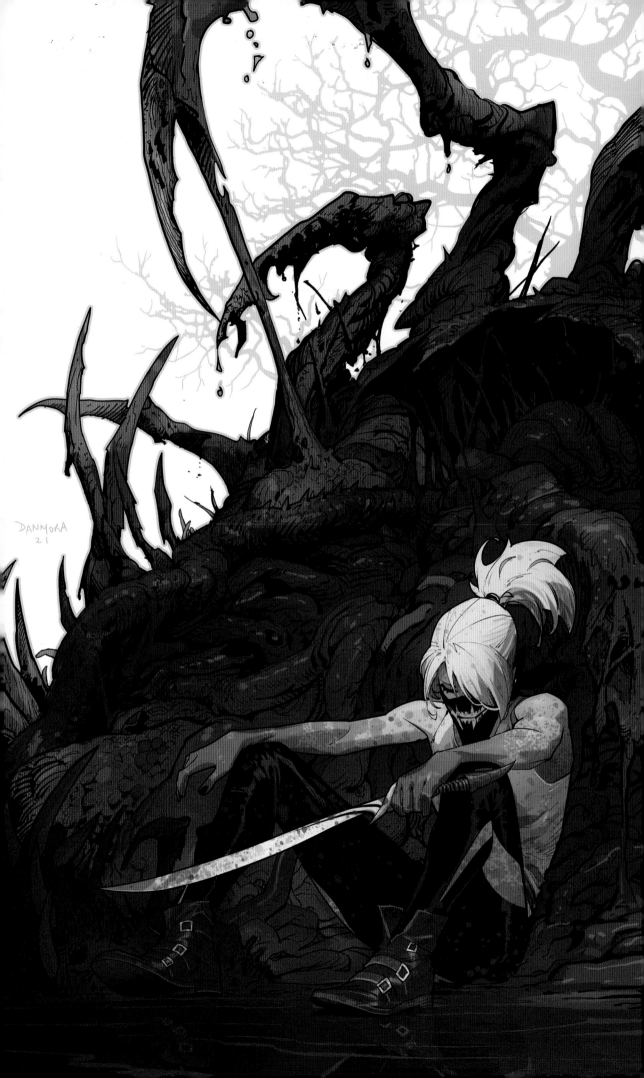

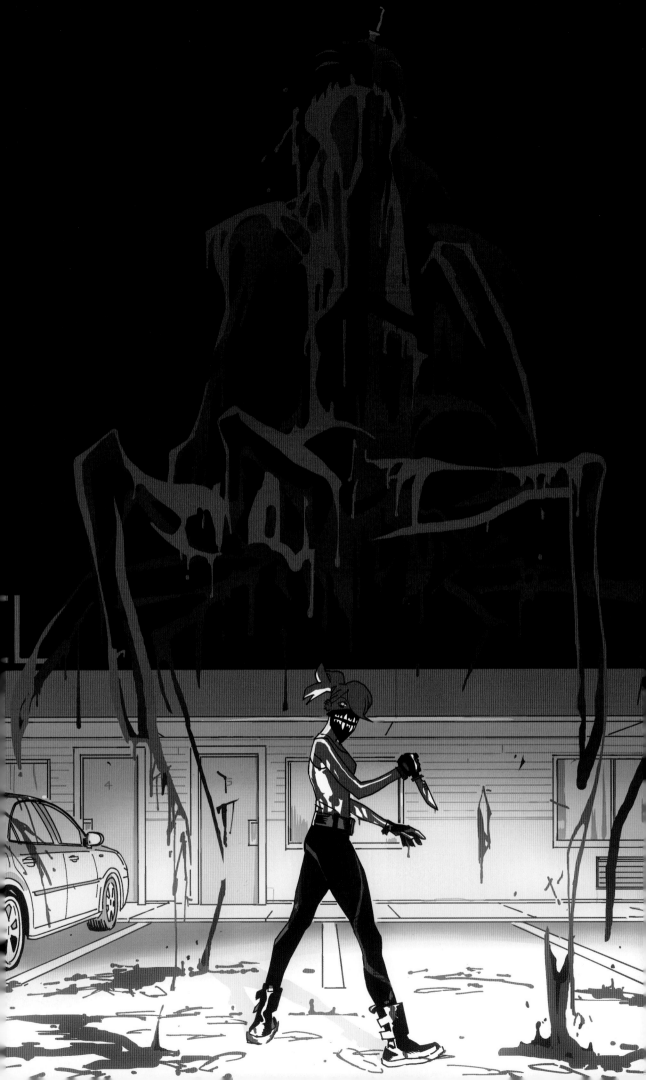

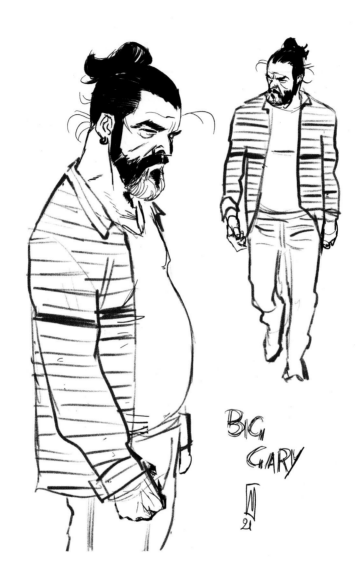

BIG GARY

RIGHT
ISSUE #26 VARIANT COVER BY JAE LEE & JUNE CHUNG

FOLLOWING, LEFT
IISSUE #29 VARIANT COVER BY ALEX ECKMAN-LAWN

FOLLOWING, RIGHT
ISSUE #31 VARIANT COVER BY FABRIZIO DE TOMMASO

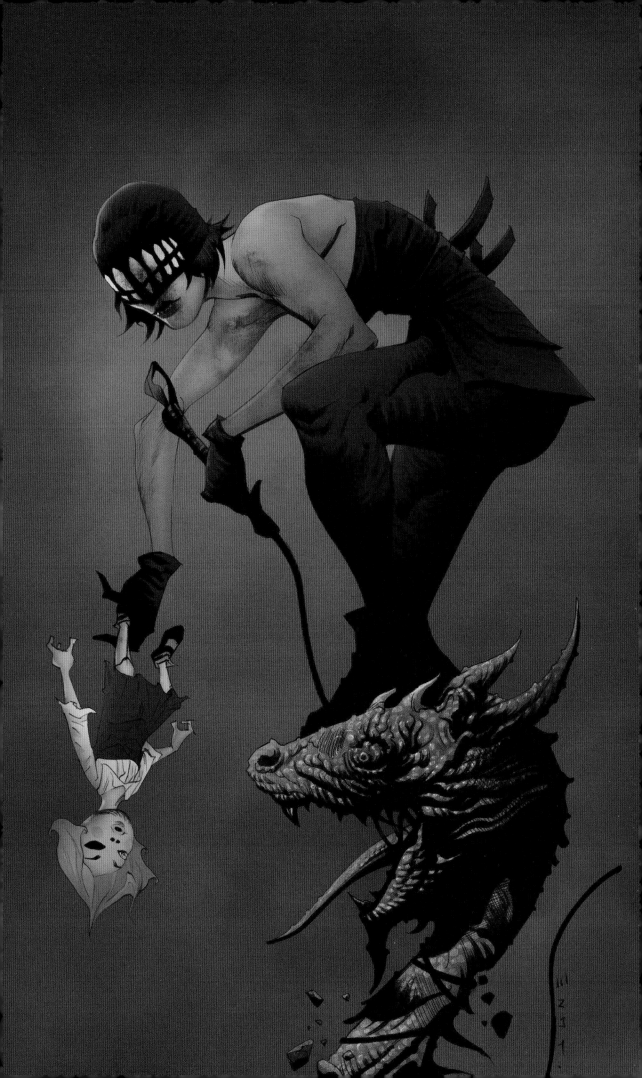

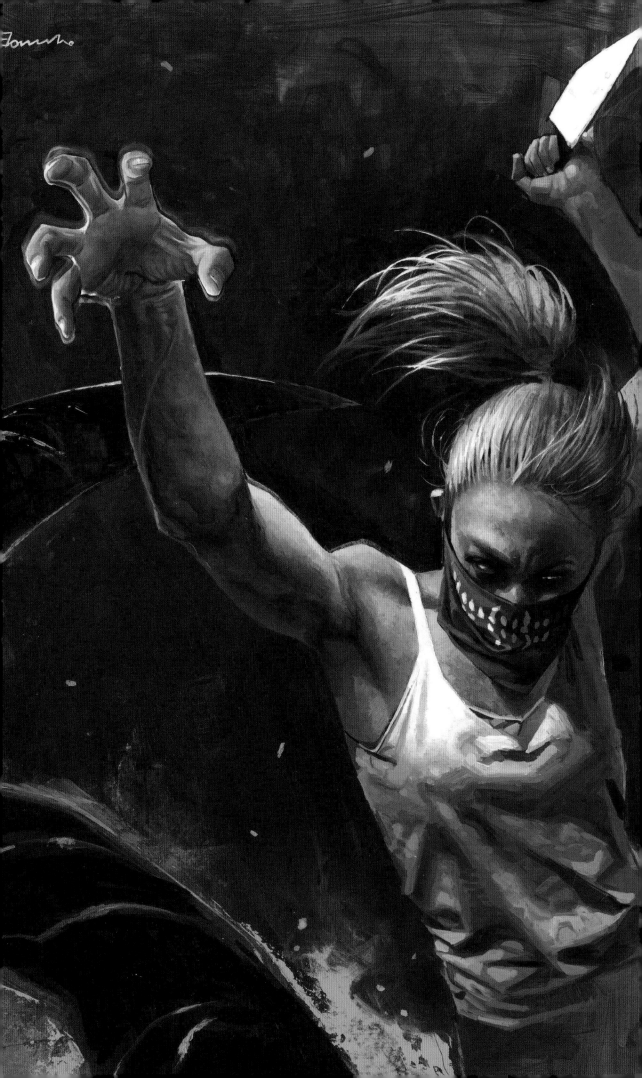

"IT IS A BIT ANXIETY-INDUCING TO THINK
THAT THERE ARE MOMENTS THAT I'M
NOT GOING TO GET TO WRITE FOR YEARS
THAT I KNOW WILL MAKE THE READERS
OF THE SERIES JUST ABSOLUTELY SOB
TO SEE, AND I CANNOT WAIT."

-JAMES

RIGHT
ISSUE #34 COVER BY WERTHER DELL'EDERA

FOLLOWING, LEFT
PEN & INK VARIANT COVER BY BELÉN ORTEGA

FOLLOWING, RIGHT
ISSUE #30 VARIANT COVER BY ÁLVARO MARTÍNEZ BUENO

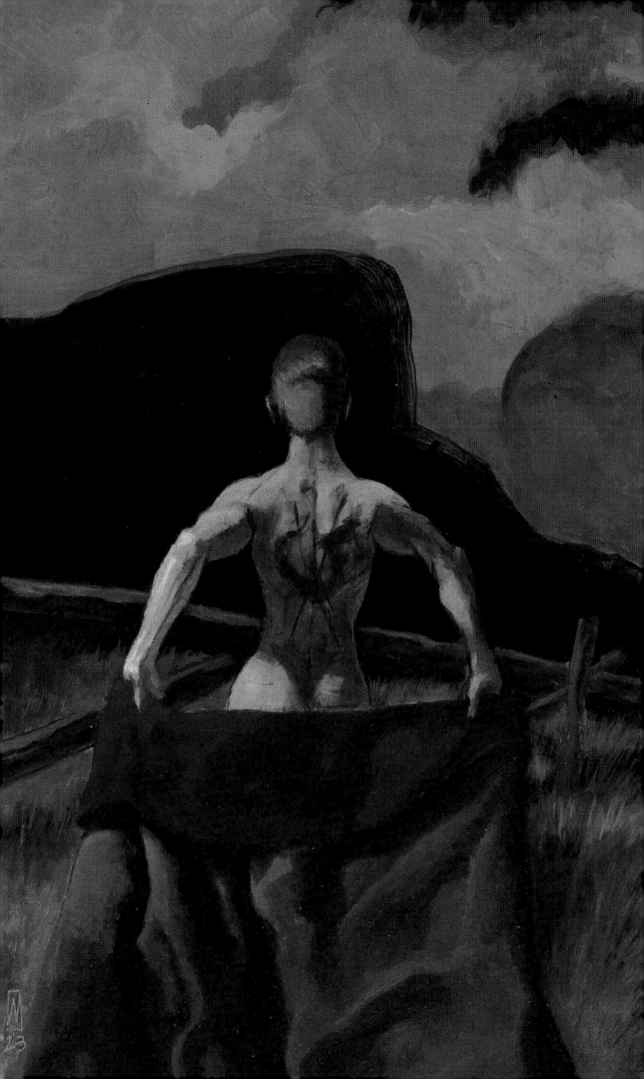

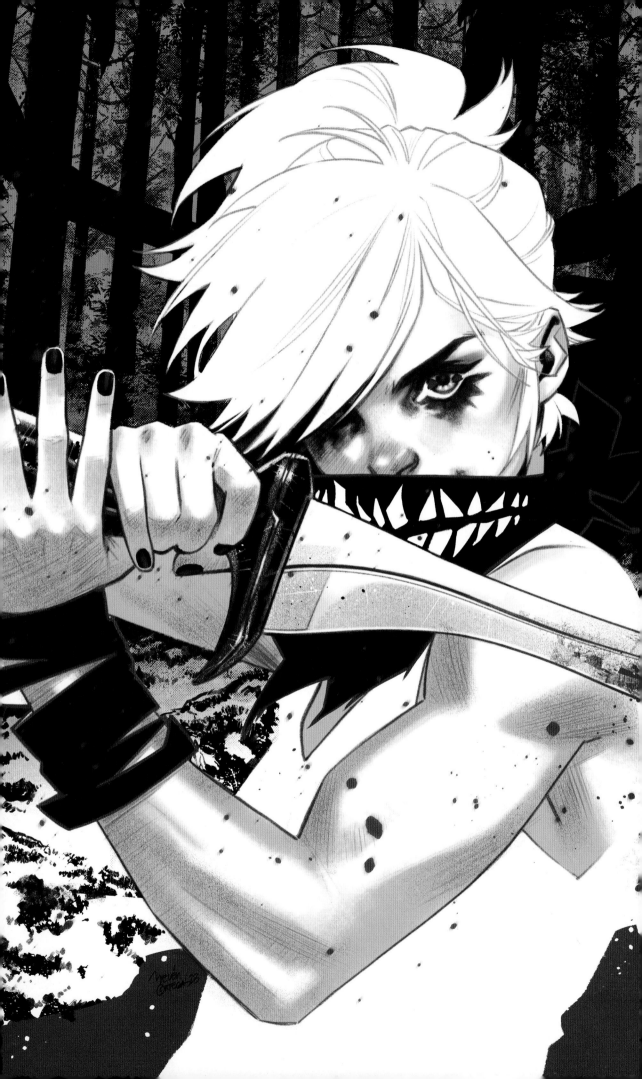

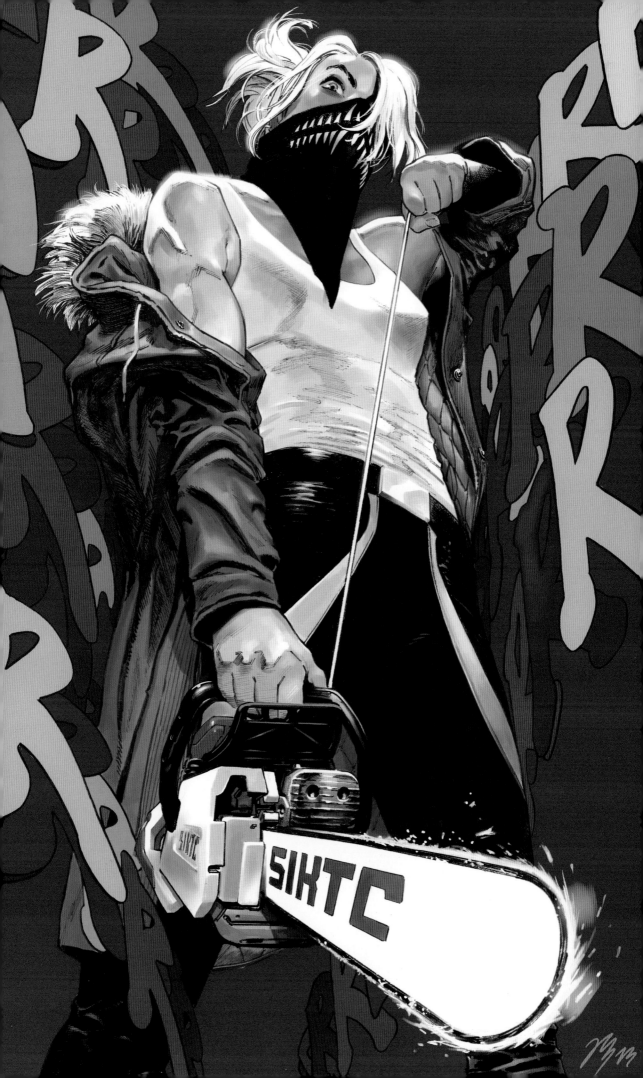

Page 6

1.
AND WE CUT INTO THE BATHROOM... where
CUTTER IS HAVING A COMPLETE NERVOUS
BREAKDOWN. She's at the sink, staring
at herself in the mirror. Twitchy and
strange.

CUTTER: Dolly Dolly Dolly what are they
doing to you...

2.
She's running her fingernails down the
wall on either side of the mirror...

CUTTER: What the fuck are they doing
to you. I won't have it I won't let her
touch you.

3.
TIGHT ON CUTTER'S UNHINGED FACE.

CUTTER: She can't touch you. Only I
can touch you.

4.
She closes her eyes, trying to center
herself...

CUTTER: Those are the fucking rules.
Those are the fucking rules.

5.
BUT THEN PUNCHES THE MIRROR HARD,
SHATTERING IT.

SFX: SMASH

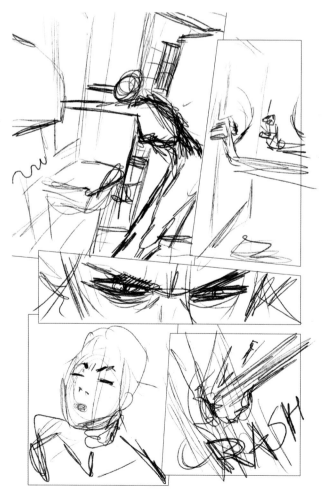

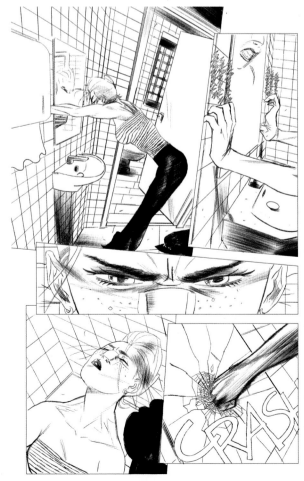

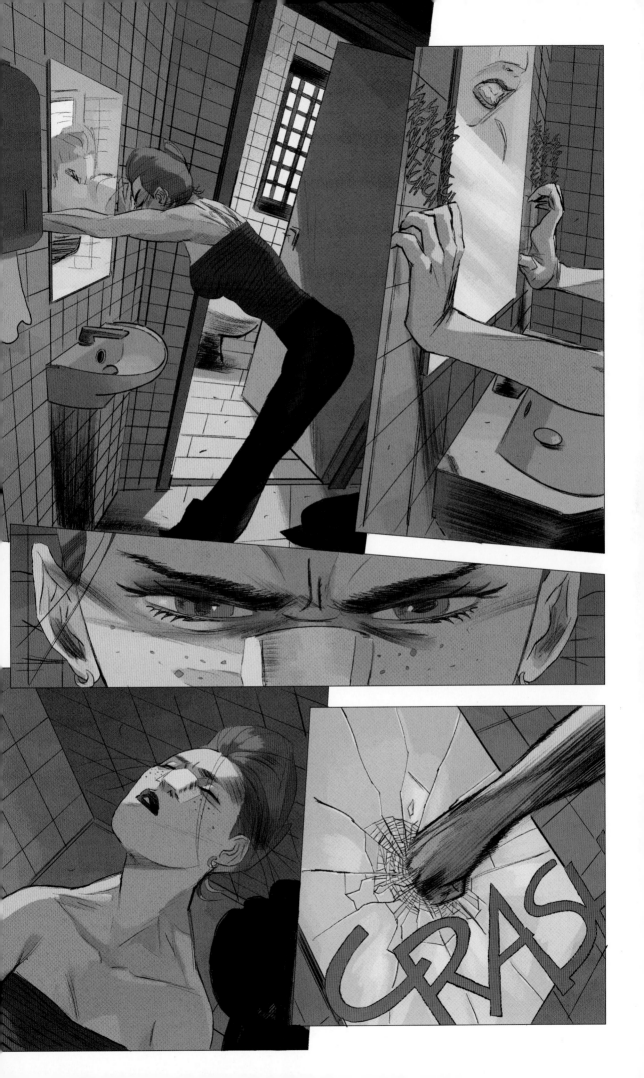

1.
WE SEE CUTTER THROUGH THE SHATTERED MIRROR, her hand now bloody.

CUTTER: Breathe, Cutter, breathe. She's strong. She's stronger than you. She's a good dolly. She's a good good dolly.

CUTTER: What would she say now?

2.
BUT HER FACE CONTORTS WITH RAGE.

CUTTER: Doesn't matter. They have to die. They all have to fucking die.

3.
AND SHE SMASHES THE BROKEN MIRROR SOME MORE...

CUTTER: THEY HAVE TO FUCKING DIE.

4.
And stumbles back.

CUTTER: But I can't...Not like this, I can't. I need to be strong. She wears the bandana to be strong.

5.
We see her pull a BLACK BANDANA out of her pocket.

CUTTER: I wear the bandana to be strong. Have to become the monster to fight the monster. That's what they taught me. That's what she taught me.

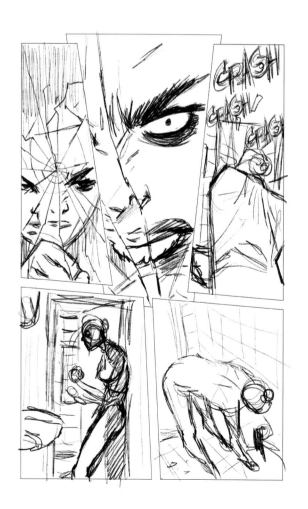
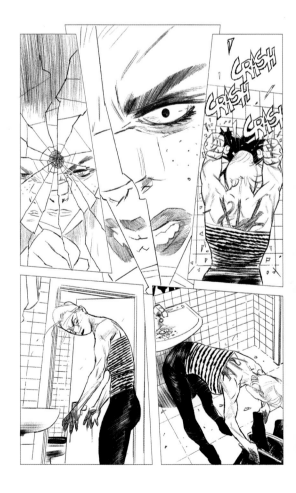

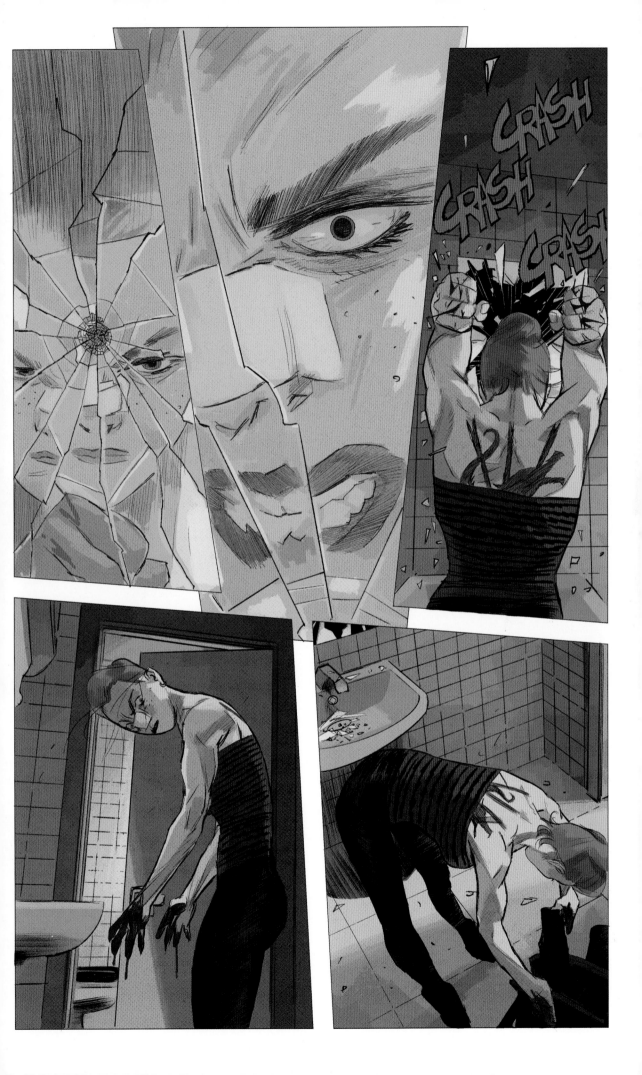

Pages 8-9

1.
SHE SMILES, UNHINGED, at the BANDANA in her hand.

CUTTER: I'm a good monster.

2.
SHE'S GRINNING MANIACALLY AND STRANGELY. She's so fucking excited to
become the monster again.

CUTTER: I am a scary scary monster and I'm going to rip her skin from
her bones and I'm going to eat it in little little strips until she's
nothing.

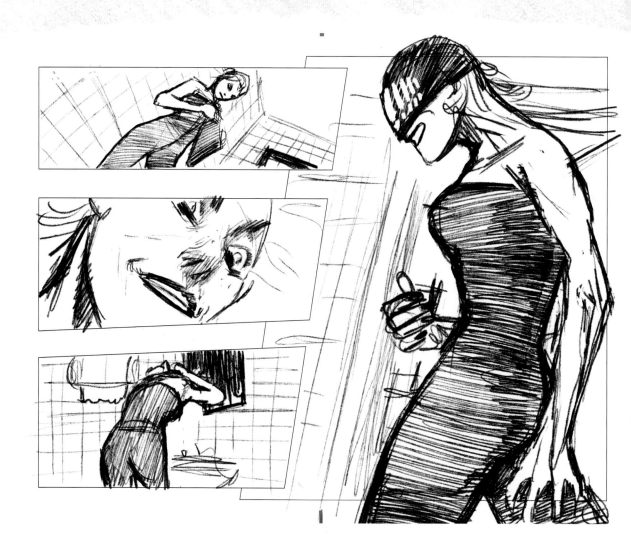

3.
She begins to pull the bandana on, tying it on her head...

CUTTER: Until she's fucking nothing.

4.
AND WE SEE CHARLOTTE CUTTER IN FULL, THE FIRST TIME SHE'S BEEN MASKED
IN THE INTERIORS OF THE BOOK... AND SHE SHOULD BE FUCKING TERRIFYING.

CUTTER: That's what I'll do. That's what I'll fucking do.

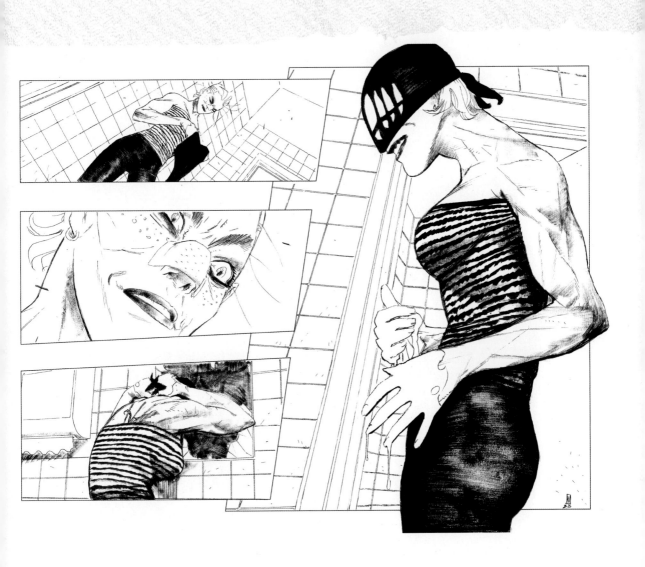

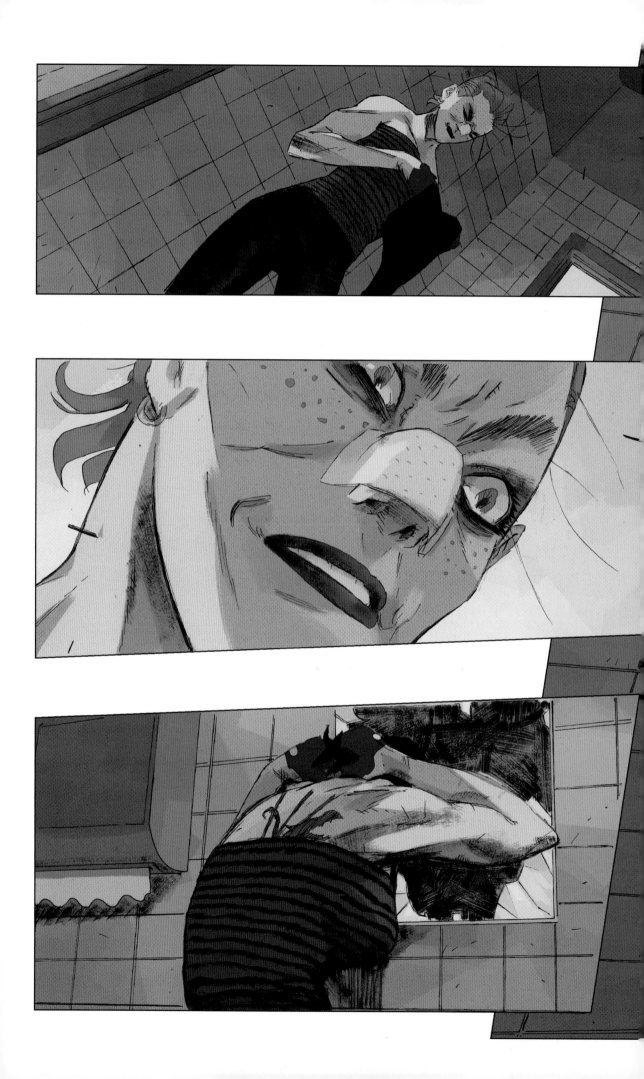

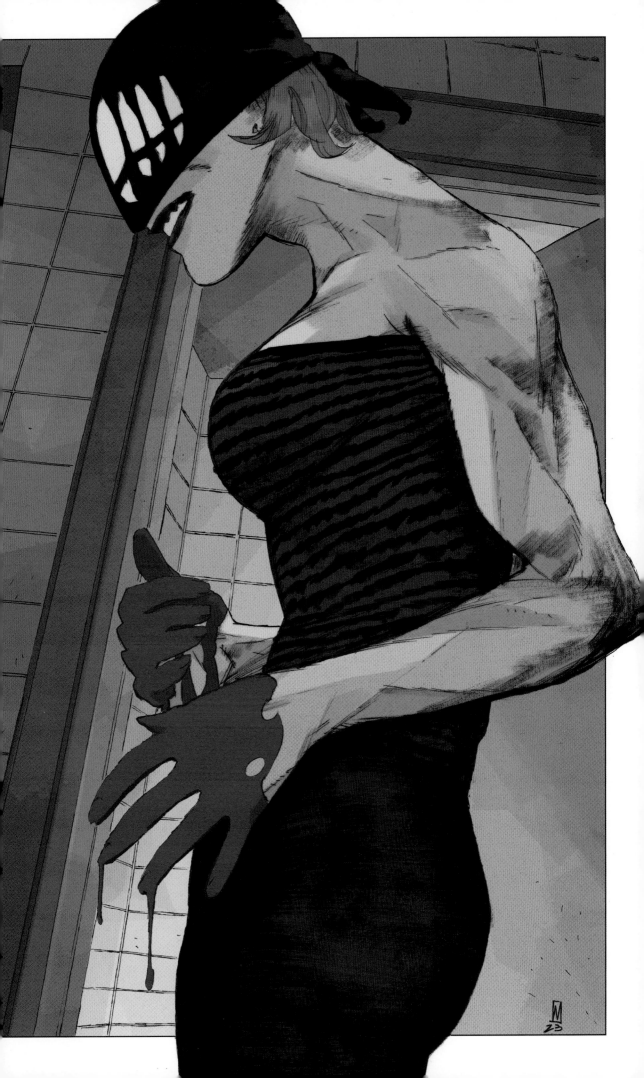

TO BE CONTINUED...

JAMES TYNION IV

is an Eisner Award-winning, *New York Times* bestselling author and publisher of comic books of all shapes and sizes. Best known as a writer of horror comics, James is the co-creator of *Something is Killing the Children* with Werther Dell'Edera for BOOM! Studios; *The Department of Truth* with Martin Simmonds and *W0RLDTR33* with Fernando Blanco for Image Comics; *Blue Book* with Michael Avon Oeming for Dark Horse Comics; and *The Nice House on the Lake* with Álvaro Martínez Bueno for DC Black Label. James also writes manga-infused genre stories for teens, like the fantasy epic *Wynd*, co-created with Michael Dialynas for BOOM! Studios.

WERTHER DELL'EDERA

is an Italian artist, born in the south of Italy. He has worked for the biggest publishers in both Italy and the U.S., with his works ranging from *Loveless* (DC Vertigo) to the graphic novel *Spider-Man: Family Business* (Marvel). He has also worked for Image, IDW, Dynamite, and Dark Horse. In Italy, he has drawn Sergio Bonelli's *Dylan Dog* and *The Crow: Memento Mori* (a co-production between IDW and Edizioni BD), for which he has won awards for Best Cover Artist, Best Series, and Best Artist.